INHERITING beauty

ROGER MOENKS

powerHouse Books Brooklyn, NY

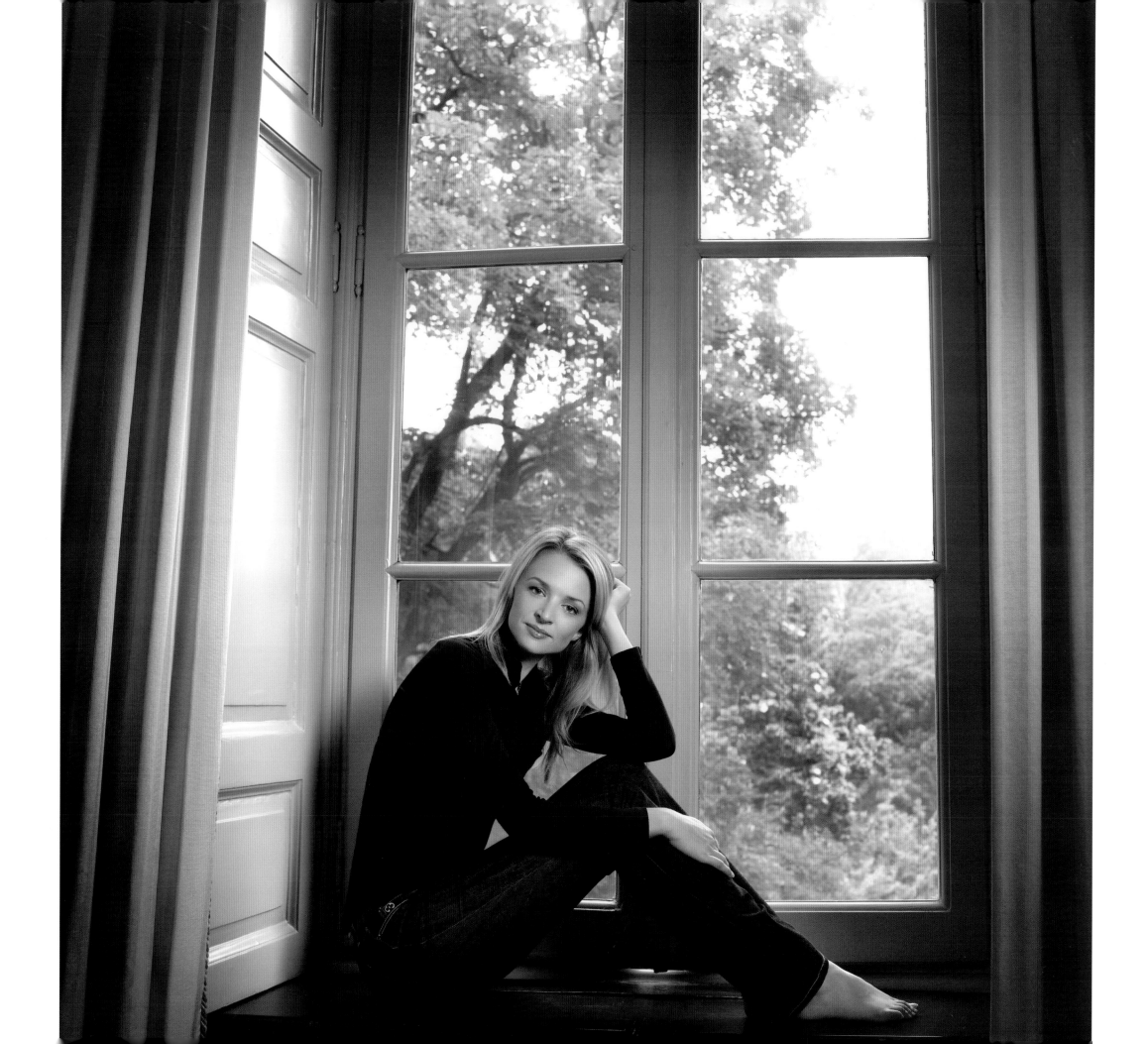

To my parents, Stefan and Pascale

Many thanks to all the women who agreed to be photographed, gave willingly of their time and contributed so generously. Special thanks also to Tristan Moenks-Jackson, David Benattar, Olivier Labesse, Giorgio Armani, Isaac Mizrahi, Massimo Ferragamo, Rudolf Moenks, Stefanie Moenks, Matt Jackson, Rhonda Palmer, Douglas Ash, Brian Long, Eric Orlando, Brenda Tidwell, Maria Laura Elli, Rod Manley, Robert Triefus, Christian Leone, George Kolasa, Frances Tsai, Belinda Goh, Gene Bresler, Anne Maree Gale, Anna Matthews, Lorenzo Benazzo, Denise Scala, Andrea Hansen, Casey Koslowski, Robert Risse, Bjorn De Carro, Patrick Kullenberg, Paola Hjelt, Andrew Glenn, Bernard Werkmeister, David Benaym, Rebecca Weinberg, Debbie Feldstein, Leslie Hofman, Anna Wintour, Jason Ashlock, Marianne Strong, Mitch Zamarin, Tatijana Suljic-Shoan, William Norwich, Julian Peploe, Christopher Tkaczyk, Graydon Carter, Nicola L., Michael Bergan, and Scott Woodward.

"If an Anglo-Saxon decides to write a personal record of fashion and the minor arts, he may find himself accused of being a propagandist of frivolity," wrote Cecil Beaton in *The Glass of Fashion*, a personal history and tribute to the people who had most influenced fashion from the turn of the last century into the 1950s. "He will certainly discover that, both in England and America, fashion is viewed with a jaundiced eye, feminine enthusiasm notwithstanding." Beaton reminded his readers of a celebrated Taoist dictum that says only those knowing the value of the useless can talk about the useful. He opined that when we talk about fashion, "we really mean the whole art of living. Its practitioners, like roofthatchers, are a disappearing race in our modern world."

Why do we care? Why shouldn't we? Style matters. Each generation turns to its tastemakers for inspiration. Fashion provides not just allure, but the motivation to do more than merely endure, to rise above the fray. Nonetheless, style ambivalence and the critically unconvinced do somehow exist. They always have. During WWII, a news magazine published an editorial urging that, in a world battling evil, *Vogue* ought to cease publishing. To which *Vogue*'s editor at the time, Edna Woolman Chase, responded that although she was mindful of the changing times, "If the new order is to be one of sackcloth and ashes, we think some women will wear theirs with a difference!"

The women in *Inheriting Beauty* are serious people, they have careers, they care for their families, and they raise millions of dollars each year for charities. "Vivid snapshots of international style through the lives of some of the world's most notable young women," said Giorgio Armani of the elegant beauties Roger Moenks has gathered for this book. And what a guest list we find inside — Delphine Arnault in France, the book's cover girl Roberta Armani in Milan, Jacqui Getty in California, Dee Dee Poon in the Far East — welcoming you to a very private visit with some of the most significant young social women in the world today.

The profile of a woman of style has come a long way from the heady days when an emerging newspaper industry anointed Georgina, Duchess of Devonshire, the first media fashion figure. When she was just 18, circa 1775, her first contribution to the gossamer history of fashion was taking the trend of her day, arranging your hair high above the head, and raising the stakes by adding a three-foot tower concocted of horse hair mingled with her own, a scented pomade as a fixative, and miniature ornaments at the top — one day a ship in full sail, and on another a pastoral tableau with tiny sheep and toy trees. Did Freud say hair is destiny? No wonder Marie Antoinette, the Duchesse de Polignac, and Georgina were such good friends.

But that was a long time ago. The women of *Inheriting Beauty* have let their hair down. They step out of their carriages. They walk in the streets. They are of this world, and not above it. What is so remarkable about Roger Moenks' exquisite labor of love is that instead of swooping in on these women with lights, cameras, hair, makeup and wardrobe, he asked the women to just be themselves, to dress as they would at home, and to let him capture them in real time.

They obliged, and he was not disappointed. He anticipated beauty, and he found it, plus an abundance of grace, elegance, and generous good manners. Getting away from the smoke and mirrors of a world maddened by celebrity culture, in the social firmament, in private lives, he discovered "a modern royalty and a modern luxury" — a luxury, as Moenks' delightful book reminds us, that is "the freedom of being so alive and having the choices to do what you want."

William Norwich
New York City
Autumn 2007

Wealth doesn't easily translate into style or sophistication, which are traits resulting from good upbringing, commitment to education, and knowing what to do with what you have, i.e., working within your means. The women in this book may or may not have been born into wealth, but each of them has made a mark on society — some by creating empires, some by refusing to accept limitations and extending boundaries, and others by lending a helping hand. I'm amazed by each of their stories.

I first began this project after attending a party in Miami hosted by Rena Sindi, who had flown in a few friends from New York. I met Emilia Fanjul and Marisa Noel Brown and decided that photos of today's society women in their homes might make for an interesting magazine story. What started as a handful of photographs eventually turned into a few dozen and the book gave birth to itself. I'd decided to seek out the tastemakers and trendsetters in all of the world's style capitals.

It is a collaboration between myself and 90 sophisticated and fashionable women to capture them in their environments, whether at home, at work, or at play. Every woman photographed herein helped me to discover their personalities, to select locations and poses, and how to best highlight their individual styles. Thanks to the advances of digital photography, I was able to immediately show them the photographs and include them in the process, making certain they would be pleased with the end result.

Unsurprisingly, these women juggle busy schedules while overseeing companies, running charities, traveling the world, meeting up with friends, raising children, and running households. On the pages accompanying their photographs, you will find candid answers to a few questions I asked them about the greatest lessons they learned from their parents and about their fondest childhood memories. No matter what defines each of our histories, we all dream of making our way in the world, how we could best contribute to it, and want for a better future. To show these women at the prime of their innocence, they contributed photographs from their youth. As children, we all look quite similar. You will find these photographs opposite the portraits I have created. I am indebted to these women for their willingness to sit for my portraits and very thankful for their contributions to this project.

The photographs of Helmut Newton and Jacques-Henri Lartigue, the genius artists of the 20th century who captured beauty on film and whose photos define an era, were an inspiration and a guide. The photographs in this book are a document to chronicle our time and the women who make it beautiful.

ROGER MOENKS

''Roger Moenks has captured international style through of the world's most notable

Giorgio Armani

vivid snapshots of
the lives of some
young women."

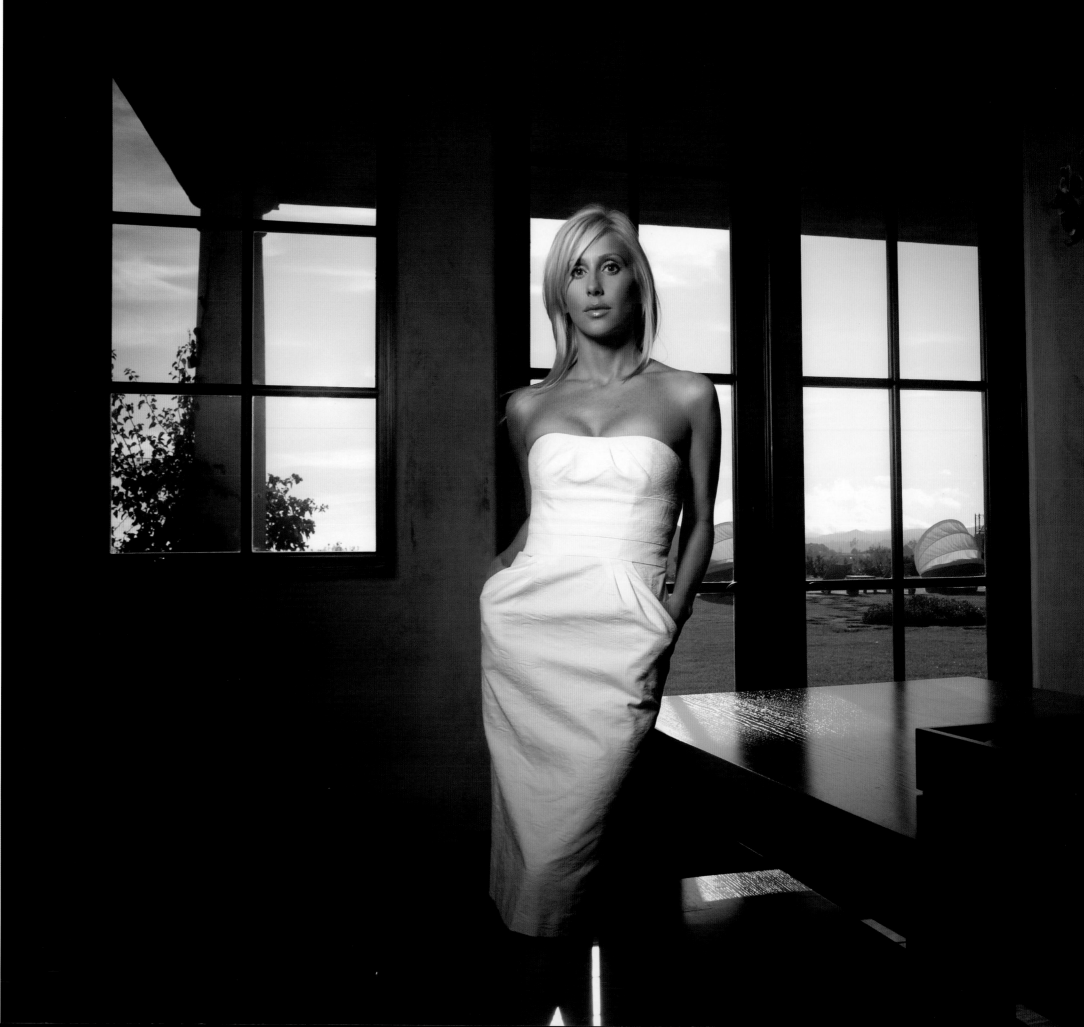

alexandra von furstenberg

The youngest of three daughters of duty-free tycoon Robert W. Miller, Alexandra grew up in Hong Kong, Paris, Switzerland and New York. After studying at Brown University, she married Alexandre von Furstenberg and was daughter-in-law to the fashion icon Diane von Furstenberg. She became the creative director of the designer's business, which she helped expand in 1997 by reviving Diane's famous wrap dress. She divorced in 2003 and now lives in Los Angeles with her two children.

Photographed in Los Angeles

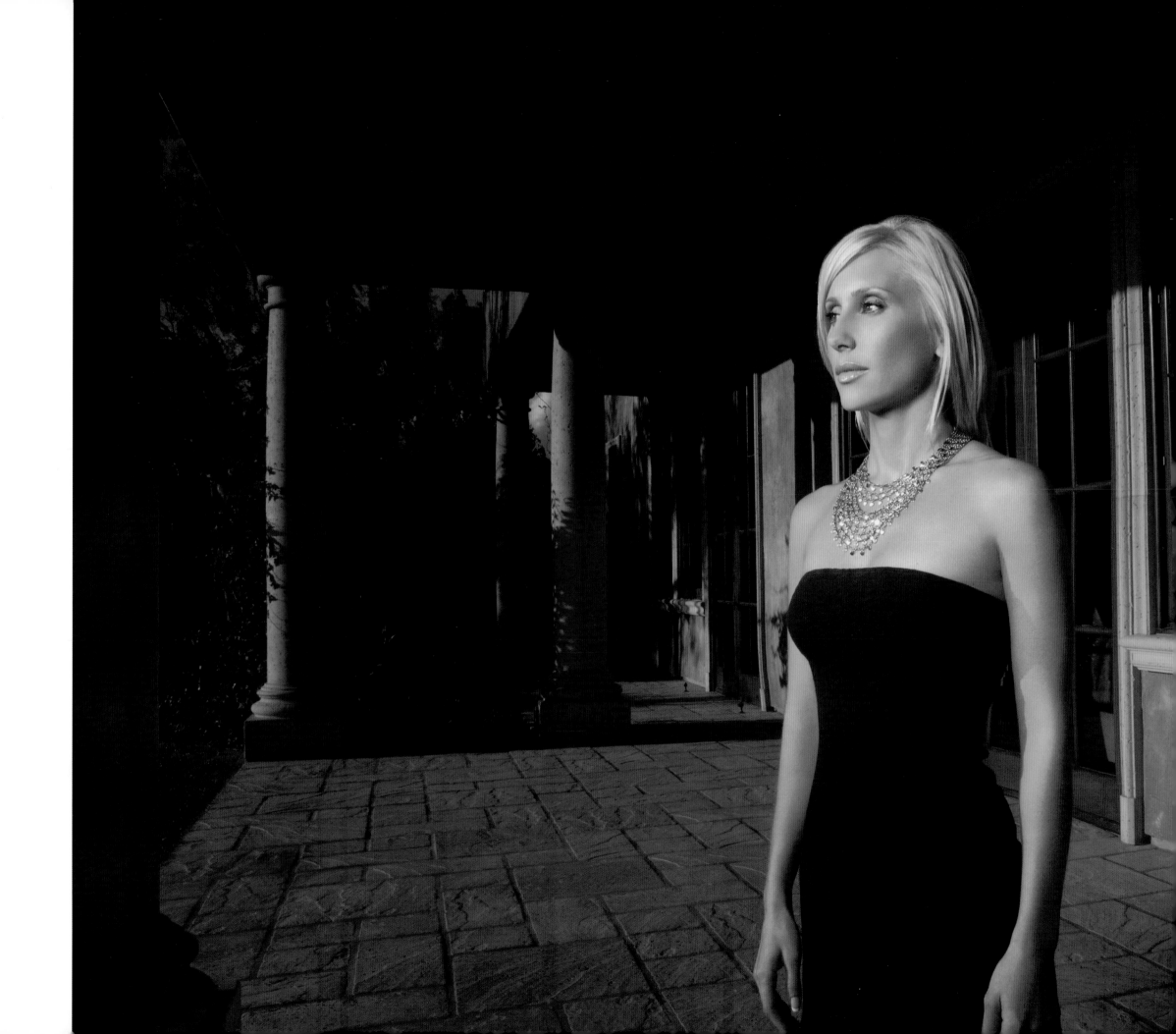

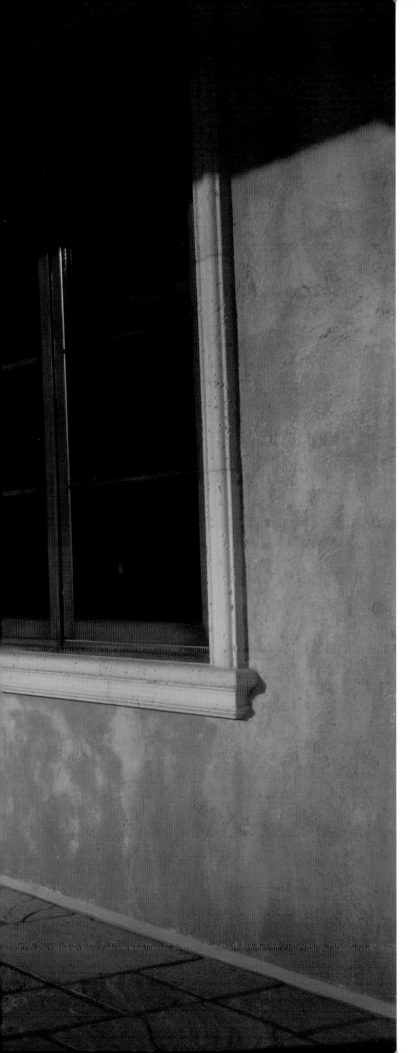

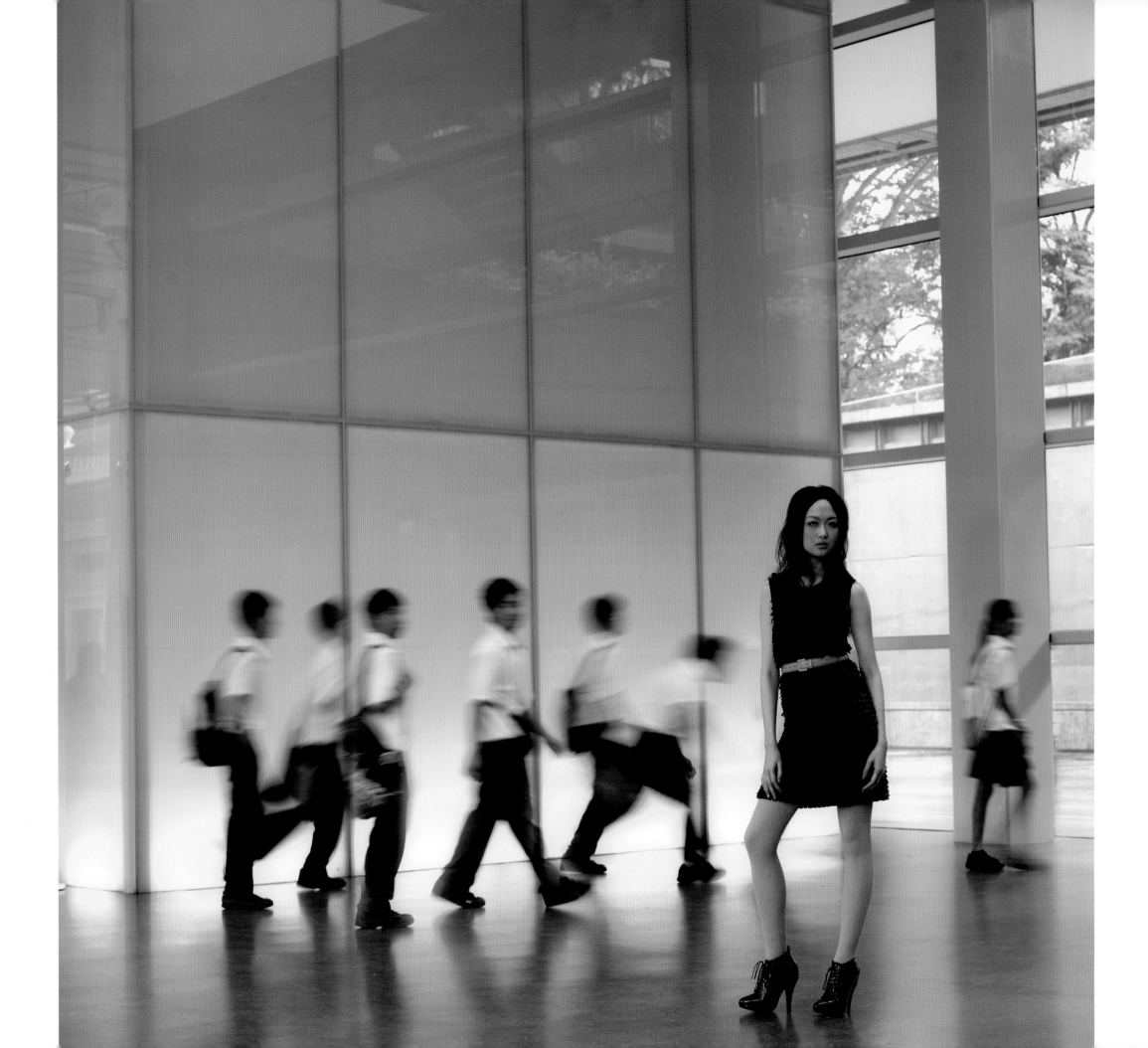

alice oei yin

As the daughter of investor and coffee and steel tycoon Oei Hong Leong, Alice is a natural born entrepreneur — she plans to open a spa in Shanghai. After studying law and English literature in London, Alice returned to Singapore to teach preschool and help her father run a charity foundation that offers scholarships and provides funding for medical research and worldwide relief work.

Photographed in Singapore

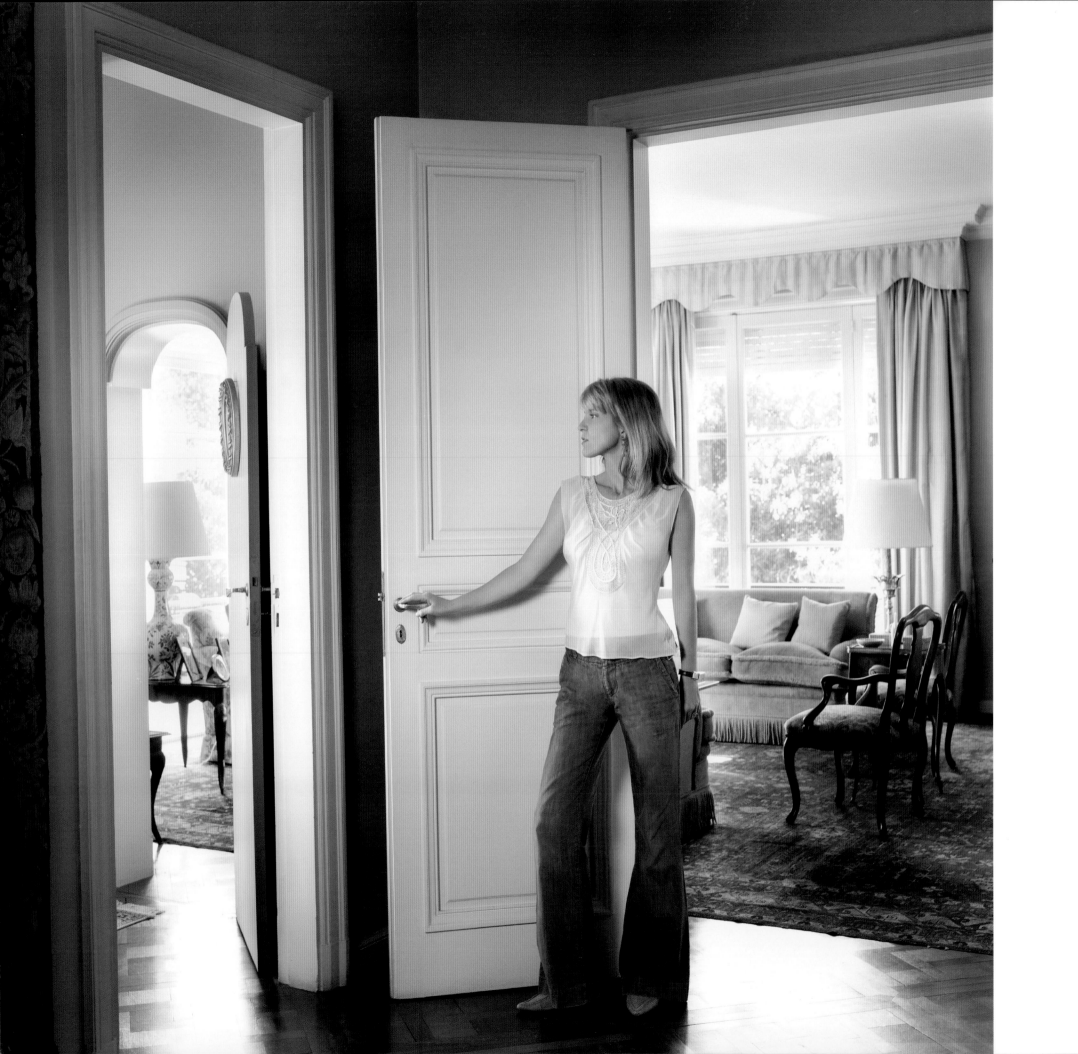

agnese fontana gribodo

Born and raised in Buenos Aires to an Italian father and an Argentine mother, Agnese later moved to Rome, where the family line includes the architect Domenico Fontana, who was asked by Pope Sisto V in 1586 to set the famous obelisk on its pedestal in St. Peter's Square. Agnese studied literature and philosophy before embarking on an early career in event planning. A job organizing football events kept her traveling the world for two years, and a short return visit to Buenos Aires was extended when she met the man who would later become her husband. She again calls Buenos Aires home and lives with Gregorio Quirno Costa and their daughter Clara on a farm in the western area of the Pampa, where she also runs a children's clothing line named Matilda.

Photographed in Buenos Aires

*My parents taught me nothing is impossible
if you really want it and try as hard as you
can to achieve it. It all depends on you.*

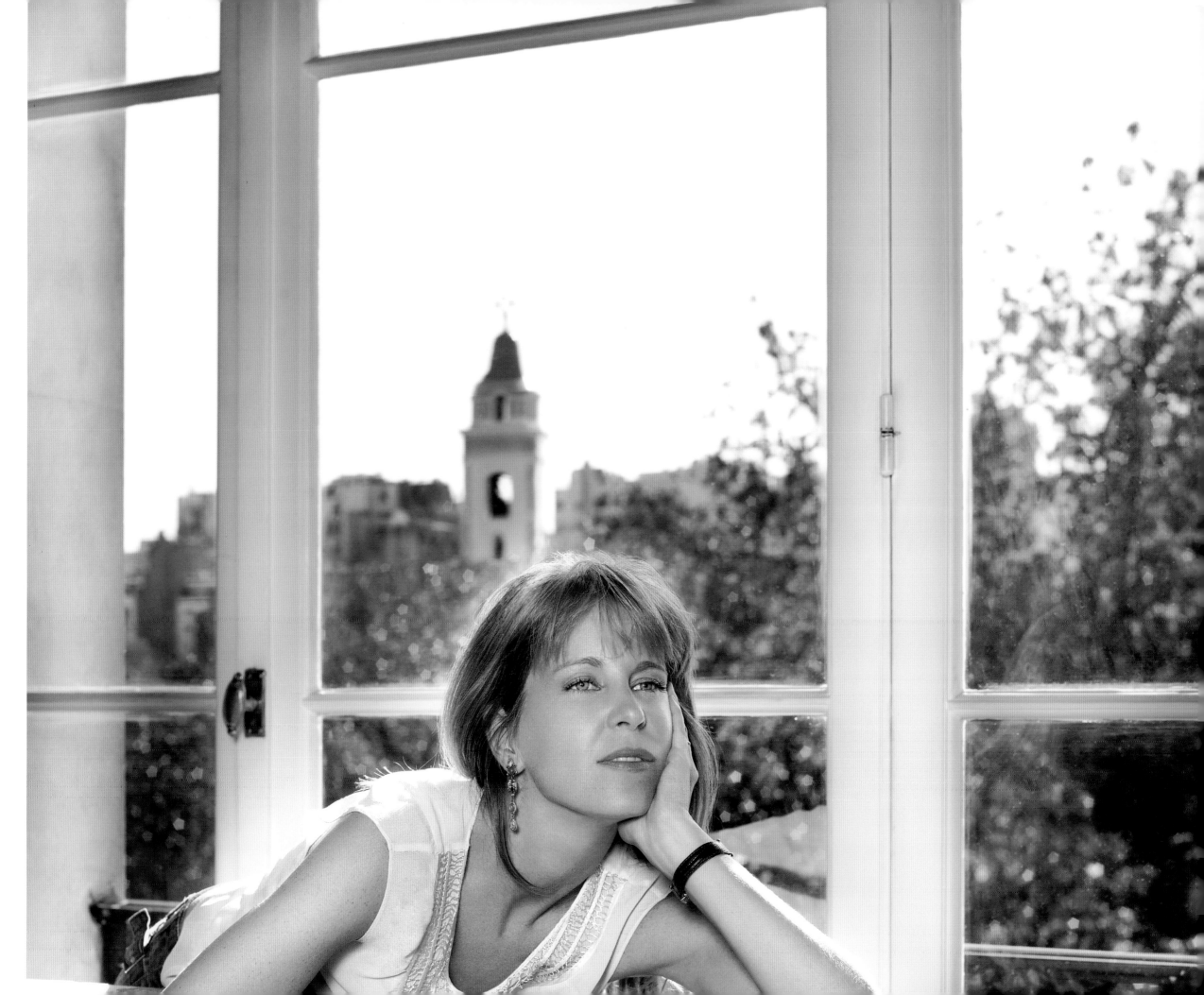

alejandra di andia

Alejandra di Andia was born in Santiago to a Chilean father and a Scottish mother. Her family moved to France when she was 10 years old. After completing high school, she moved to Florence to study drawing at the Instituto per l'Arte, followed by a return to Paris to learn fashion design at the Ecole de la Chambre Syndicale de la Haute Couture. A career in French fashion was born, and Alejandra built her name while working in the houses of Balmain & Torrente and Carven. After 10 years of creating ready-to-wear collections that were sold in Le Bon Marché, FranckFils (Paris), and Henri Bendel (New York), she opened a Parisian salon to cater to international private clientele. Alejandra also competes in motorcar rallies in deserts to support humanitarian organizations for children.

Don't ever take anything for granted.

francisca matteoli

Born in Santiago, Francisca has lived in Brazil and now resides in Paris. Her travel writing has appeared in *National Geographic*, the *Relais & Châteaux magazine*, the literary magazine *Senso* and *Air France* magazine, among others. Her first story for *National Geographic* detailed her husband's humanitarian mission to Rwanda to perform free plastic surgery operations for patients suffering from war injuries. She has written three collections of short stories set in hotels and appears regularly on the French TV channel Voyage.

Photographed in Paris

Be yourself, fight for your ideas and have the ability to prepare a good pisco sour.

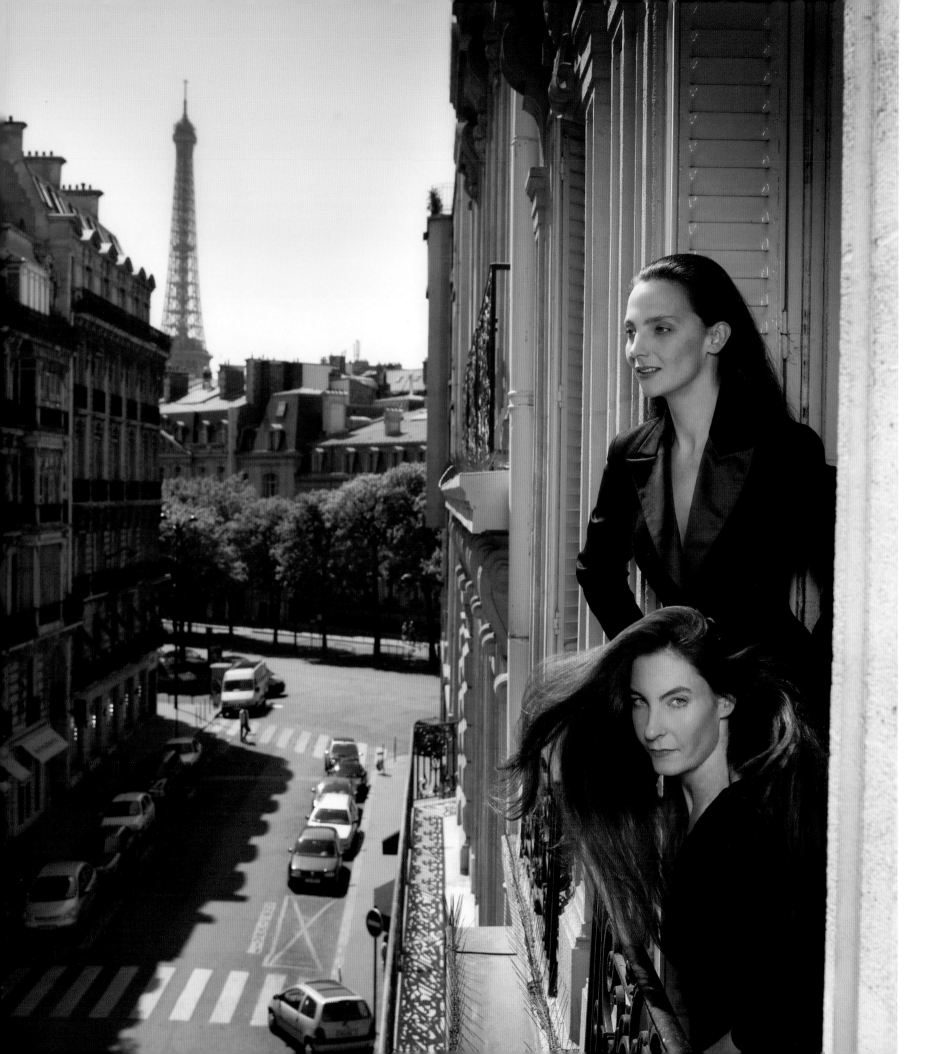

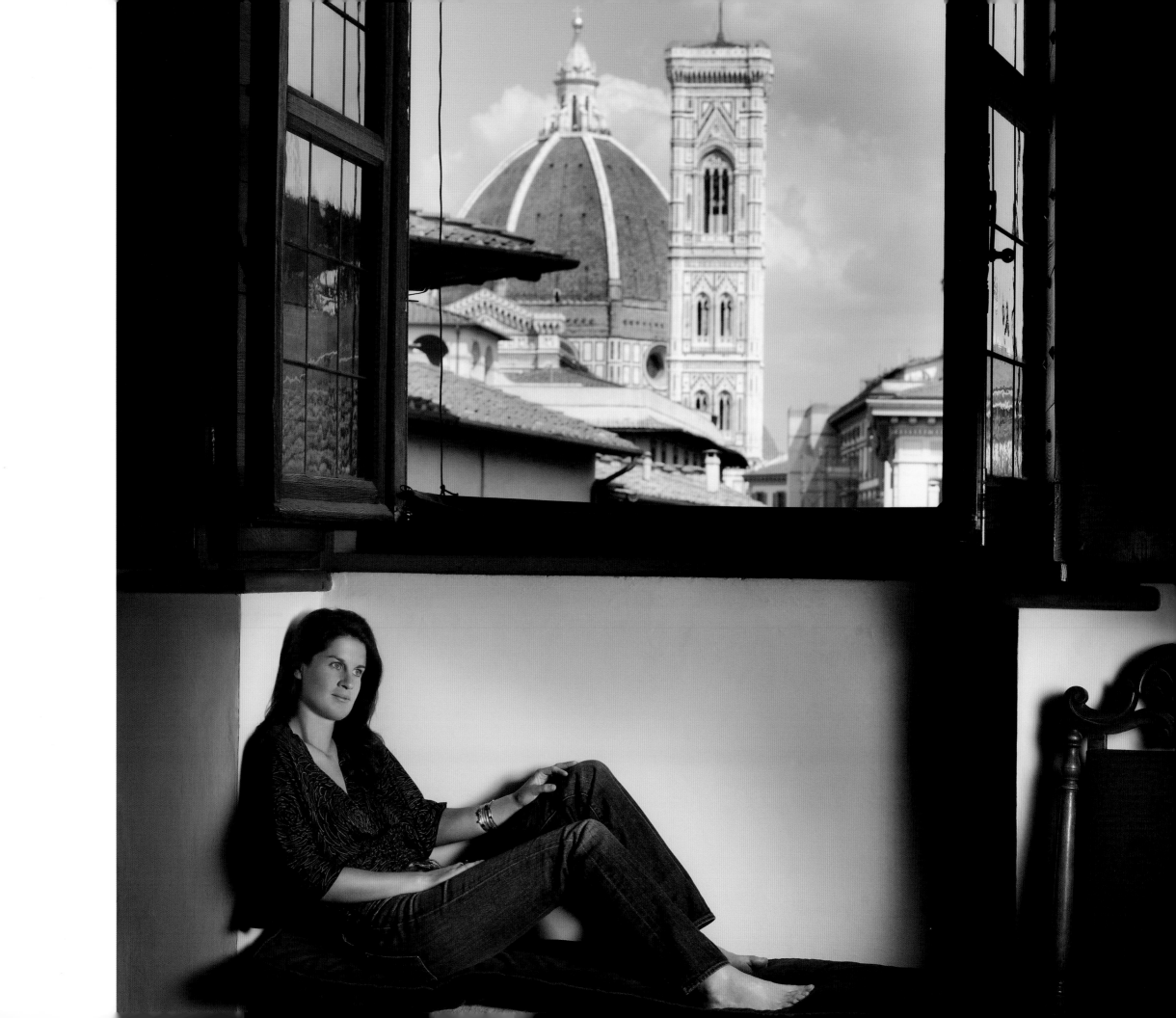

alessia antinori

Alessia Antinori is the youngest of three daughters of Marchese Piero Antinori, president of the famous Italian vineyard. She was raised in the family's 15th century palazzo in Florence, which has been the headquarters of the family business since 1506, and in the wine estates in Tuscany and Umbria, where she spent summers helping with the estate. She was educated in Florence and then studied viticulture and oenology at the Agrarian University of Milan. Since then, she has worked as an oenologist and has created a new estate in Franciacorta for the production of sparkling wines. To expand the brand, she spends four months of the year in Asia. She has served as president of the Premium Familiae Vini, an organization of 12 of the most prestigious wine families in the world.

Photographed in Florence

From my parents I have learned many values of life: That we are extremely fortunate to inherit so much history and tradition; the way to stay and communicate with every kind of person; and to be very respectful to older people and to those who work for you.

alexandra spencer-churchill

Alexandra Spencer-Churchill graduated with a bachelor's degree in economics and politics from Bristol University. She then worked for Merrill Lynch for almost four years before helping to raise money for the Laureus World Sports Awards (a charity started by DaimlerChrysler and Richemont). She is currently based in London, working for Mariner Investment Group, an American hedge fund. She has traveled extensively in Europe, Africa and Asia and enjoys skiing, riding, swimming, skydiving and bungee-jumping.

Photographed in London

alexandra aitken

The daughter of the former Tory politician Jonathan Aitken, Alexandra is an artist and entrepreneur who has worked with award-winning directors Mike Figgis and Roger Michelle. In the film *Enduring Love*, she appears alongside Samantha Morton and Daniel Craig. She is currently working on an installation and film in collaboration with Shu Uemera and a new media installation in partnership with Intandem Films. Her stage roles include Imogen Parrott in Pinero's Victorian classic *Trelawny of the Wells* and Edith Mole in David Gieslmann's *Mr. Kolpert* in London's West End. She has written articles for *The Times*, *The Sunday Telegraph*, *GQ* and *Tatler*, among others.

Photographed in New York

"Everyone knows that the women. Women today stylish and self-assured we men gladly fall into

Massimo Ferragamo

world revolves around
seem more beautiful,
than ever before, while
their orbit!"

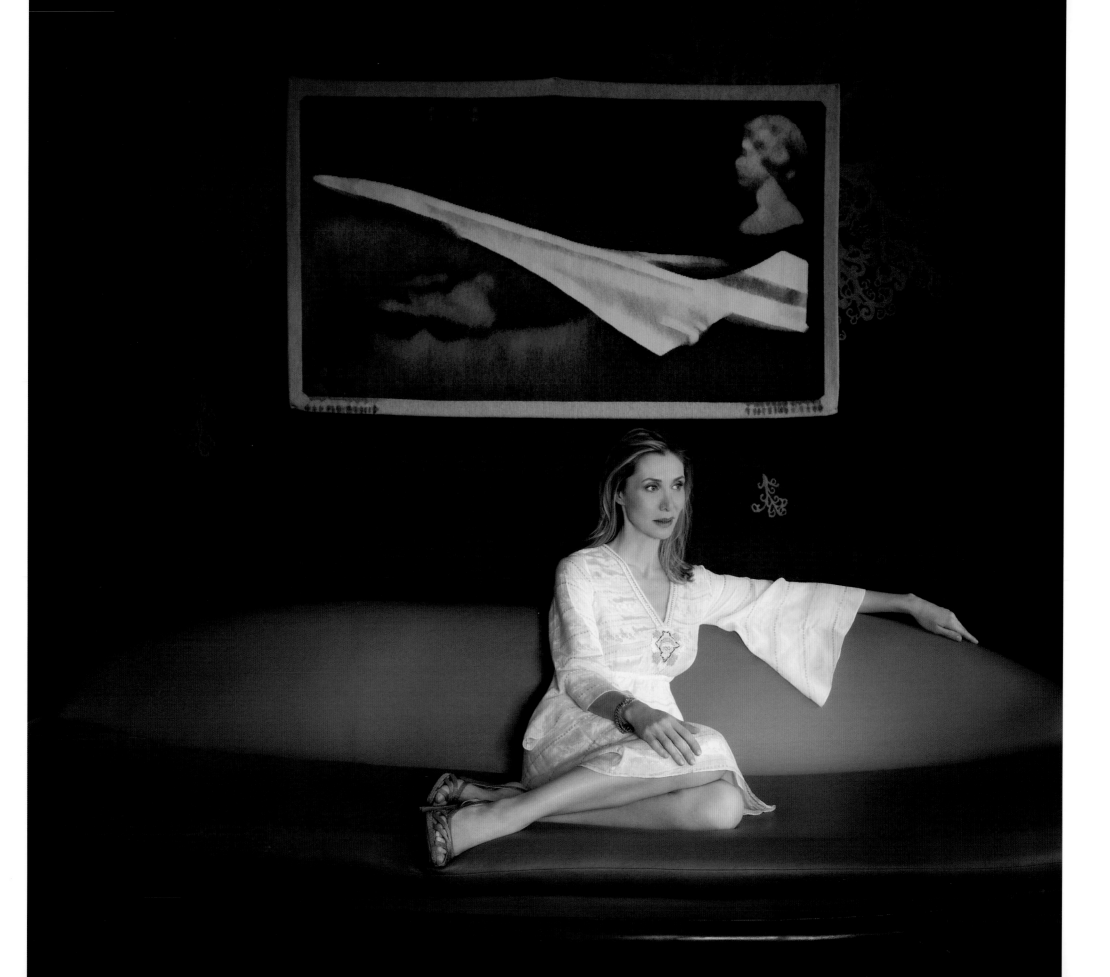

allegra hicks

As the one-time assistant to American artist Donald Baechler, Allegra Hicks immersed herself in the art world and recognized an inspiration for organic, natural design. Her studies at the Polytechnic School of Design in Milan and the Ecole de Peinture in Brussels built a foundation for her work as a print designer. She has worked with furniture designer husband Ashley Hicks, creating the upholstery and wallpaper for his interiors. Her fashion business offers a range of clothing for women and a collection for the home, with stores in New York and London, where she lives with Ashley and their two children.

Photographed in New York

I learned discipline from my mother and love of music from my father.

amanda hearst

A great-granddaughter of William Randolph Hearst, Amanda has built a reputation as a fashion model, appearing in *Cosmopolitan* and *Vanity Fair* and gracing the cover of *Town & Country*, among others, and is the face of Lilly Pulitzer. She has also written columns for *Hamptons* and *Gotham* magazines. An interest in environmental causes feeds her charity work for Riverkeeper, and her studies in art history at Fordham University inspire her work for the Princess Grace Foundation, which offers scholarships to young artists. She currently divides her time between Manhattan and Bridgehampton.

Photographed in New York

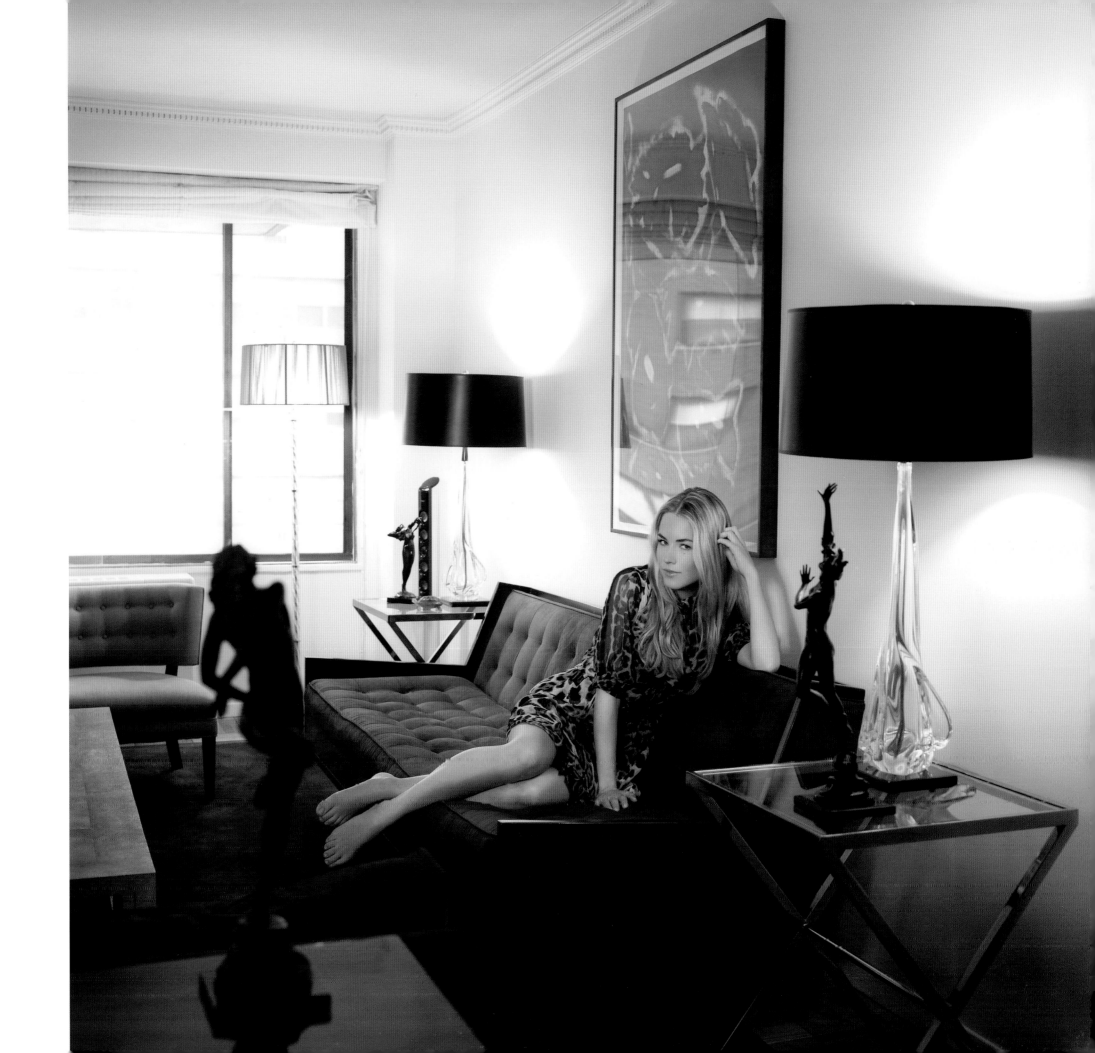

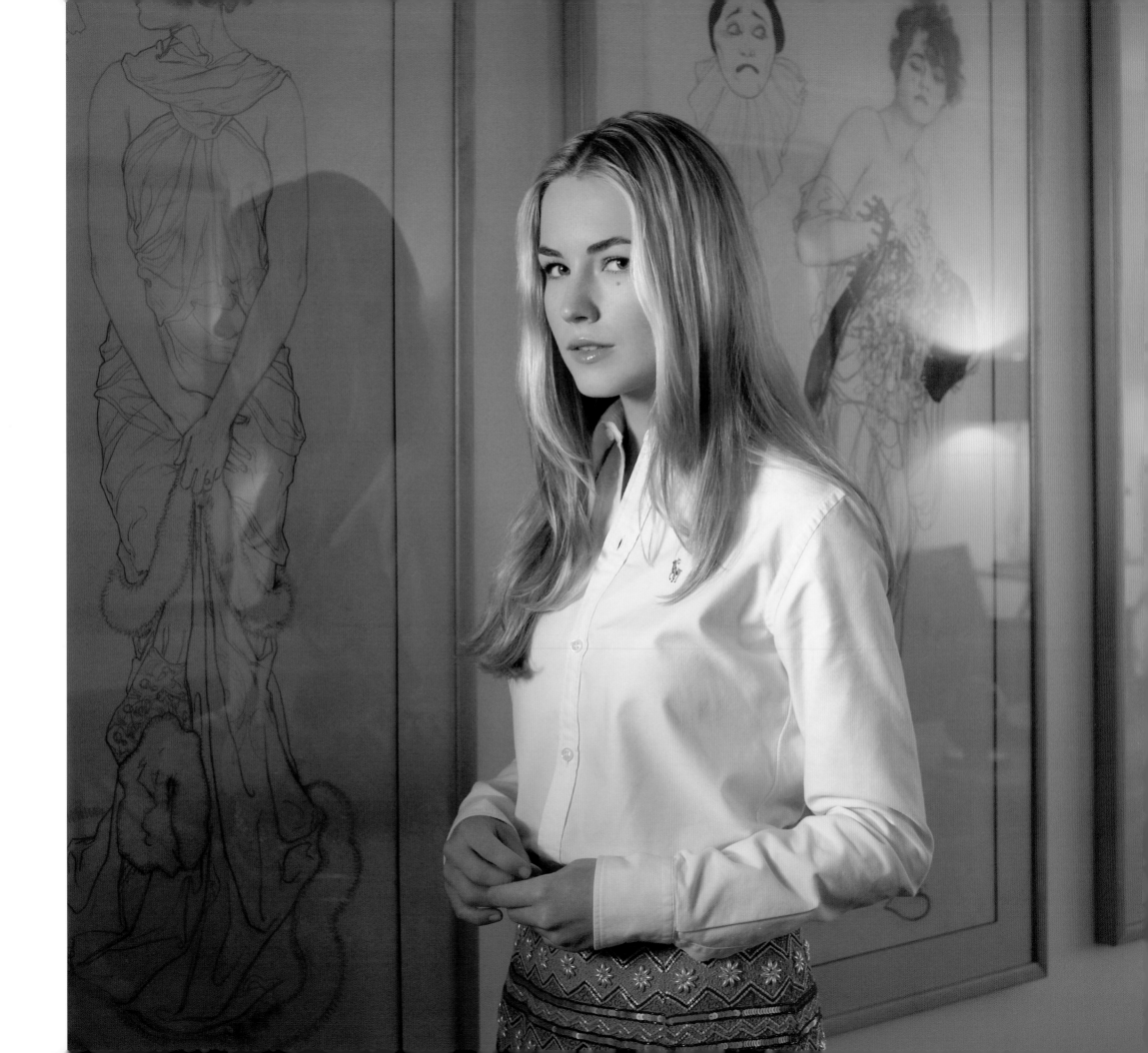

ana cristina defortuna

Born and raised in Lima, Ana Cristina studied finance and business administration at Boston University. After working in banking and finance in Miami, she met and married Edgardo Defortuna, a prominent real estate broker. She began working with him by expanding the international division of his Fortune International Realty and extending its reaches to Latin America and Europe. Together, they ventured into development and have built some of the most exciting buildings of the Miami skyline. She is involved in new conceptual design, marketing and sales of the construction, while serving as the company's vice-president of sales. They reside with their three children in Key Biscayne, where she and Edgardo have started a community foundation.

Photographed in Miami

Both my parents have always been and still are my role models. When we were children my home was filled with happiness. Very early in my childhood they taught us to be very close to our sisters and brothers, and to always protect each other. Today, my sisters and I have an incredible relationship and we are the best of friends. They also taught us the importance of being very considerate and respectful of others and to never judge or hurt anybody.

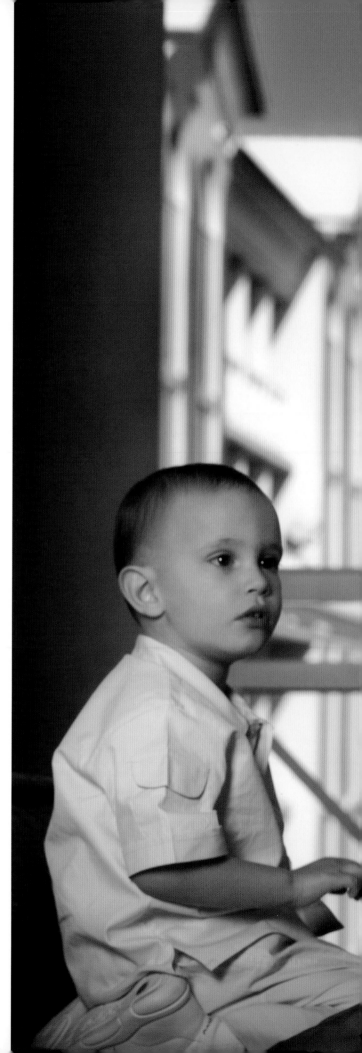

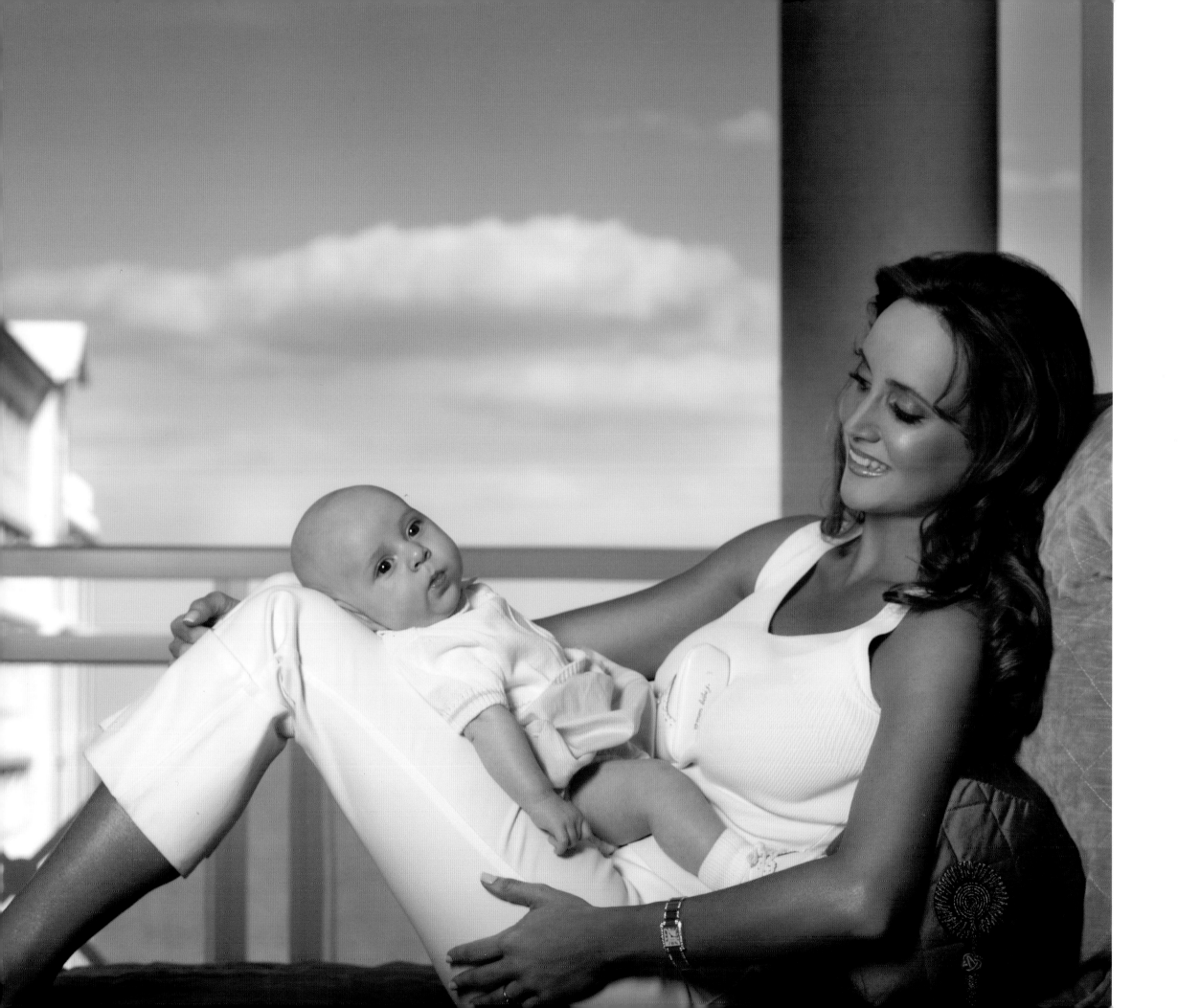

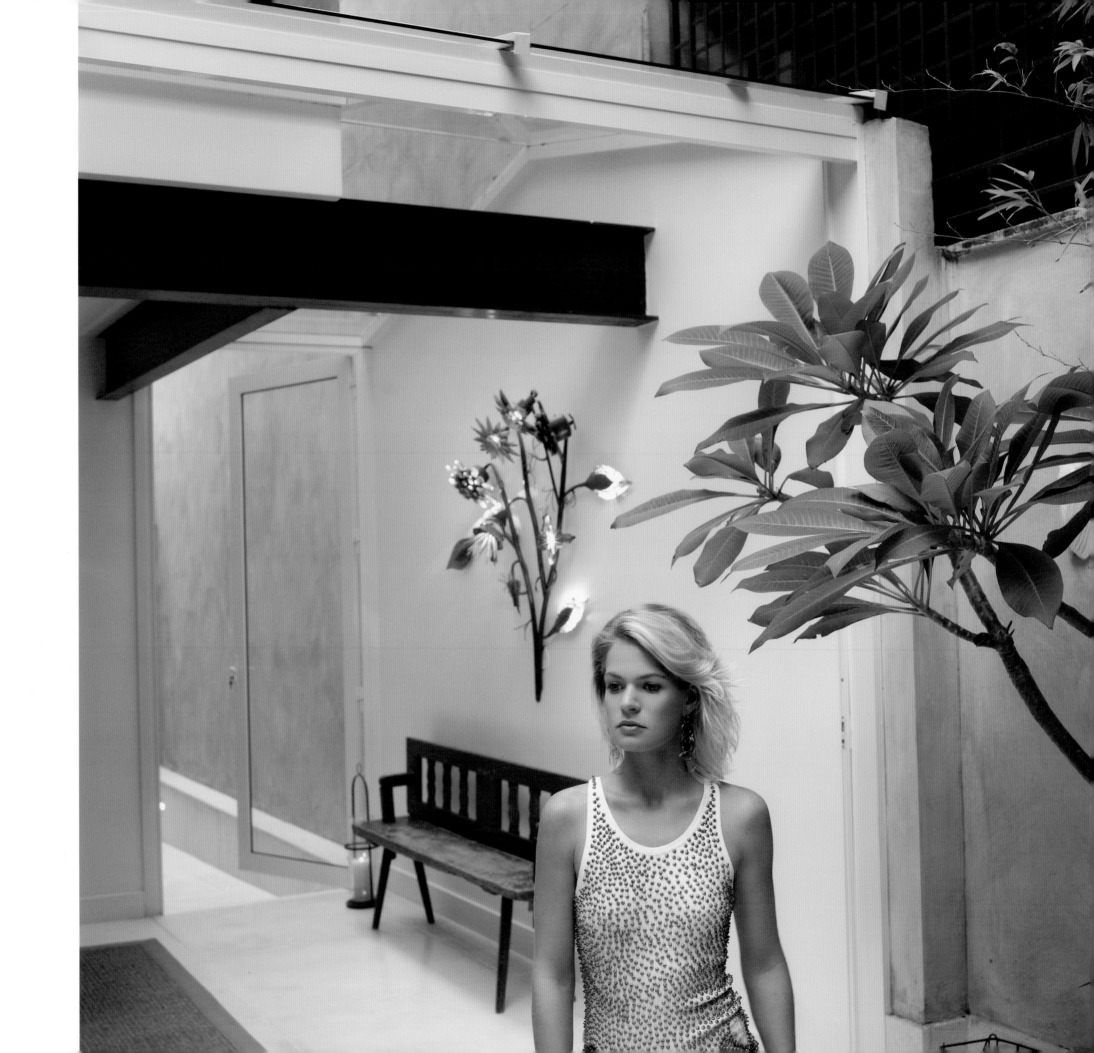

ana monteiro de carvalho

Ana Monteiro de Carvalho was born in Brazil and studied sociology at New York University before attending Parsons to study fashion. She returned to Brazil to design clothing and founded the fashion label Isabelo Capeto. Today the company unveils more than 15,000 products each season and exports to 25 countries.

Photographed in Rio de Janeiro

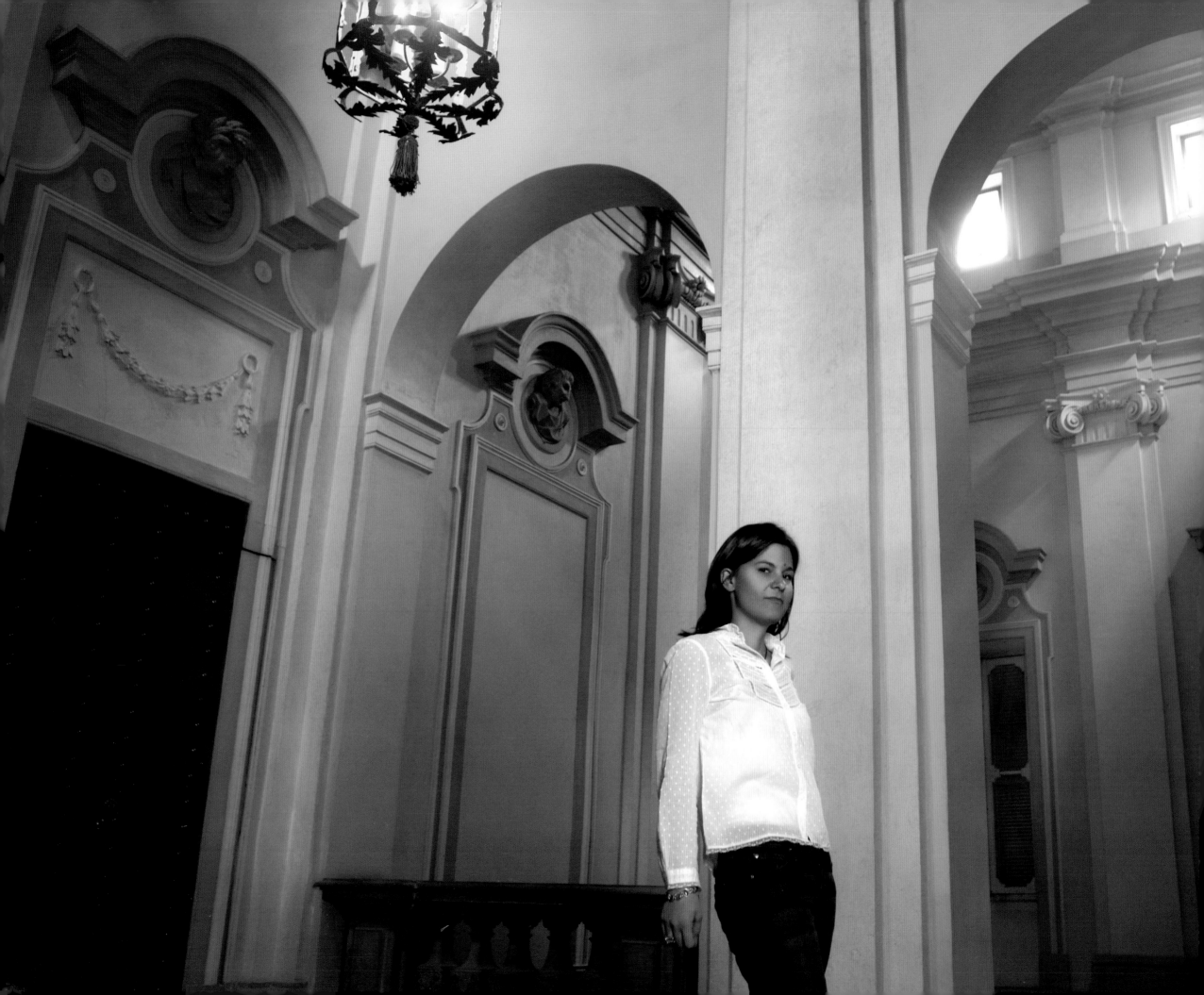

angelica visconti

One of 22 grandchildren of Salvatore Ferragamo, Angelica was born in Milan and went to business school before starting in the family's empire in Florence and New York. She has overseen development for the label's Asian market while based in Shanghai.

Photographed in Milan

From my parents I learned to look at things from a different point of view.

anna anisimova

In 1991, Vasily Anisimova stayed behind in Moscow to oversee his mining business and sent his wife and daughters to live in New York, when Anna was six. While a student at Brooklyn's Poly Prep Country Day School, she modeled and appeared in *Black Book* and *Jane* magazines before pursuing undergraduate work at New York University. Now she's helping with her father's American real estate interests and harbors an ambition for acting.

Photographed in New York

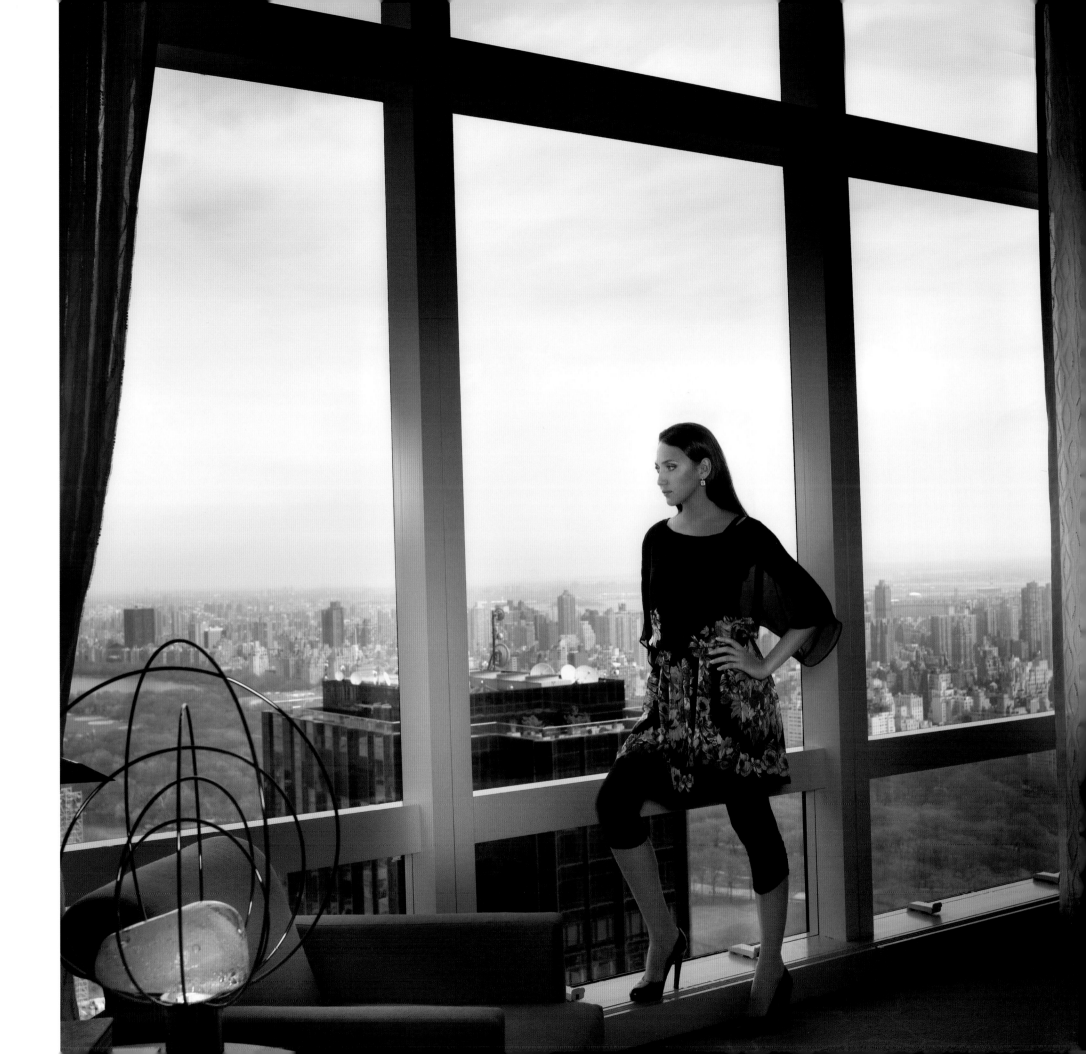

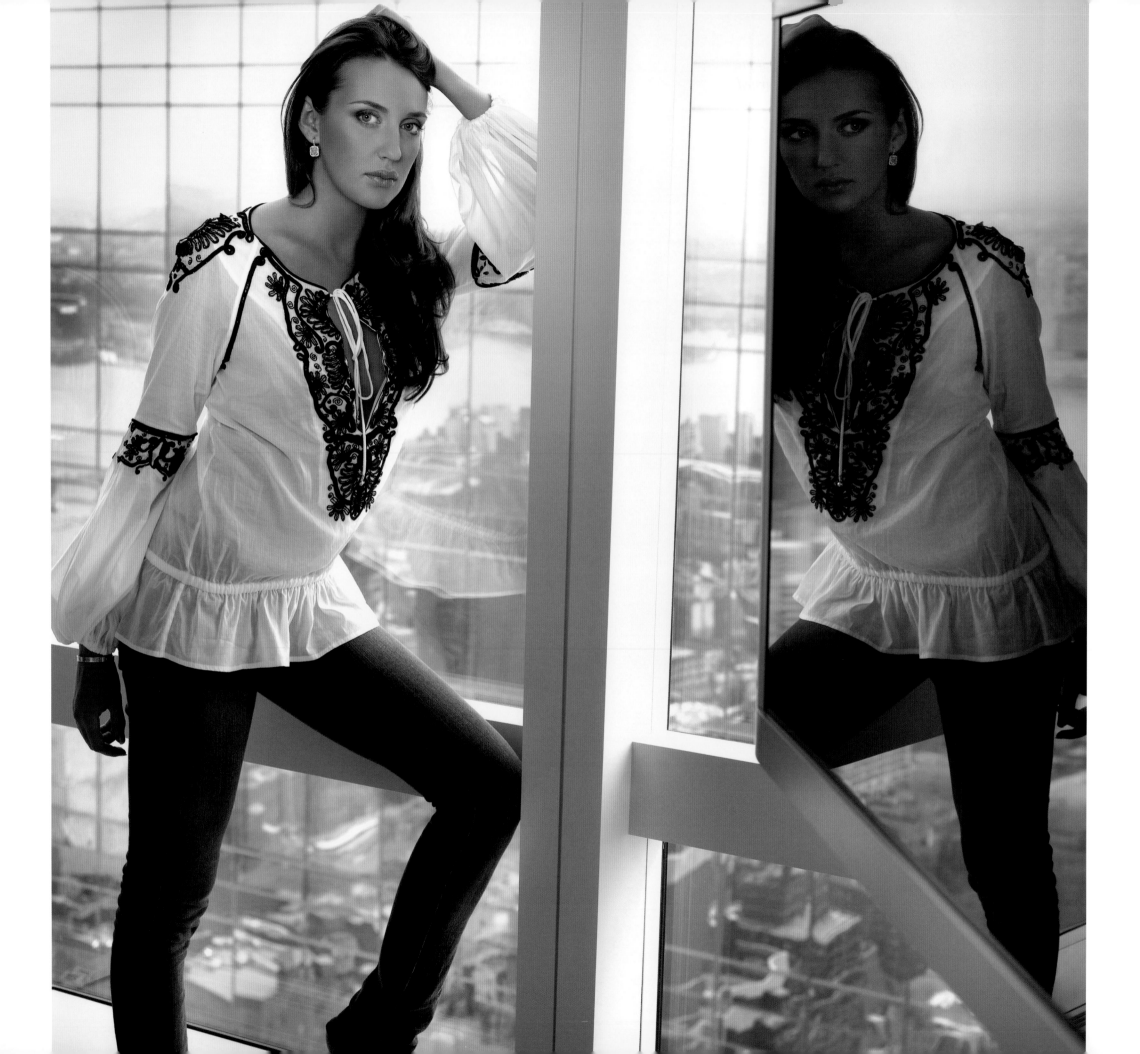

Both my parents are the most generous people I know. They taught me to be giving and help those in need. One of the biggest lessons I learned is to never be afraid to dream big.

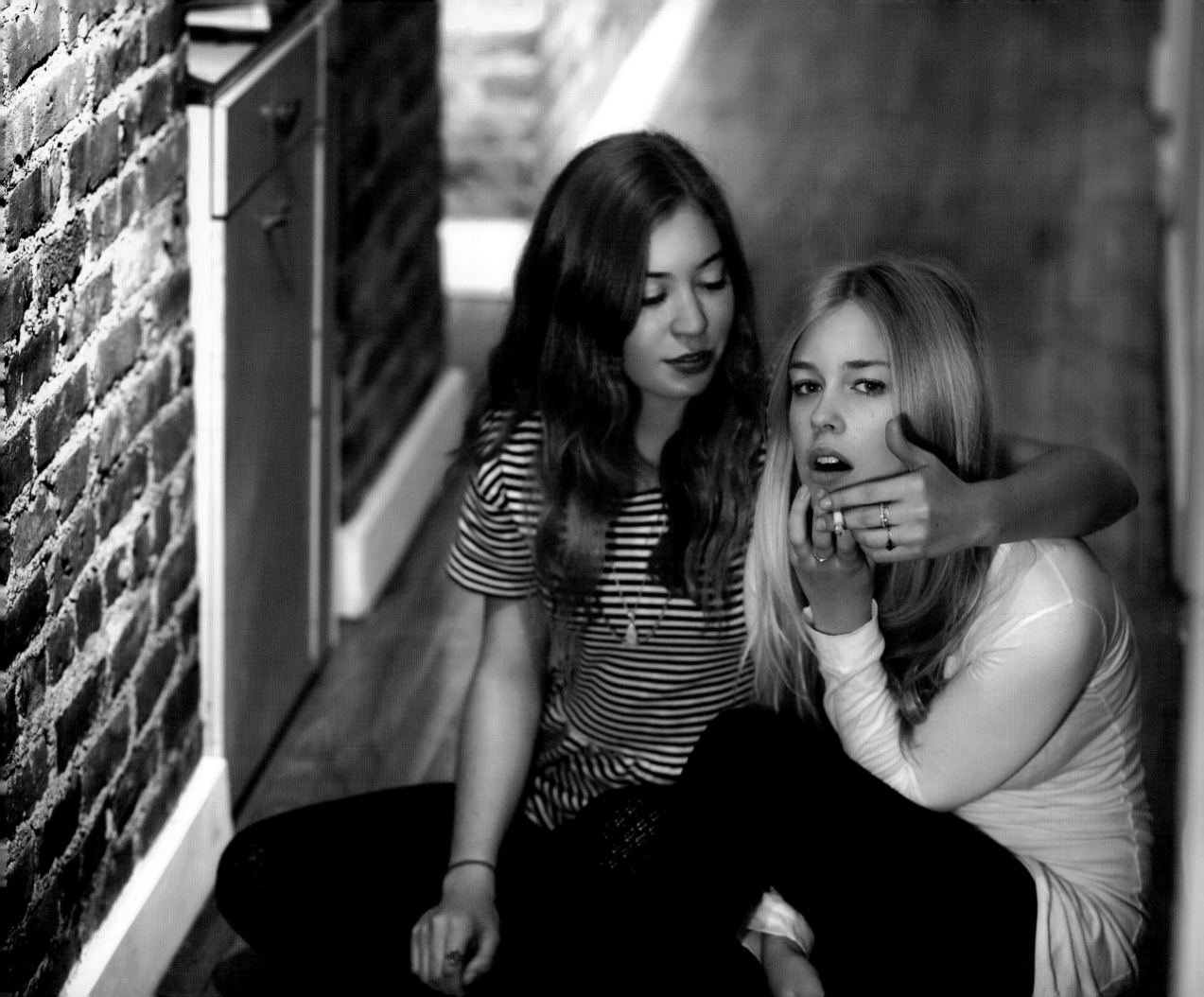

anouska beckwith

The daughter of Tamara Beckwith and William Gerhauser was raised in London. At the age of 18, she moved to New York to study method acting at the Lee Strasberg Institute, then returned to London to pursue a career in film. She also has written for *Teen Vogue*.

I learned to be independent. My parents taught me to be open-minded and not to judge others, since no one wants to be judged themselves. I also learned about the the arts as an outlet for escapism.

mary olivia charteris

Mary Olivia is a descendant of the Guiness family. She has lived in London and Paris and attended Parsons to study art foundation. An internship at *Teen Vogue* brought her to New York in 2007.

Photographed in New York

I want to live in as many different cities as I can in my lifetime as I think it is important to discover different cultures and meet people from all over the world.

bianca nygård-murray

As one of eight children of Peter Nygård, one of Canada's most successful clothing designers and manufacturers, Bianca has worked in every aspect of the family business. From sewing and pattern making to publicity, retail stores and fashion shows, she's learned the business firsthand and was responsible for the launch of the company's website. She now resides in the Bahamas with her husband and two children.

Photographed in the Bahamas

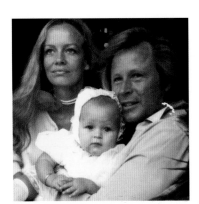

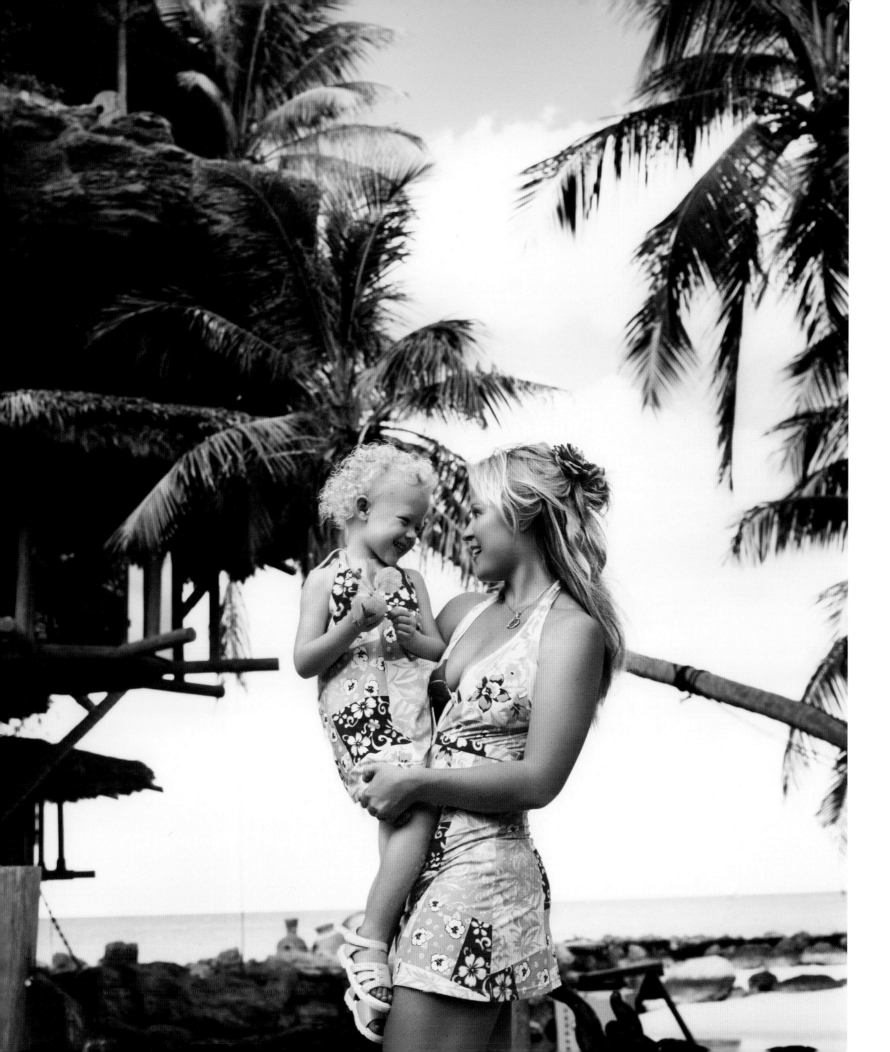

casey johnson

An heir to the founder of health care products giant Johnson & Johnson,
Casey grew up in New York, but moved to Los Angeles in 2001 to pursue an
acting career. She adopted a baby daughter from Kazakhstan in 2007.

Photographed in Los Angeles

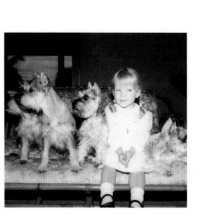

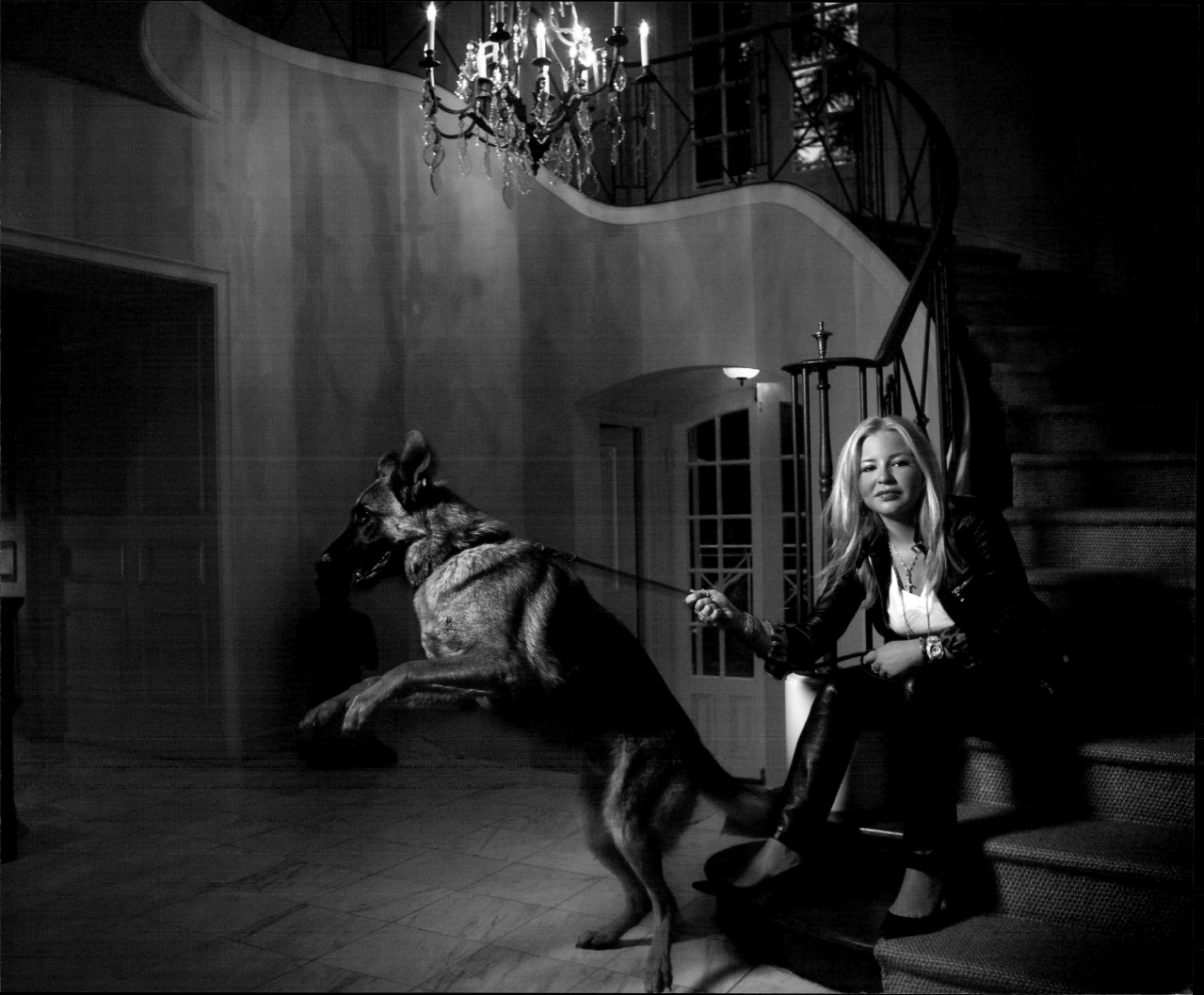

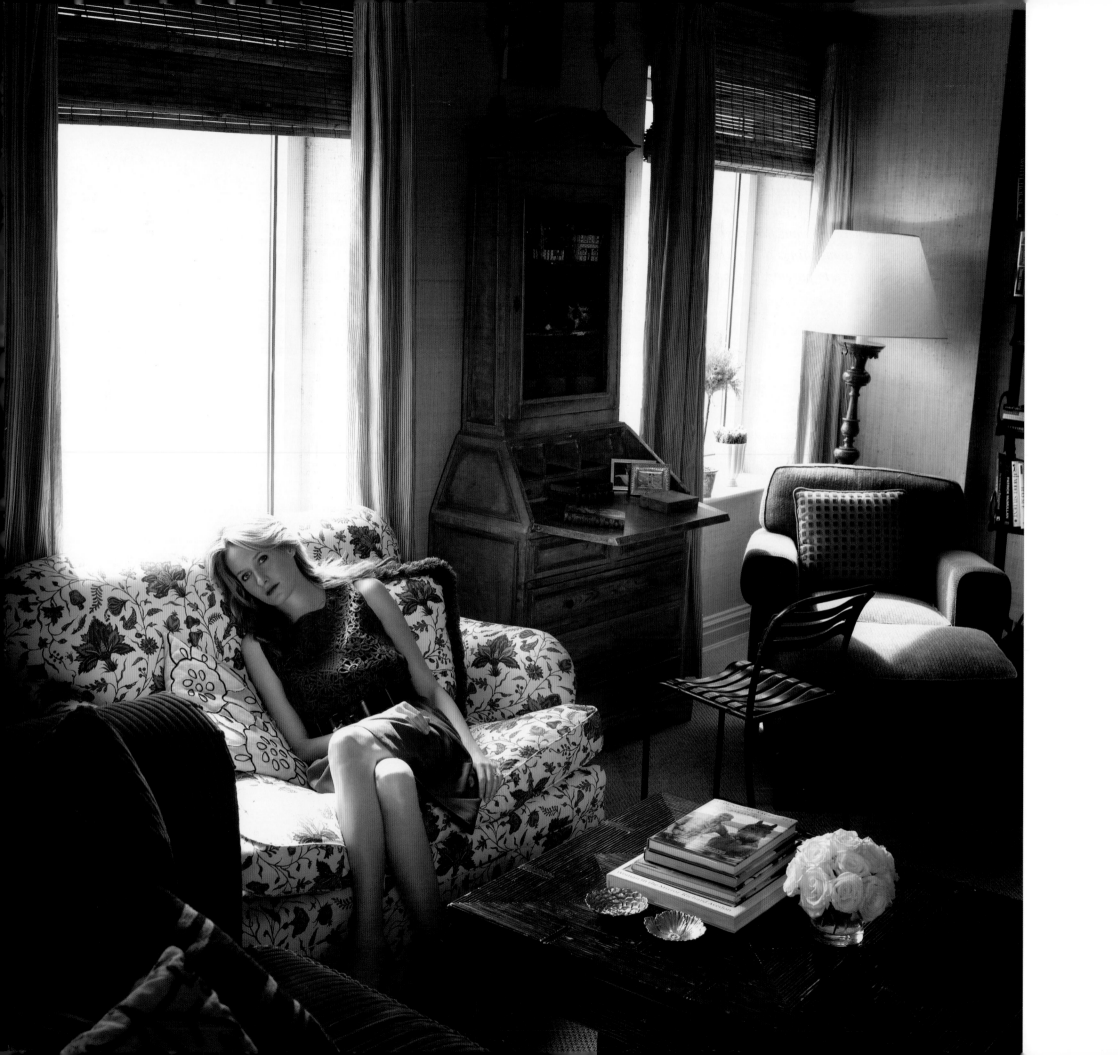

celerie kemble

Raised by Mimi McMakin, Celerie Kemble was born into a world of interior design. After studying at Harvard University, she worked briefly in film before returning to her roots to create interiors for clients in Florida and New York. She has been named one of the top 50 tastemakers for the future of design by *House & Garden* and has appeared six times on *House Beautiful*'s list of top designers. Additionally, she designs furniture for Laneventure, printed grass cloths for Zoffany, fabric and wallpaper designs for Schumacher and technical surfaces with Valtekz. Her work has been photographed for *Elle Décor*, *Metropolitan Home*, *InStyle Home*, *Domino*, *Traditional Home* and *The New York Times*.

My parents taught me humor, kindness, a bit of gluttony, with a deep well of sentimentality. We all share great appetites for food, beauty, and experience. We are a messy, chatty, touchy-feely bunch, quick to meddle in each other's business and are always emotionally engaged. There are some things your parents give (love, shelter, time), some things they teach (patience, generosity), and some things they impart (a sense of humor, curiosity, compassion, and work ethic). I was lucky enough to be born to parents generous in all of the above.

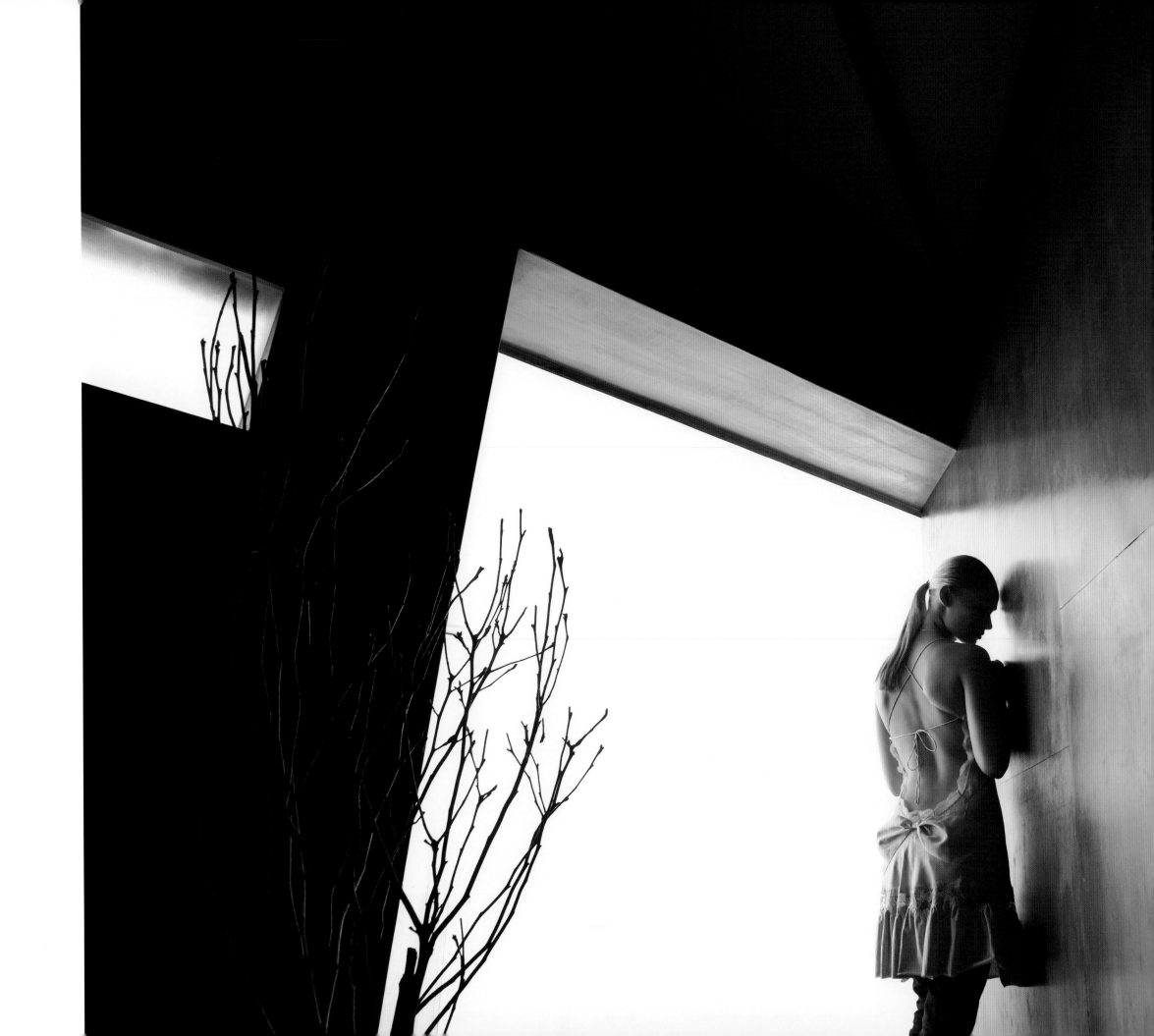

claire guerlain

Growing up within a fragrance family, Claire was surrounded by fashion from a very early age. Her studies at Central St. Martins and Sotheby's also taught her the artistry of working with gems and precious stones. Now, as a Reiki Master, she has learned to apply the art of healing energy to the designs of her jewelry line Celeste Bijoux. She travels regularly for inspiration throughout the Far East, Africa and the Americas.

Photographed in New York

"The only real elegance
if you've got that, the
from it."

Diana Vreeland

is in the mind;
rest really comes

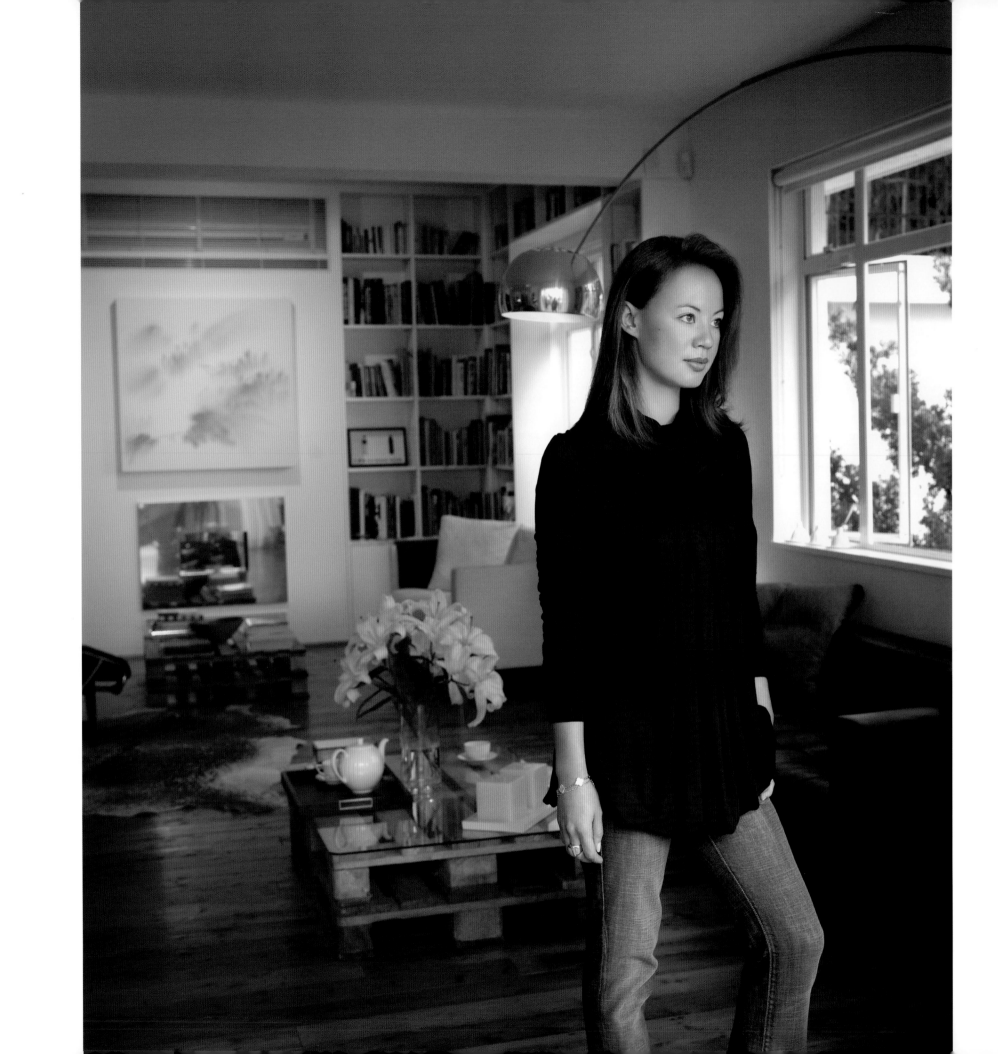

claire hsu-vuchot

Born to an Austrian mother and Chinese father, Claire moved from London to Hong Kong at the age of 10. After graduating early from high school at the age of 16, she spent a year in Beijing studying Mandarin and then went on to complete bachelor's and master's degrees in art history at London University's School of Oriental and African Studies. She moved back to Hong Kong in 2000 to cofound and run the Asia Art Archive, a nonprofit organization that boasts the world's most comprehensive public resource for contemporary Asian art. She is married to Benjamin Vuchot.

Photographed in Hong Kong

My parents taught me the importance of embracing different cultures, honesty, to fight for what you believe in, and how to appreciate good food.

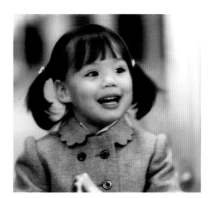

cordelia de castellane

As a child, Cordelia loved to design princess gowns in the Chanel studios, where she was fascinated by the imagination and talent of her uncle Gilles Dufour and cousin Victoire de Castellane, who worked there as designers. Cordelia is again designing clothes for young beauties with the CdeC label she founded with friends Ségolène Galliene, Elise Douin and Mélonie Hennessy. Following seven years of working closely with Emmanuel Ungaro, she turned her attention to children following the birth of her newborn sons Andreas and Stanislas. Her goal is to revolutionize children's luxury clothing by making it less conventional and more accessible.

Photographed in Paris

I grew up between Paris and Gstaad in the middle of the mountains. It's now the place I go to relax out of season. I think it's good for kids to see things other than cities. It gives you healthy values.

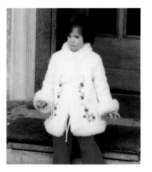

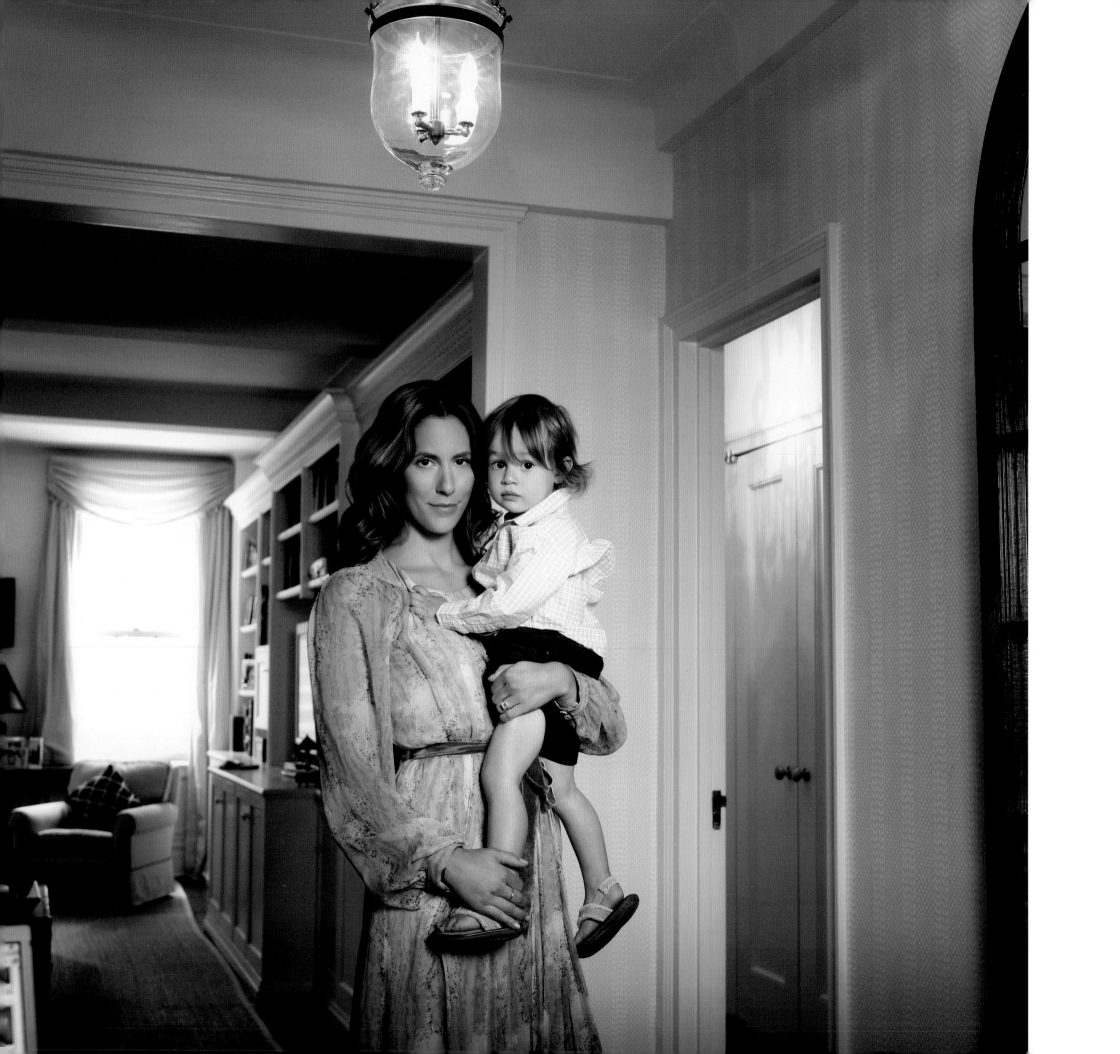

cristina greeven cuomo

A New Yorker of German and Brazilian heritage, Cristina is a descendant of the physicist Gustav Kirchhoff, an early pioneer of X-ray technology, and Hermann Kirchhoff, the German minister of state who founded the Orient Express in the early 1900s. Her grandfather headed Standard Oil's Esso for Europe and coined the name "Exxon." Her mother is a relative of the former Brazilian president João Figueiredo. Cristina attended Cornell University and later founded and ran the lifestyle magazines *Manhattan File*, *Vegas File* and *Hamptons File*. Currently, she is the publishing director and vice president of Niche Media, publisher of nine regional magazines. She is married to *Good Morning America* anchor Christopher Cuomo, son of New York's three-term governor Mario Cuomo, and they have two children, Bella and Mario. She is an avid supporter of the New York Public Library, The New York Botanical Gardens, HELP and Mentoring USA, among other charities.

Photographed in New York

I grew up in New York City, but my most poignant memories are of the ski trips I used to take with my dad to Jackson Hole every spring break or the weekends in the country with my family. I still live in New York City, but I still crave the mountains and the country and go when possible with my husband and two kids to take them skiing.

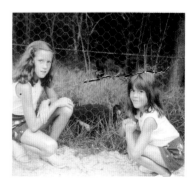

cristina valls

Fifty years ago, Cristina Valls's father and uncle founded a bank that later became Banco Popular. Like her successful father, she studied business, finance and economics, but Cristina's career took a different run when she partnered with her mother to create a corporate design company. They produce corporate attire, ties, scarves, and leather accessories under the brand name Chris&Cris. In 2002, Cristina was named the best young entrepreneur in Spain by the IESE business school, Actualidad Economica and Jaguar. The following year she and her mother began a real estate investment business. Cristina currently sits on the board of the investment bank Brasilinvest.

Photographed in London

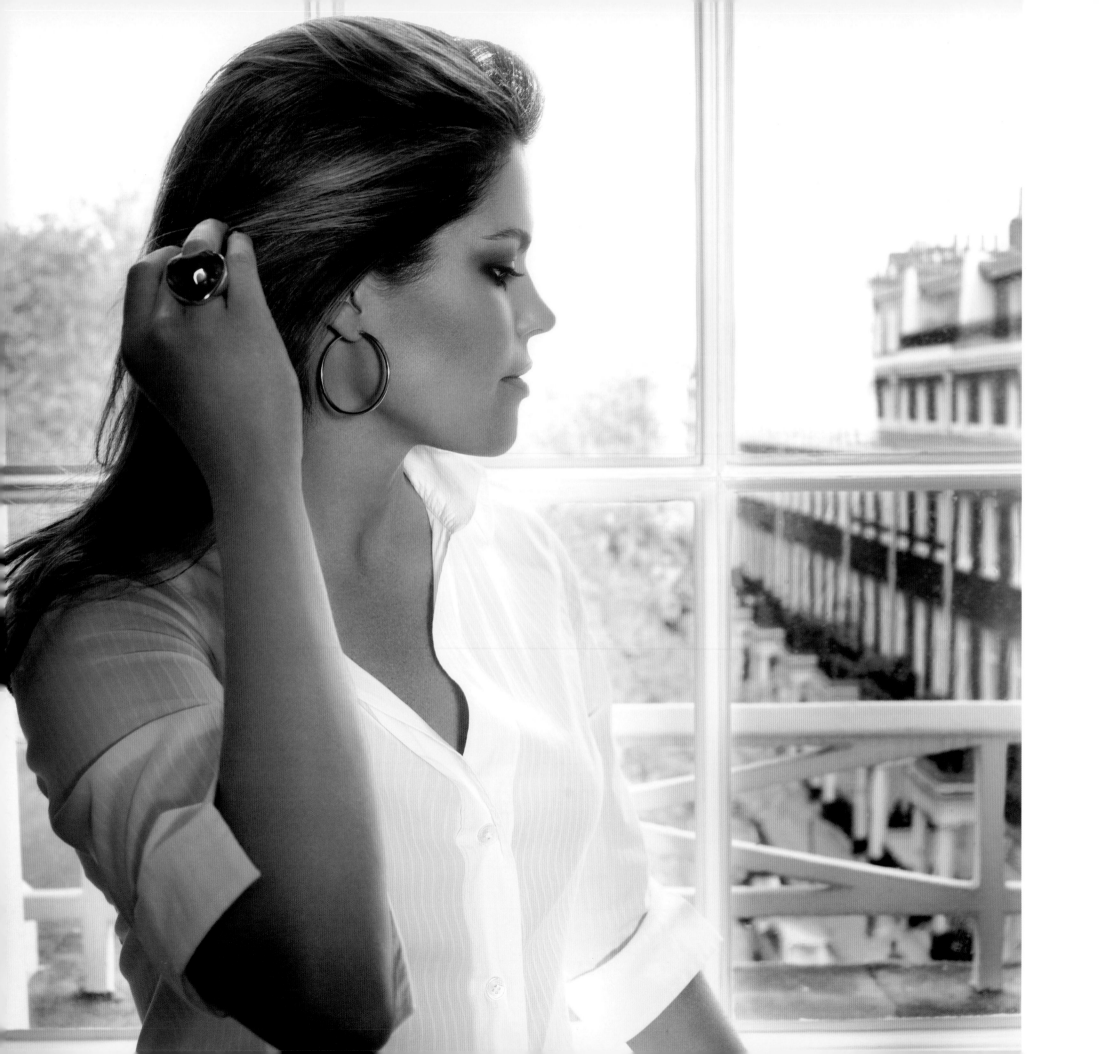

My parents taught me honesty, diplomacy, loyalty, effort and the value of things.

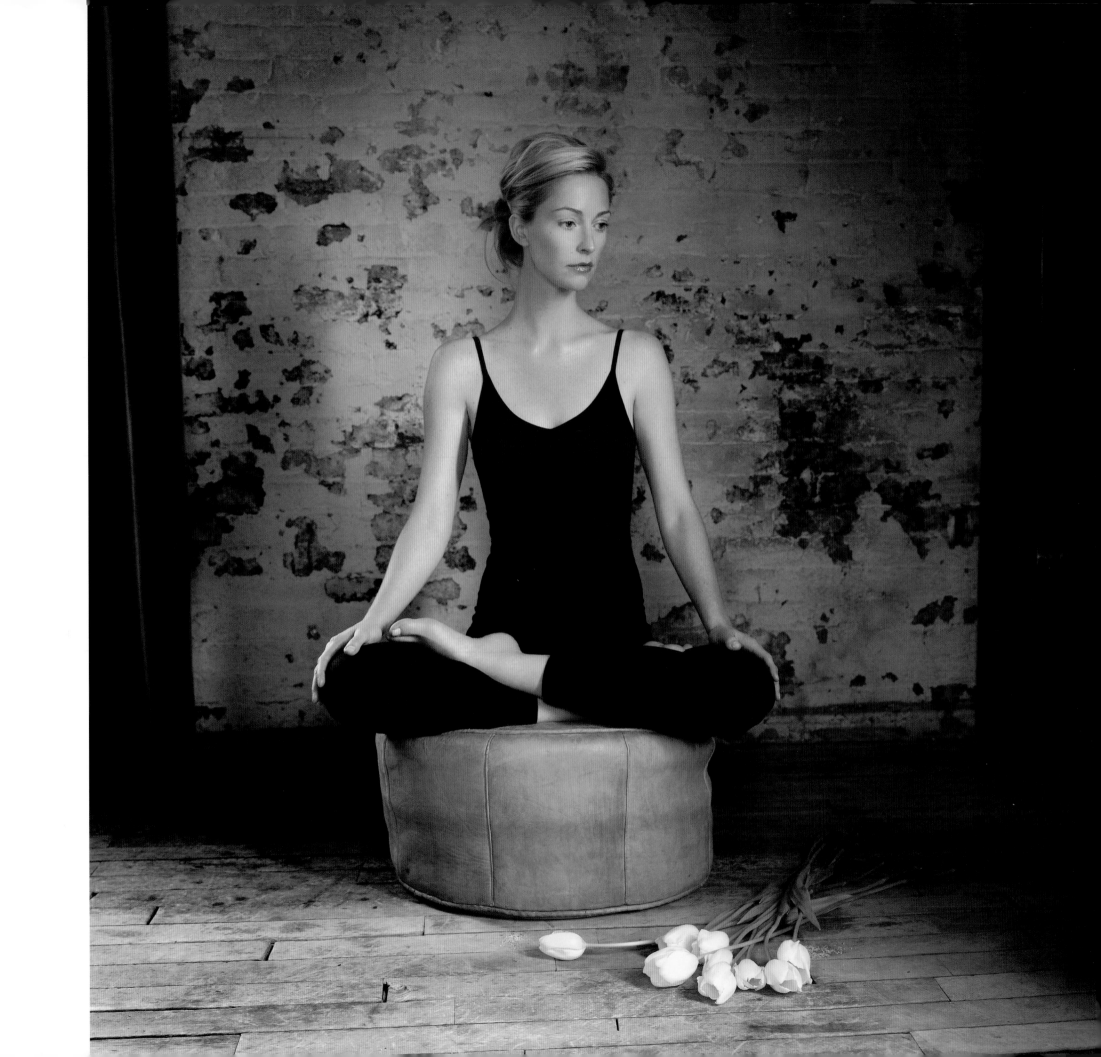

dawn russell

When American-born Dawn Russell turned 25, she was diagnosed with stage III metastatic melanoma and underwent four surgeries. After contracting a dangerous bone infection during surgery, she could not undergo chemotherapy or radiation. Instead of giving up hope, Dawn set out on a three-year journey traveling the globe to research Eastern medicine for a potential cure. She now devotes her time and knowledge to helping young girls with their struggles, ranging from relationships to addiction and self-esteem issues. She sits on the advisory board at Beth Israel Hospital's Integrative Center and her speaking engagements are sponsored by Giorgio Armani. She writes a column for *Ellegirl.com* and is working on a book for teenagers. Her husband is Jamie Russell, an environmental venture capitalist.

Photographed in New York

My mother has been involved in the Tibetan movement my whole life. Having the Dalai Lama and his monks visit us from a young age, I was taught and always reminded through example the power of calm, precise, focused attention. My childhood was like a cocktail, a bit of everything, East Coast, West Coast, and Europe. While I became very schooled at adapting to new cultures, what I remember most are independence and self-assurance.

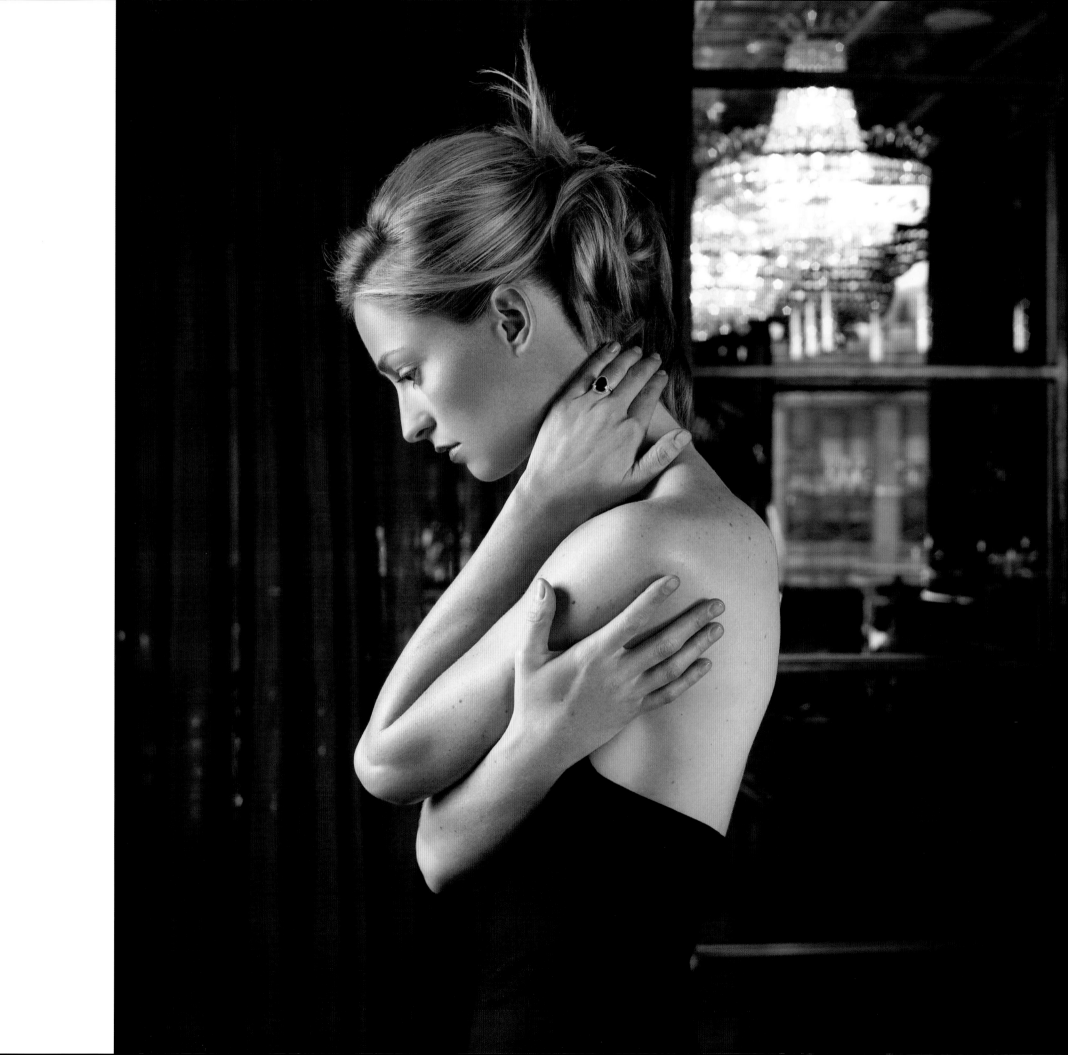

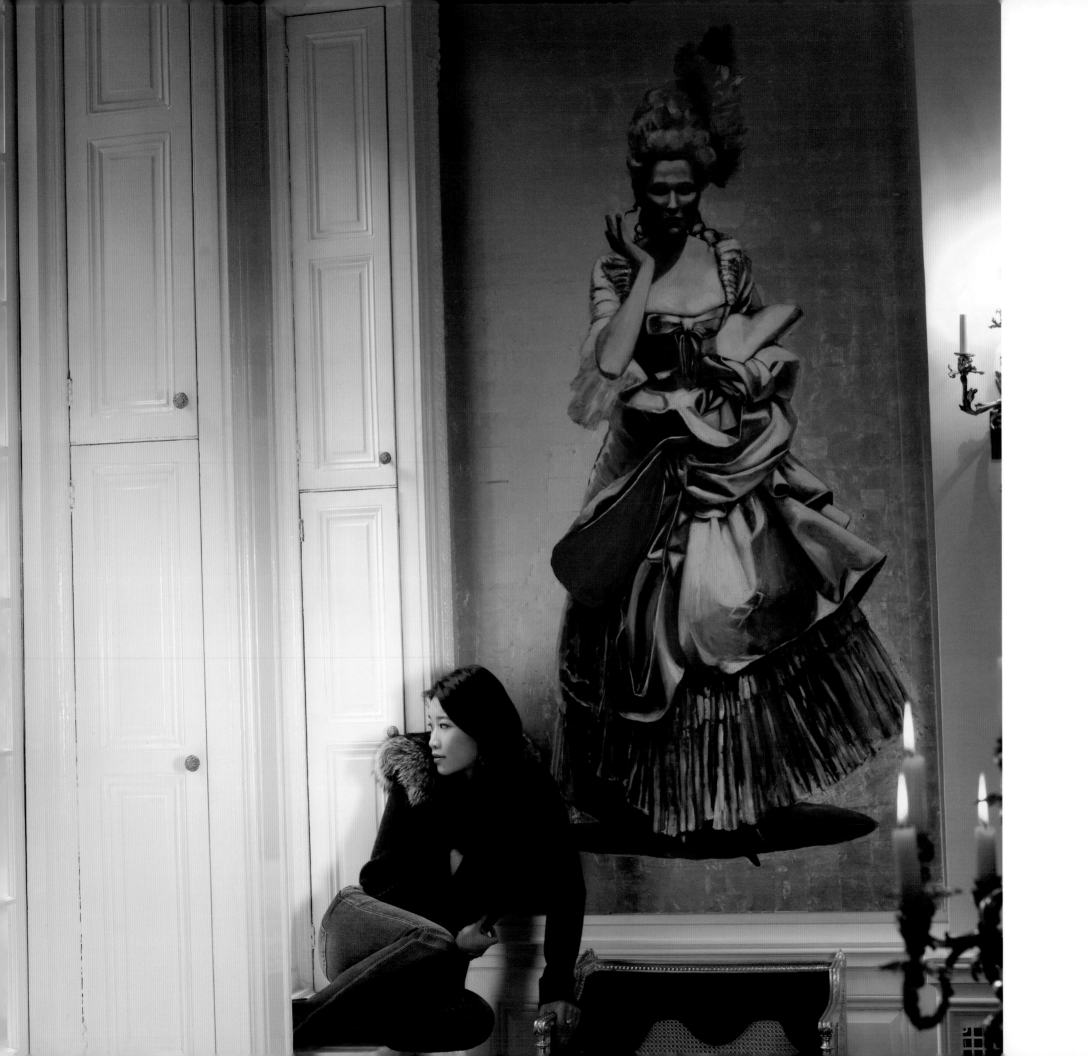

dee dee poon

Dee Dee Poon is the daughter of Margie Yang and Dickson Poon, executives at the fashion companies Esquel Group and Dickson Concepts. Dee Dee spent most of her youth traveling between New York, London and Hong Kong. After studying philosophy at Harvard University, she followed her parents into the fashion industry, first as an accessories buyer in Hong Kong, and then she joined her mother's company to develop its retail business in Beijing. She is an ambassador for the Hong Kong Design Center and sits on the boards of the YL Yang-Esquel Education Foundation.

Photographed in New York

I would say that my dad taught me about taste. He is a particularly focused person and he showed me how to bring things into my world and to view the world through my perspective. My mom is the opposite of him. She sees things from every point of view, which at times leaves us both a bit confused. She taught me how to go crazy without losing my mind and how to manage multiple ideas and passions and thoughts. I learned to be myself and to do what I want, think or must do. That's what my parents have in common and what probably led to their multiple successes in life.

delphine arnault-gancia

The daughter of Bernard Arnault was born into a family business that would become LVMH (Moët Hennessy - Louis Vuitton), the largest luxury goods conglomerate in history. She studied at the Ecole Des Hautes Etudes Commerciales du Nord in Lille and at the London School of Economics before working for McKinsey and Co. in Paris. She then turned her attention to LVMH, where she worked alongside John Galliano to develop his label. Since 2001, she has worked for Christian Dior where she is now marketing director for leather goods. In 2003, she was appointed to the LVMH board of directors and also sits on the board of Loewe, the Spanish luxury leather goods company. She is married to Alessandro Vallarino Gancia of the Italian wine dynasty.

Photographed in Milan

My parents taught me honesty, generosity, kindness and love of family, value of work well done and effort, importance of academic studies, to look at the big picture and at the details, to think outside the box, to believe in your convictions and instincts and to be determined. To dare, to be open-minded, to be simple and down to earth. To be passionate about art, music and fashion.

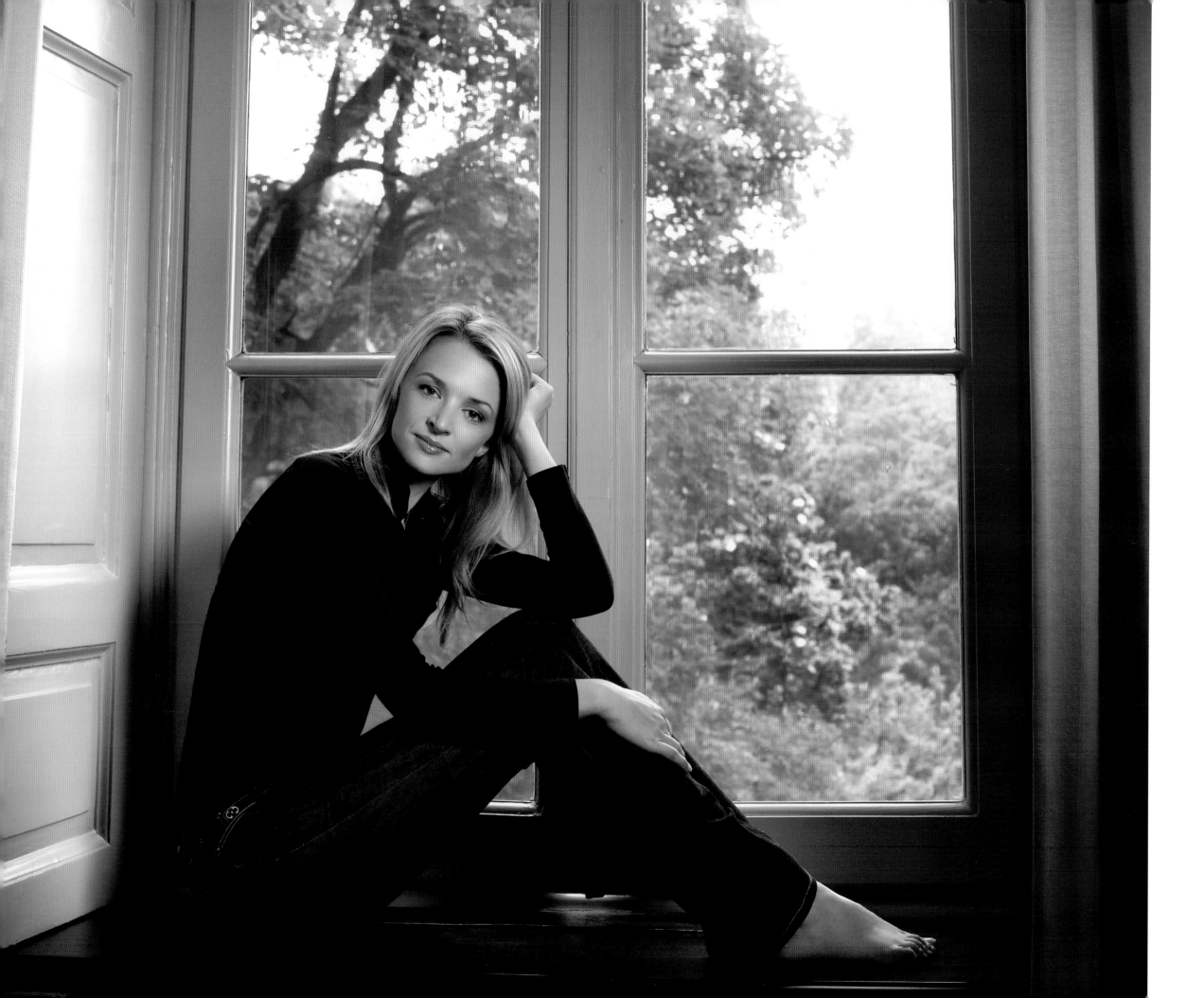

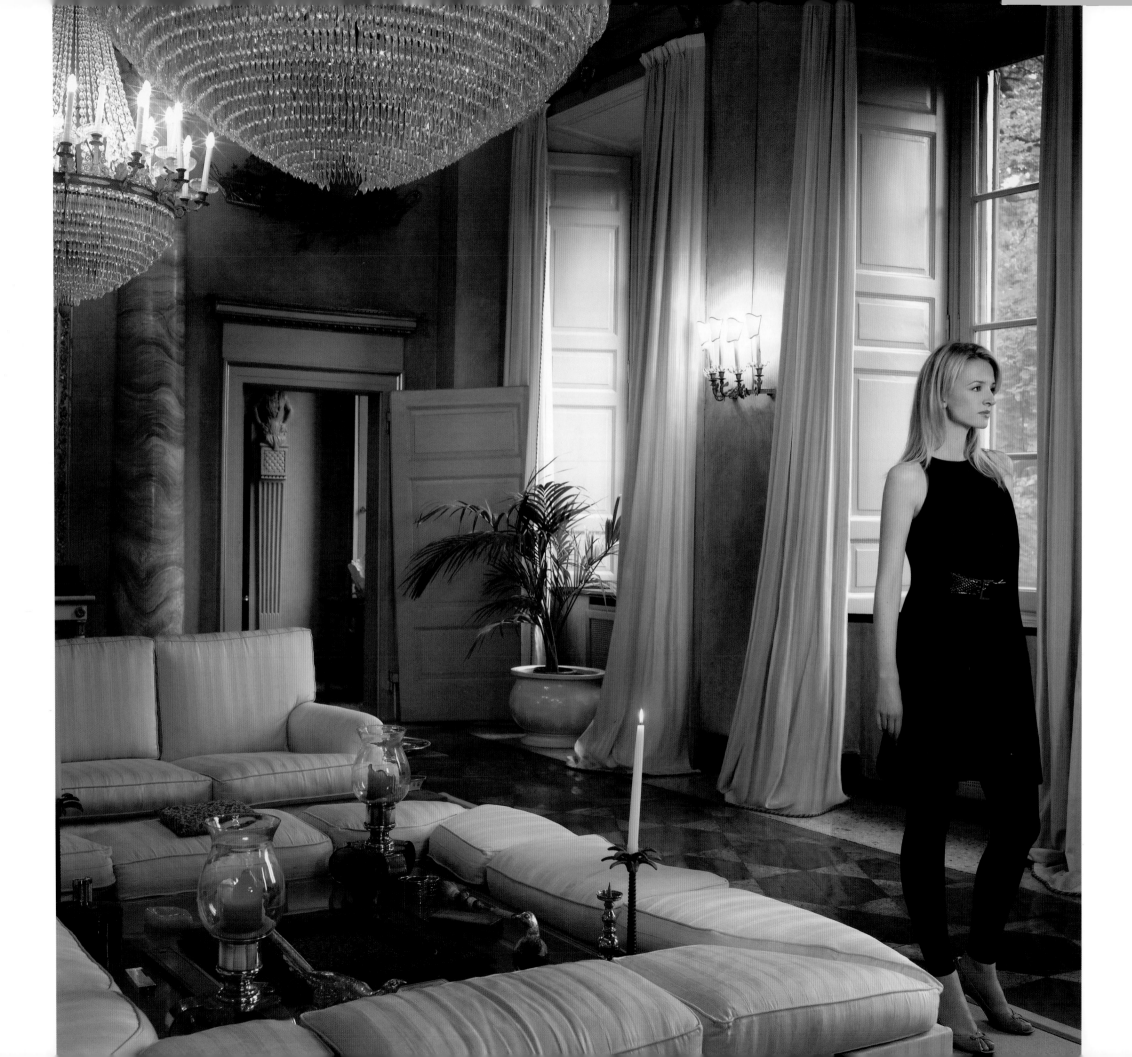

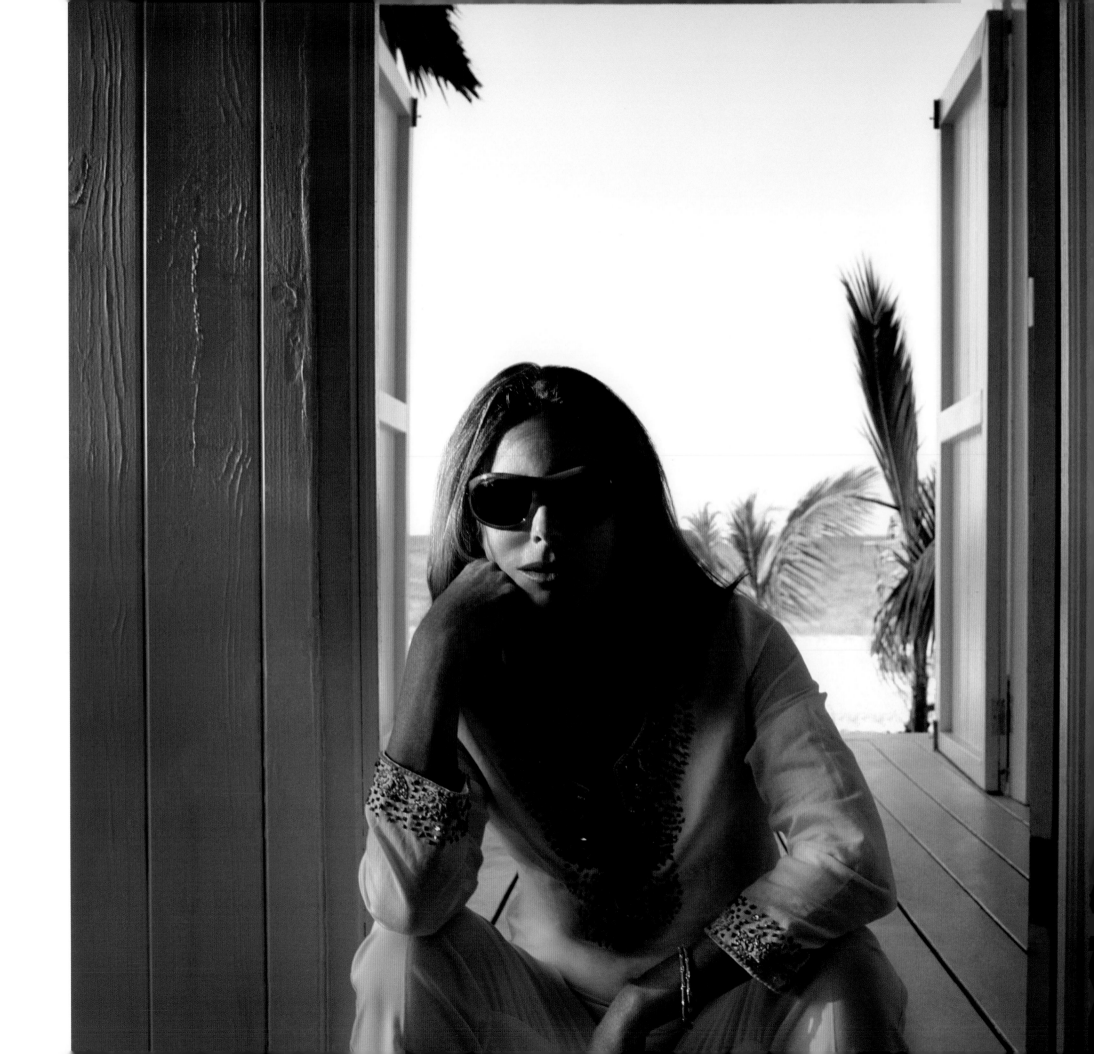

diane hartford

Diane Hartford grew up on a farm in Upper Bucks County, Pennsylvania. She met Huntington Hartford in New York and then married him in 1962. In addition to teaching school in Africa, Diane has also worked with political refugees. She studied acting with Lee Strasberg and appears in the James Bond film *Casino Royale*.

Photographed in Lyford Cay

I'm an avid reader and choose what to read based on wherever I am at the moment. When in the Bahamas, I'm likely to read Graham Greene, and when in Africa, I'm apt to choose Achebe or Doris Lessing.

dylan lauren

One of three children of American fashion legend Ralph Lauren, Dylan continues her father's entrepreneurial spirit with Dylan's Candy Bar, an eponymous brand and chain of Willy Wonka-esque candy stores. Her first flagship store opened on New York's Upper East Side in 2001 and has since blossomed into three more locations in Long Island, Houston, and Orlando. As its CEO and founder, she is involved in all the creative choices and visionary aspects of the company and travels the world in search of the perfect chocolates and confections. She plans to open more stores throughout the U.S., Europe, and Asia.

Photographed in New York

My parents taught me to always trust my gut and intuition no matter if people have doubt. Their own talents and success lead me to be an entrepreneur and business leader and not to be afraid of going for a goal even if it's challenging or if I lack all the skills — I should surround myself with a strong team who could help. Since my parents are so young at heart, hip and fit, they have inspired me to always be in touch with my creative inner child and never lose my youthful spirit, no matter what age I am or who I am with.

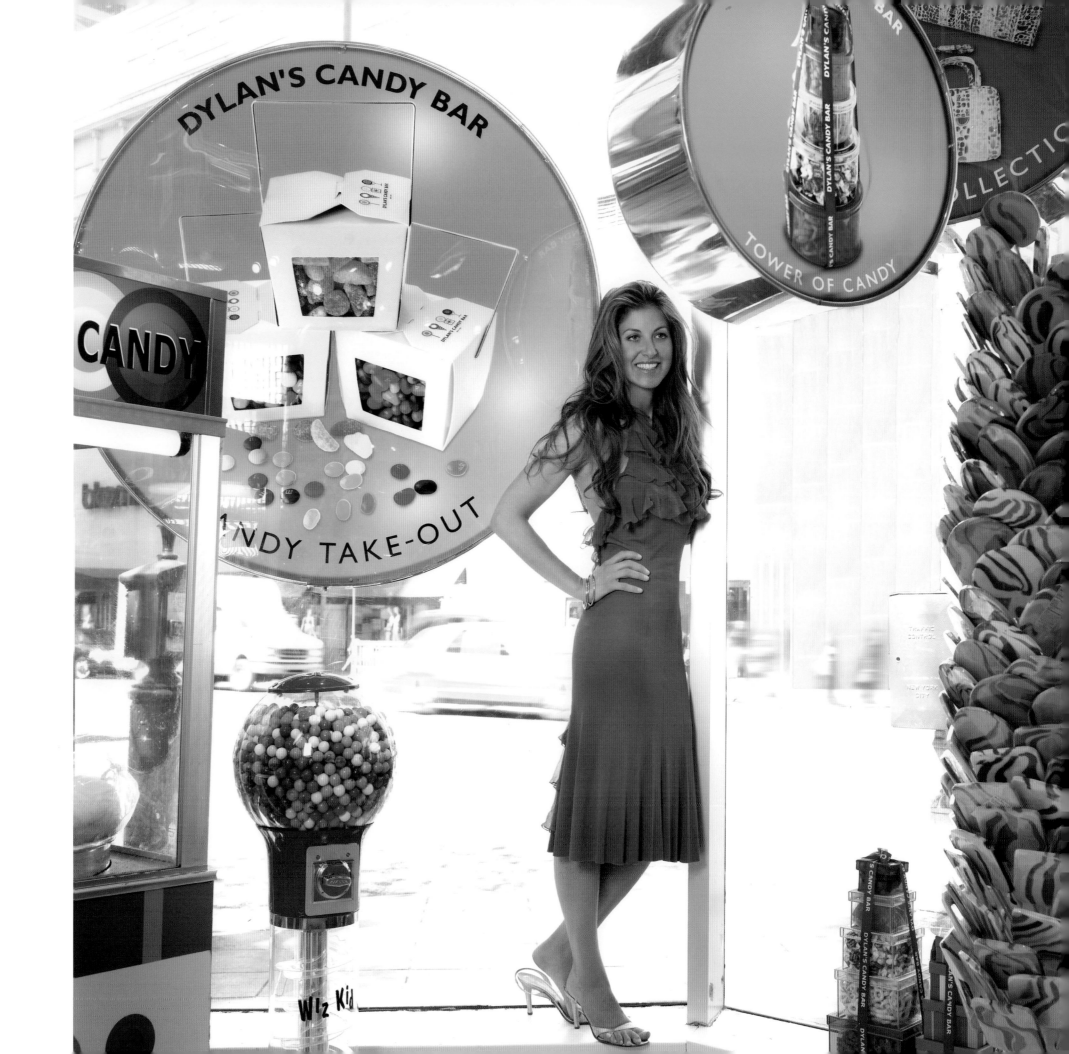

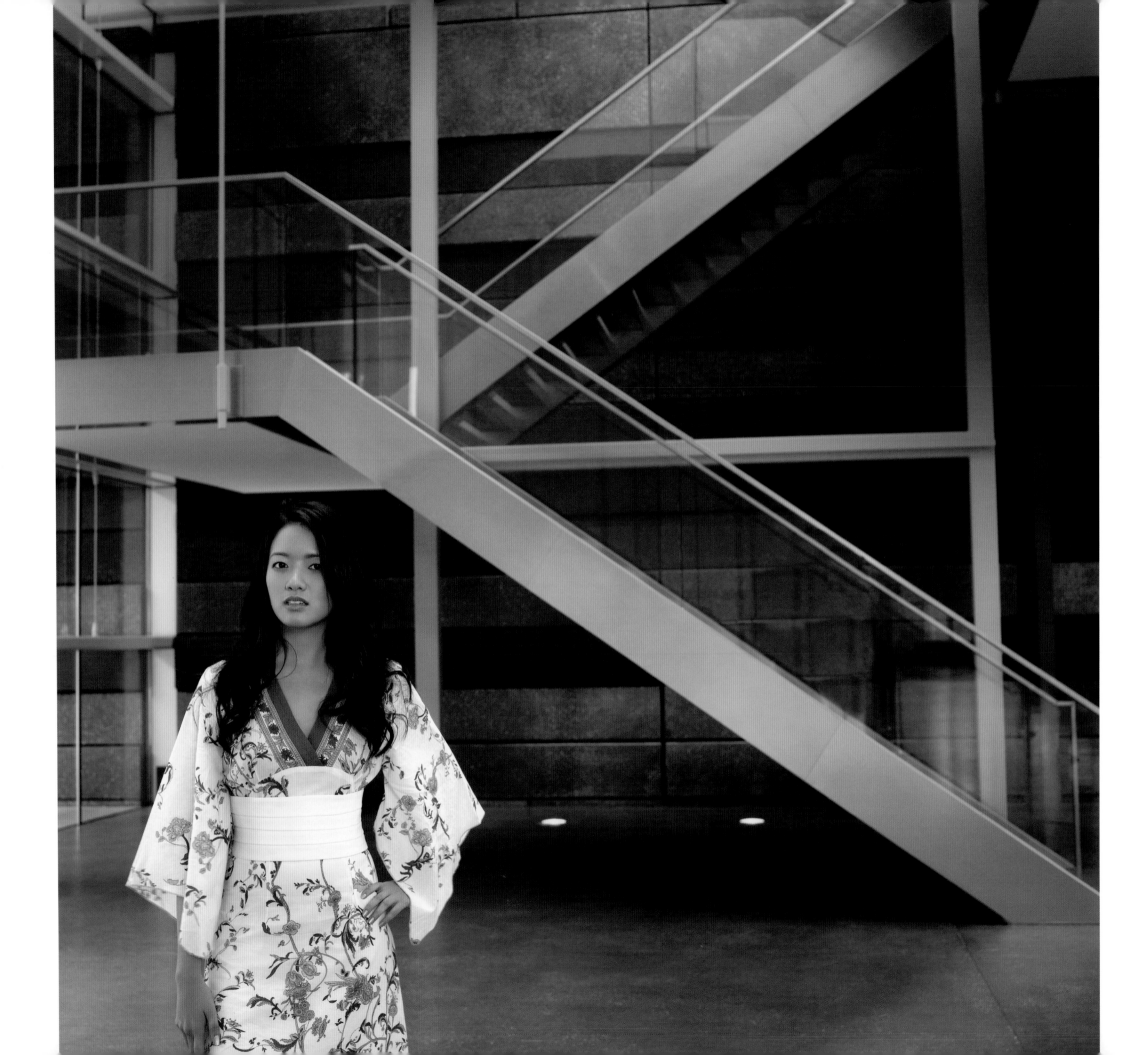

elaine neo

Elaine Neo was born in Singapore to Dr. Lily Neo, a member of the Singapore
Parliament, and Dr. Ben Neo, an obstetrician/gynecologist. She followed in her
parents' footsteps to become a physician and works for the Dover Park Hospice.

Photographed in Singapore

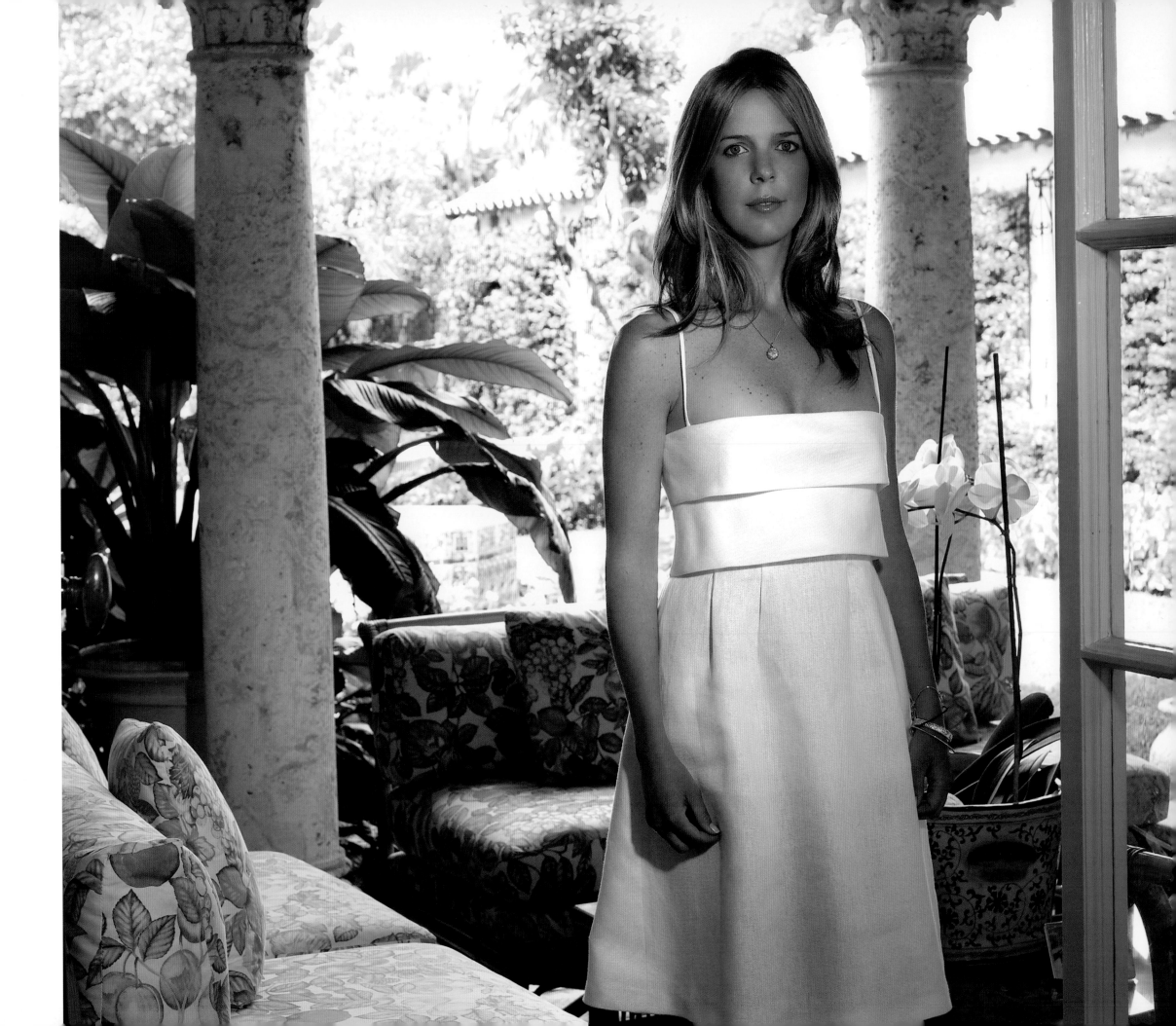

emilia fanjul

Emilia Fanjul was born and raised in Palm Beach to Cuban-American parents who operate Flo-Sun, a family-owned business and one of the largest sugar companies in the world, controlling more than 400,000 acres of sugar farms in Florida and the Dominican Republic. Emilia once owned a communications firm and now freelances in public relations and marketing.

Photographed in Palm Beach

I've learned that family is very important. They have always supported me in everything I do, which has given me the confidence to pursue what makes me happy.

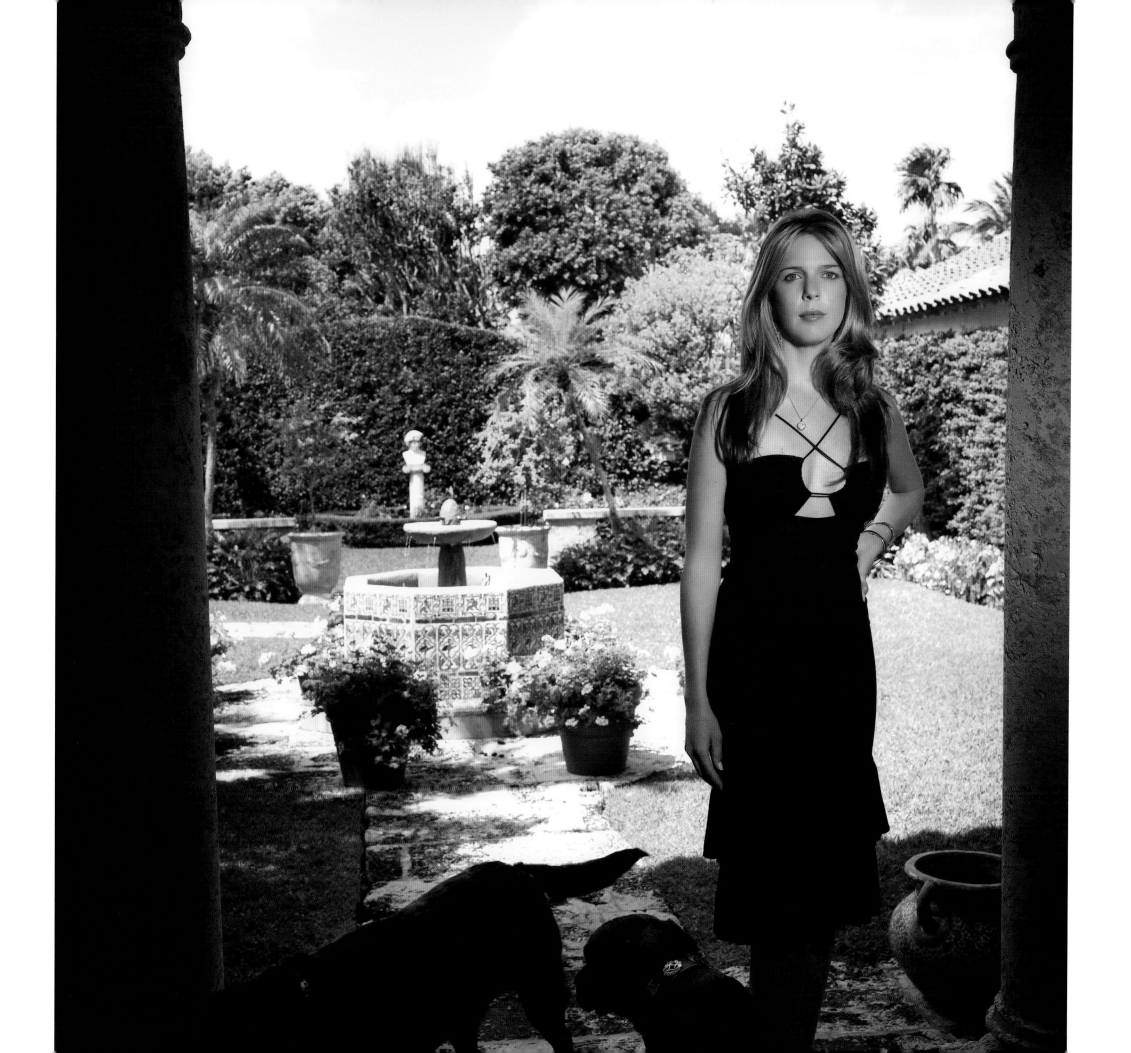

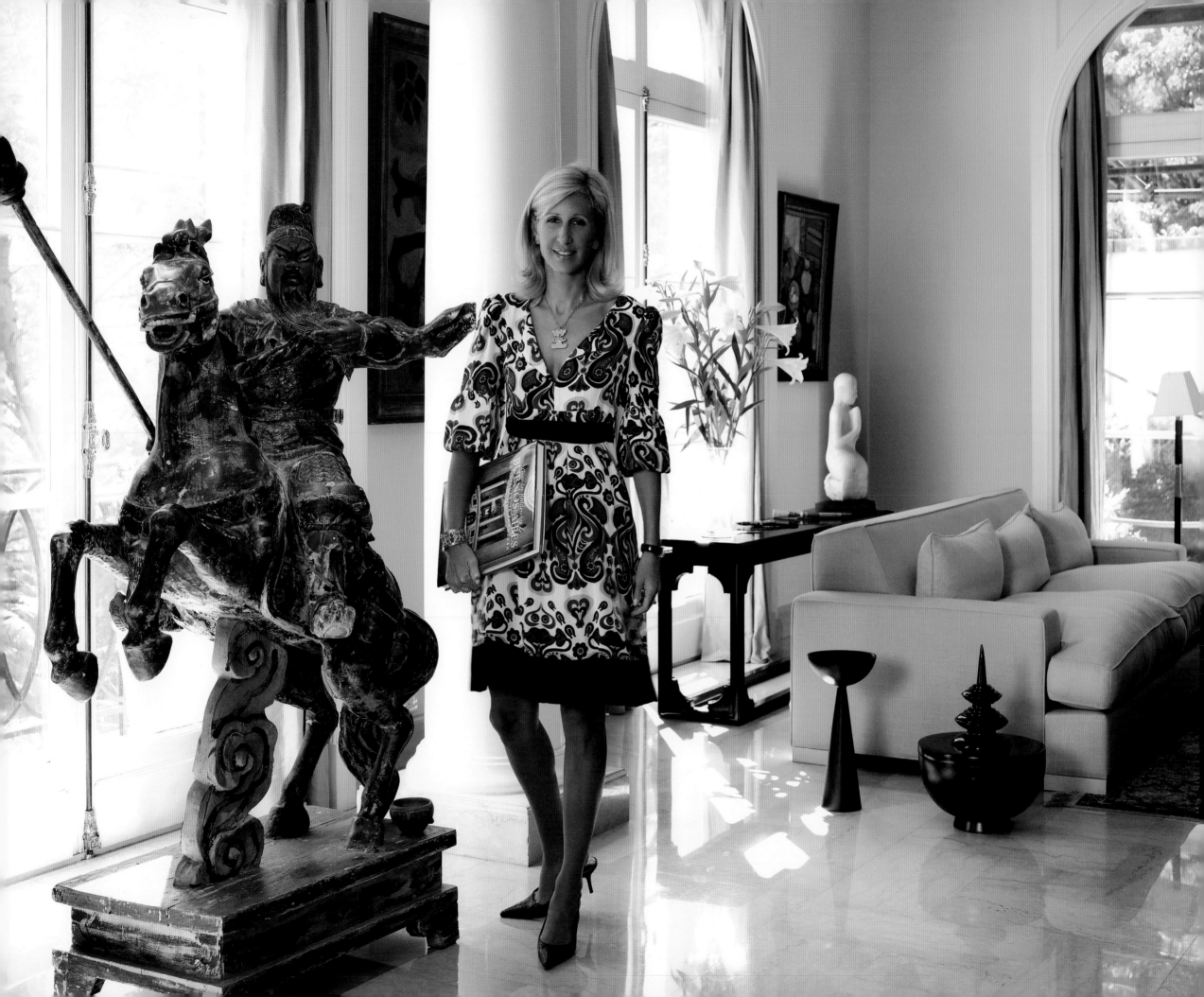

erica roberts

Erica was born in Argentina and attended high school in the United Kingdom before pursuing a liberal arts degree at Swarthmore College in Pennsylvania. She returned to her homeland to work in the family's banking business. She continues to add to the art collection begun by her father and sits on the board of the Art Exhibition Center of Argentina. She is actively involved in the Ronald McDonald House, a charity for children undergoing cancer treatment. Her husband, Woods Staton, is the president of McDonalds Latin America. They live in Buenos Aires with their daughter Lauren.

Photographed in Buenos Aires

I grew up between England and Argentina. My most vivid memories are my holiday travels with my parents to countries where few if any other children ventured at that time (diverse places such as Mongolia, Uzbekistan, and Greenland). I consider these to have been eye-opening experiences that gave me the opportunity to see the richness of each culture and which today enable me to feel at ease in whichever country I find myself. But despite, or perhaps because of all these trips, Argentina always remained home to me, a fact that both my parents were very proud of, since family values have always been of the utmost importance to them.

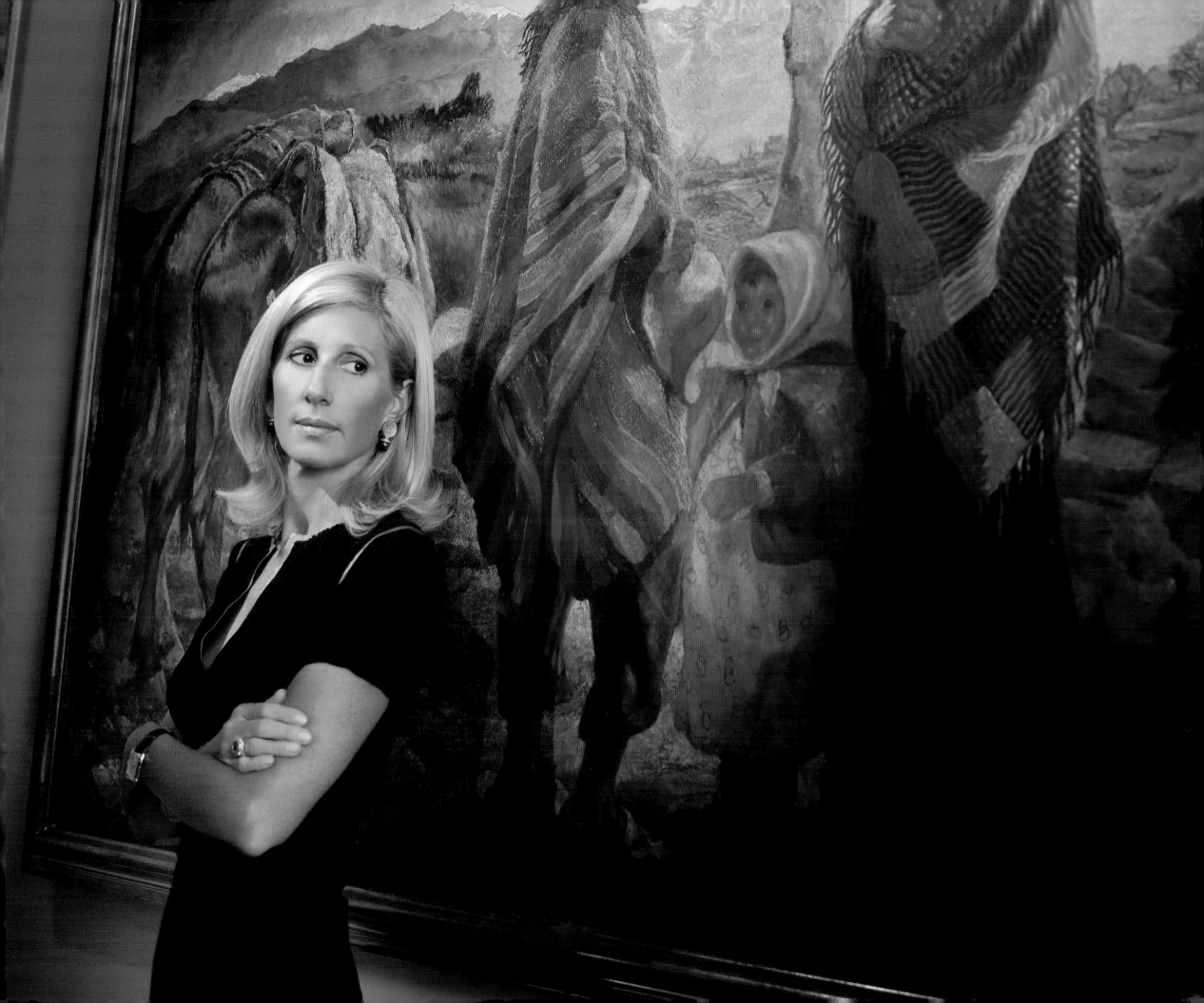

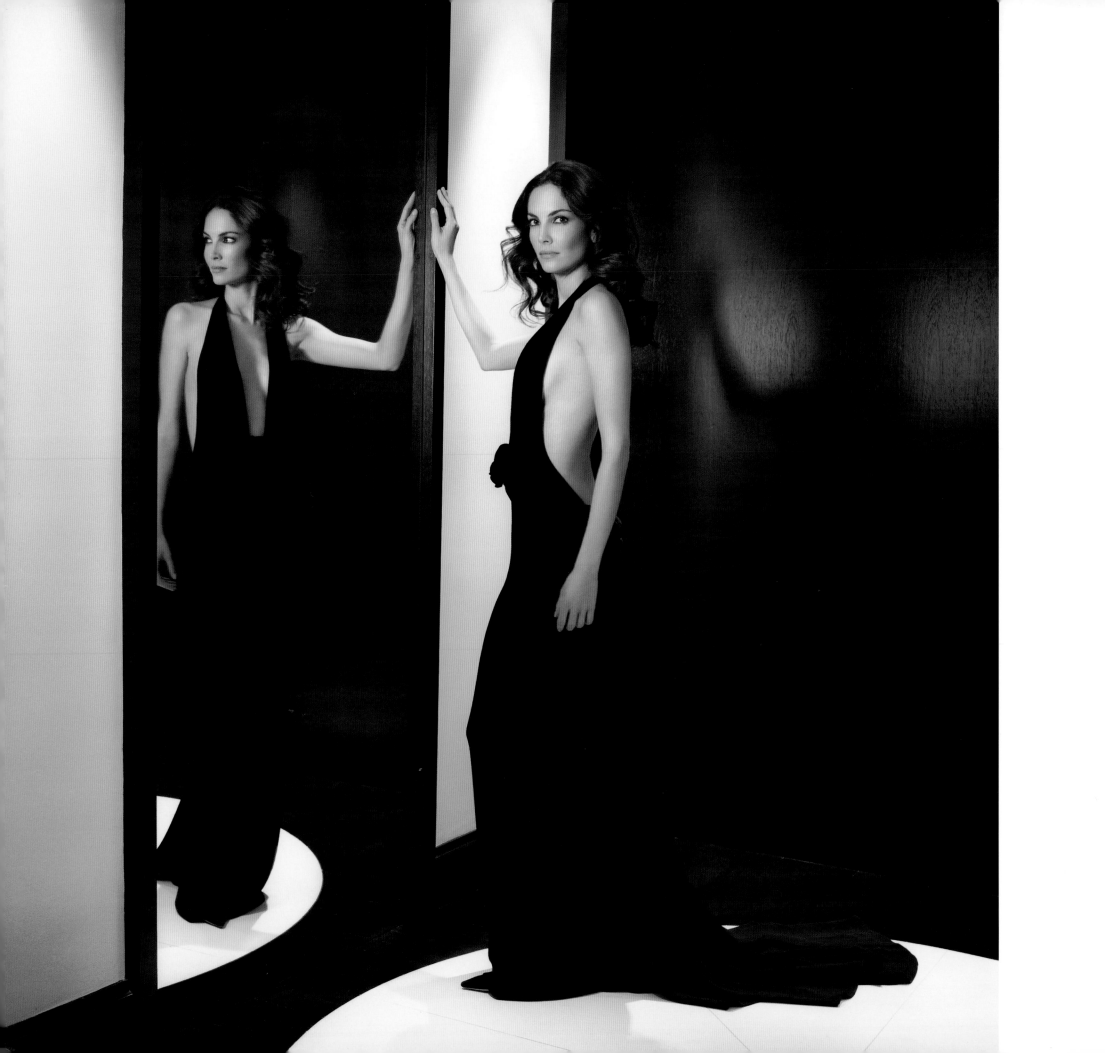

eugenia silva

Though she makes a living as a fashion model, Eugenia followed in her father's footsteps by earning a law degree from the Universidad Complutense de Madrid. She has twice been on the cover of Italian *Vogue* with photography by Stephen Meisel, and has appeared in advertisements for Givenchy Pour Homme, Loewe, Escada, Clinique Happy, and Victoria's Secret. Spanish *ELLE* has recognized her in its style awards issue, and she was named *GQ* Spain's Woman of the Year in 2003. She co-owns a hat store in Madrid with her cousin Fatima de Burnay and lives in New York.

Photographed in New York

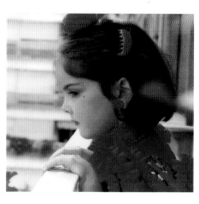

eva jeanbart lorenzotti

A native of Geneva, Eva pursued an undergraduate education at Barnard College in New York. She then joined Lazard Freres as an investment banker, but left in 1996 to found Vivre, a luxury goods retailer that brings a European influence to the American luxury market. Today, it has grown to serve hundreds of thousands of clients by selling only the items she handpicks on her travels.

Photographed in New York

My parents always taught me the importance of having an open mind and an open spirit with a commitment toward being devoted to anything and everything in my life.

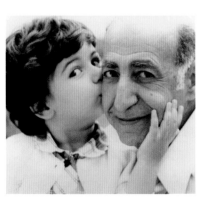

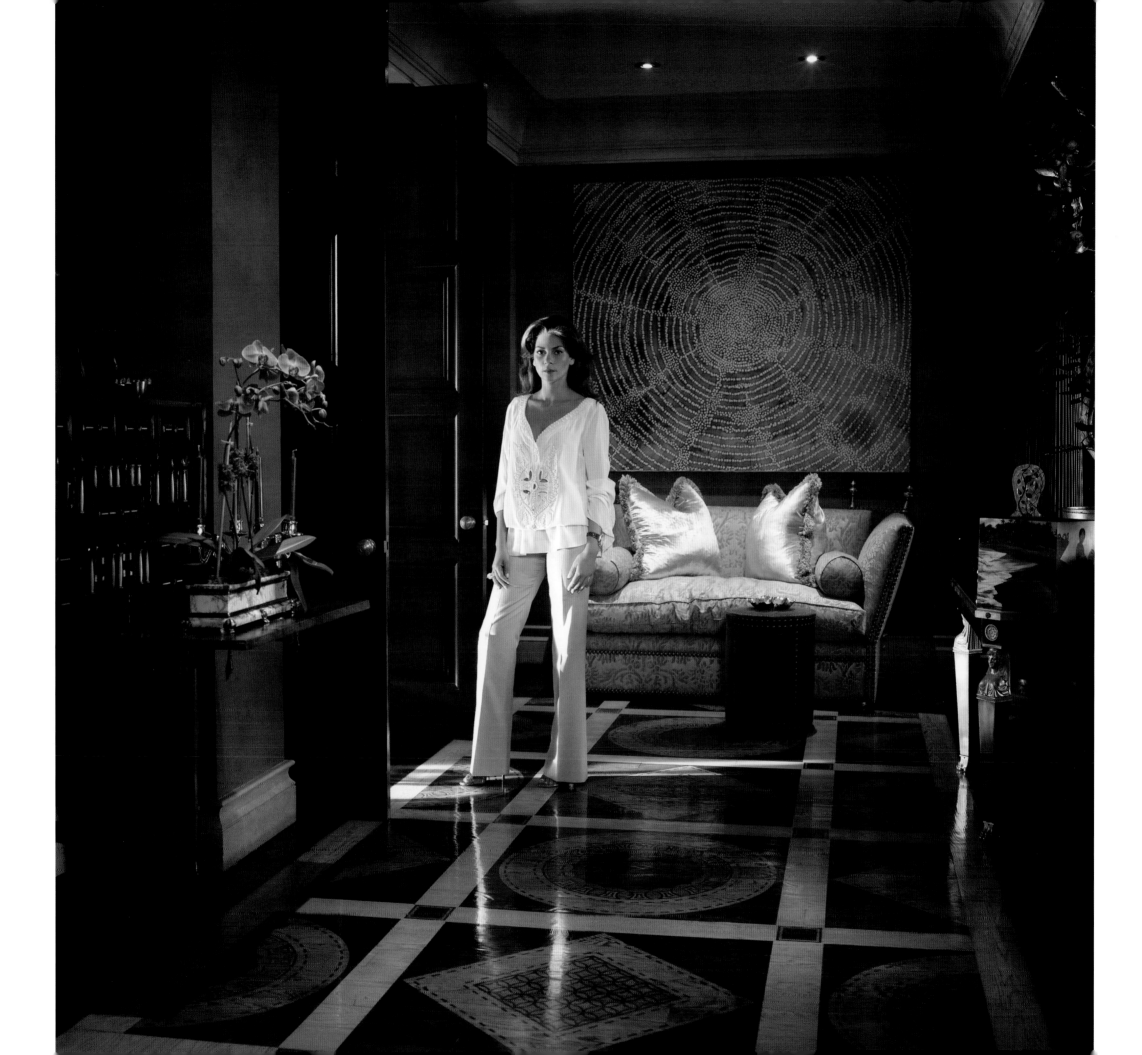

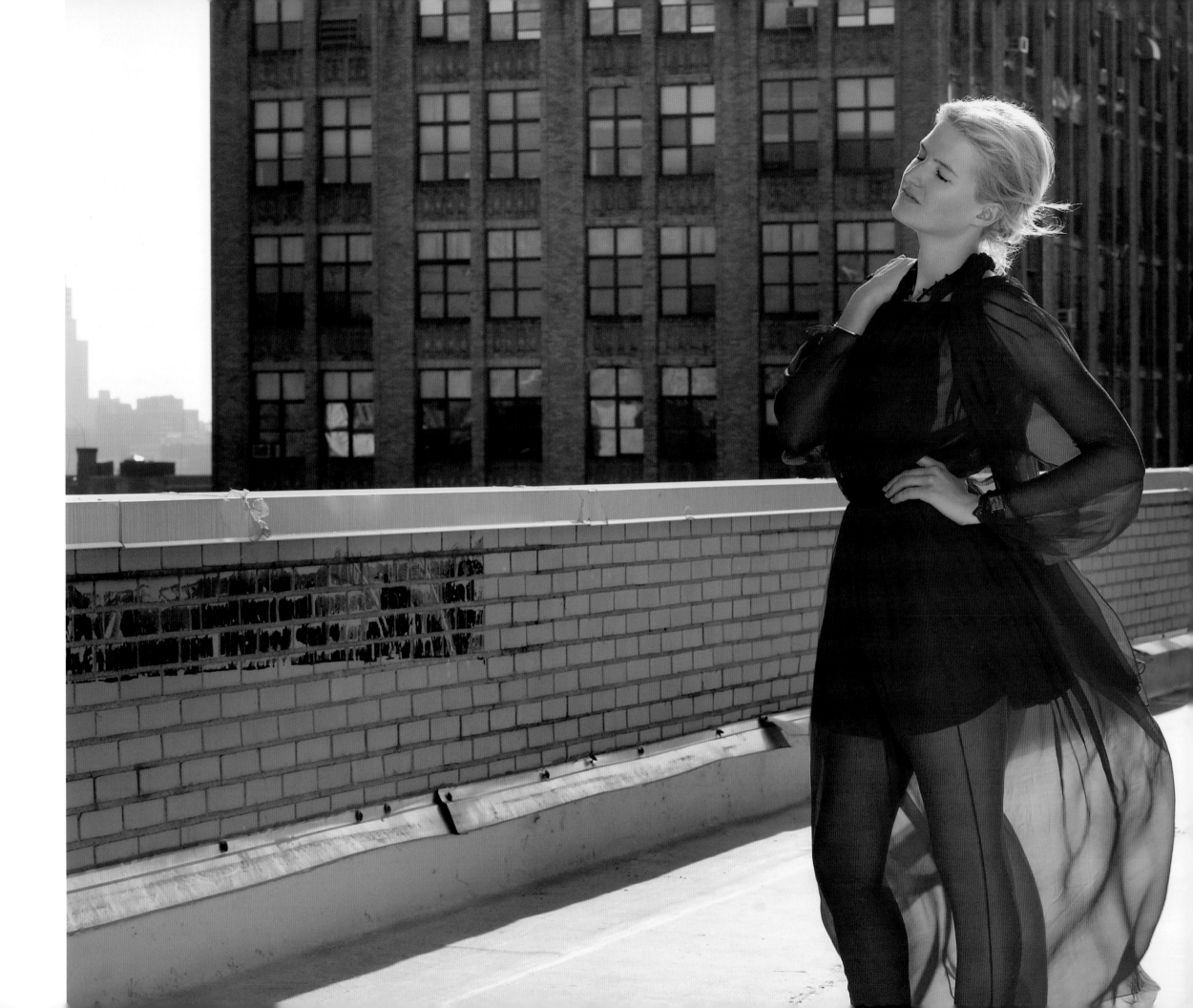

fiona scarry

The granddaughter of children's book author and illustrator Richard Scarry was born in Switzerland and raised in Venice, London and New York. She studied art history and philosophy at the University College London and began working in the fashion industry in various positions for Alexander McQueen, Zac Posen, and J. Mendel. She has achieved It-girl fame for her work as a sometime actress, model, and muse, starring in indie films and consulting for shows during Paris and New York fashion weeks.

Photographed in New York

My parents taught me taste for beauty and love for life.

"The superiority of one over another's is never the opinion is about a

Henry James

man's opinion
so great as when
woman."

francesca versace

Francesca is the daughter of Gianni Versace's older brother Santo, and was named for their mother. As a girl, she made clothes for her Corolle dolls. Years later, she studied fashion design and marketing at Central Saint Martins, where her senior thesis line earned critical praise. She now works as a freelance fashion designer, focusing on clothing, accessories and lifestyle. Recent projects include a capsule collection for a new brand in Singapore with plans to launch her own label. She also founded the charity Milano Young with friends in Italy, where she develops the MY sportswear line.

Photographed in Milan

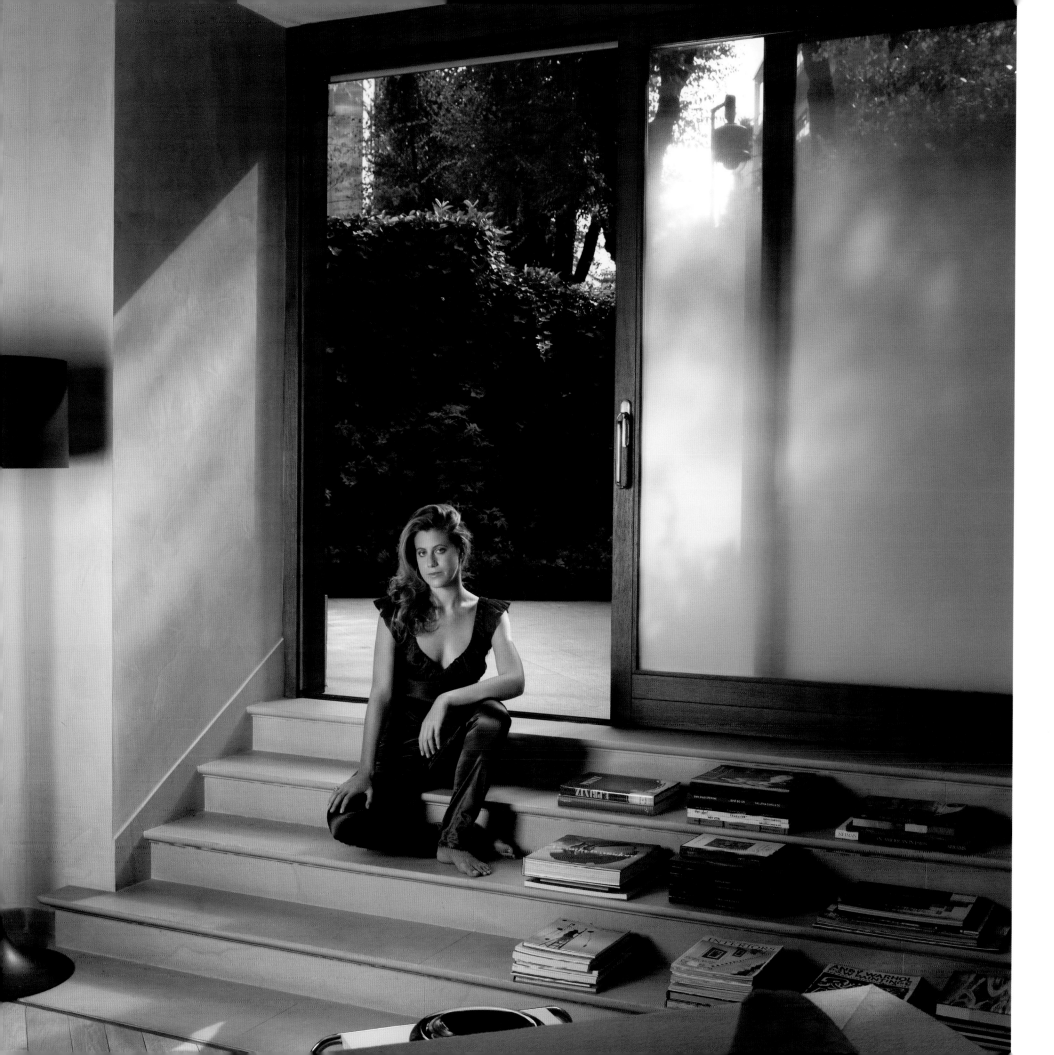

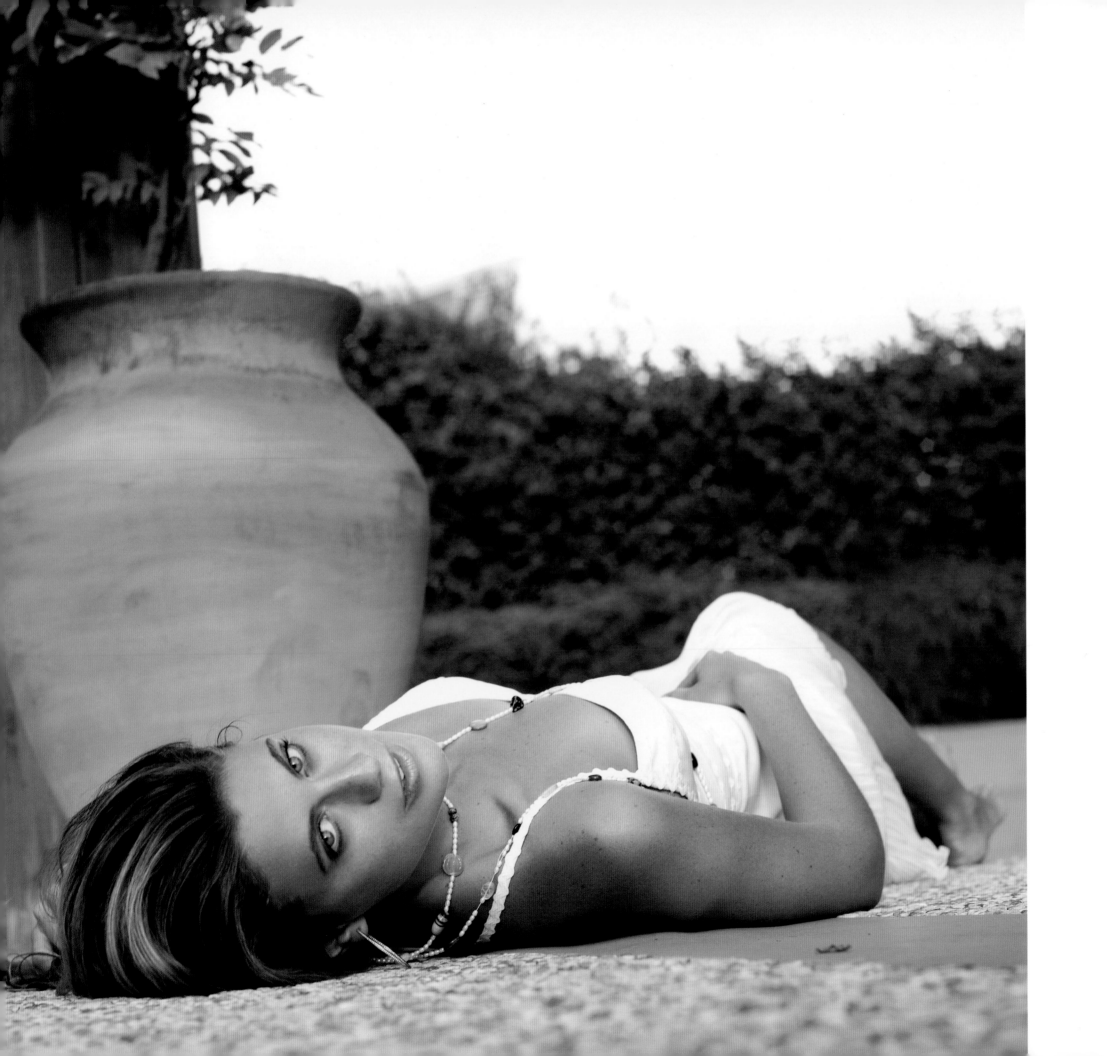

If you got it then you live with it, in your day-to-day life, in every moment everything really matters, how you do things, what you wear , where you go, what you see.

ségolène gallienne

The daughter of Belgian businessman Albert Frère studied economics and finance before spending four years at Dior. In 2006, she launched a children's clothing line named "CdeC" with her cousin Cordelia de Castellane. Their children are inspiration for the label, which is a mix of boho, chic and trendy but affordable clothes. She is married to Ian Gallienne, a private equity financier, and has two children, Eliott and Sienna.

Photographed in Brussels

My parents taught me discretion, curiosity, respect and passion for family, art, dogs and food.

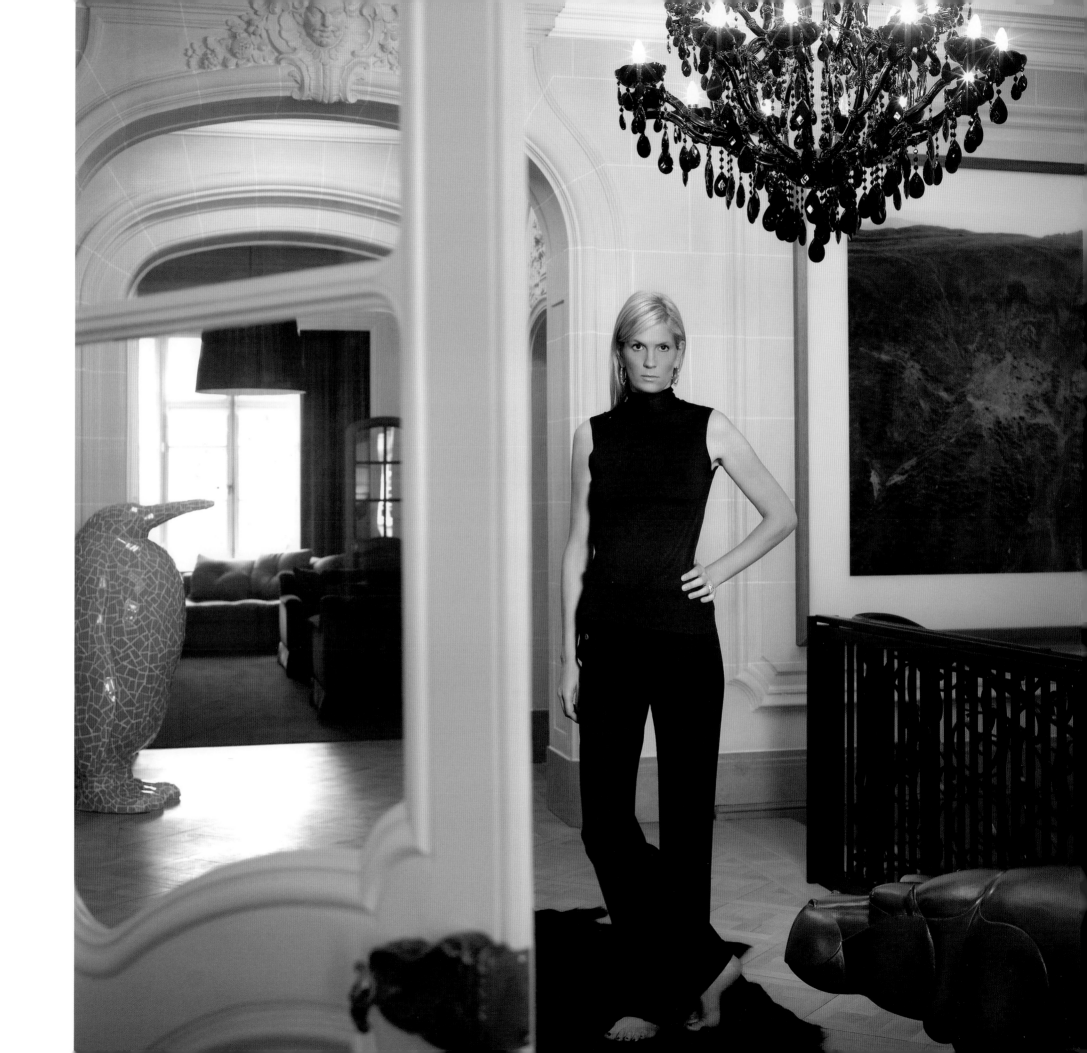

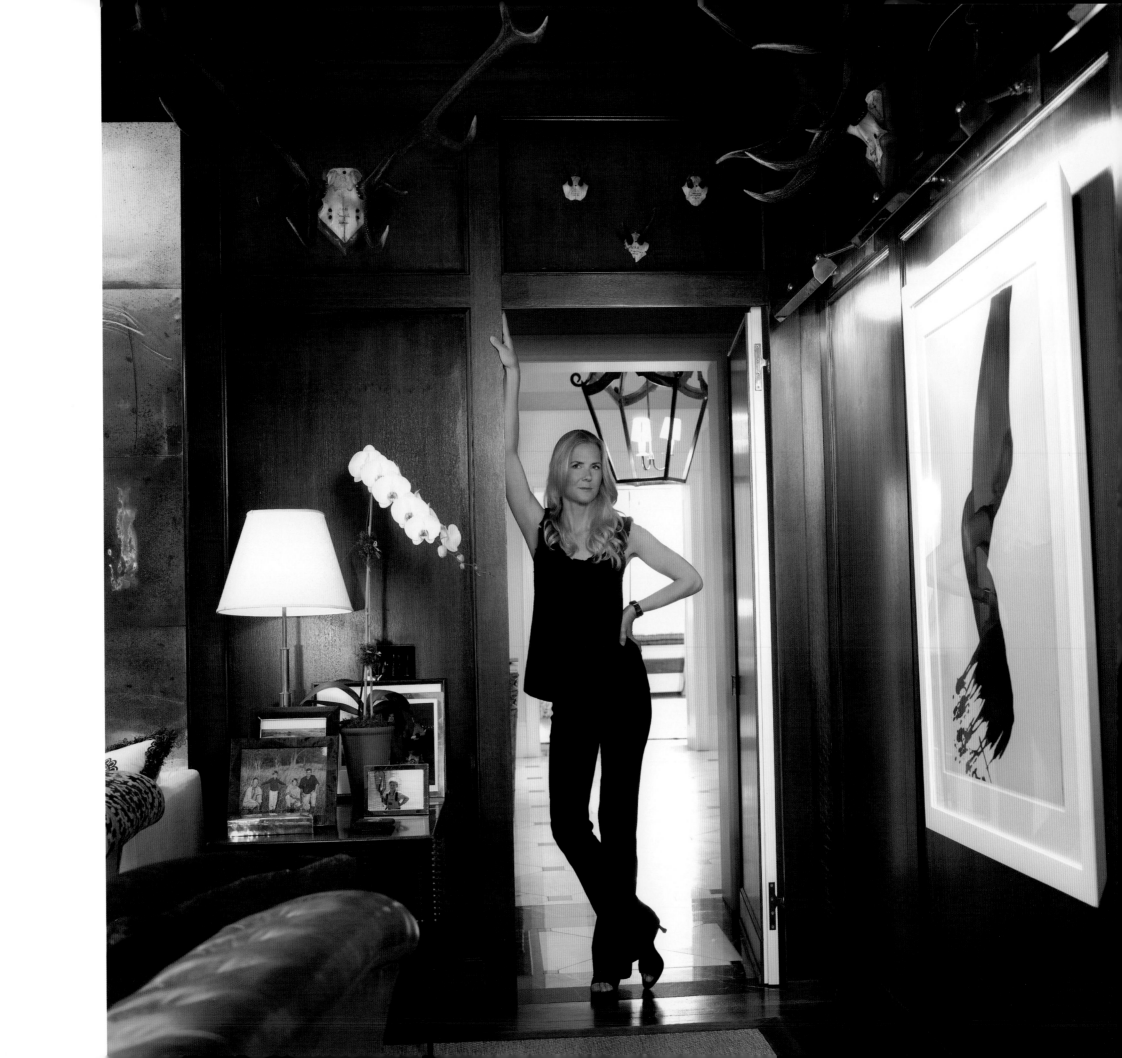

gigi mortimer

Gigi began working in the fashion industry as a photostylist in the 1980s, but soon turned to design and became
the director of women's accessories for Ralph Lauren. In 1995, she began a three-year stint as the design director
of Vera Wang. After having her third son, she gave up a fashion career to focus on her family, but still exercises
creativity by working on freelance projects. She is married to Averell Harriman Mortimer.

Photographed in New York

*My parents taught me enthusiasm and manners. I grew up in Bermuda with
five brothers and sisters; we lived like nymphs roaming an island paradise. We
would wake at dawn to swim on the beach before school.*

ginevra visconti

Ginevra lives far away from the Italian fashion spotlight by making her home in Argentina, where she's married to Andrea Bassetti and is the mother of Ottavia and Leonardo. In addition to looking after her children, she's a writer and equestrian and is studying for a master's degree in journalism.

Photographed in Buenos Aires

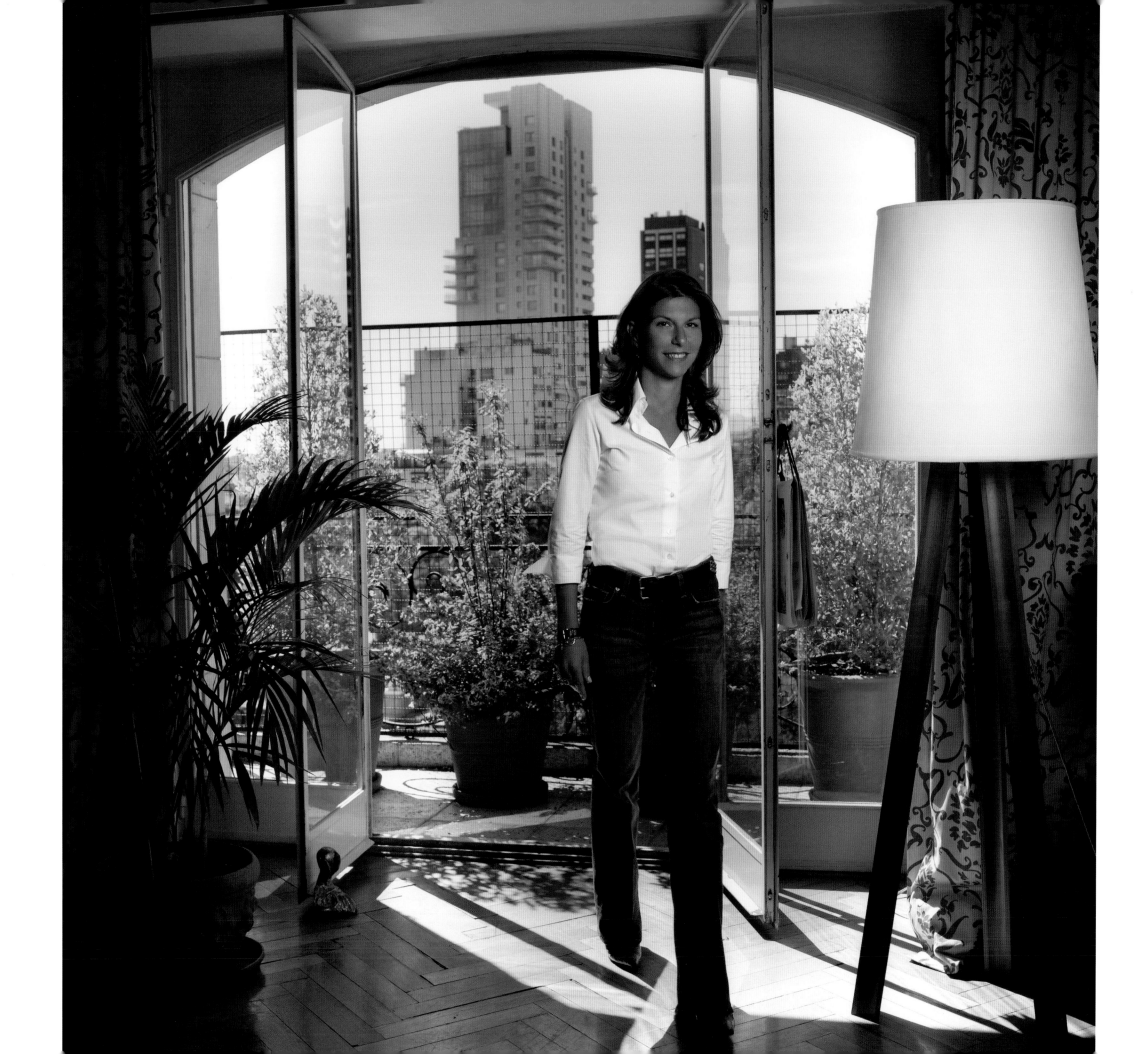

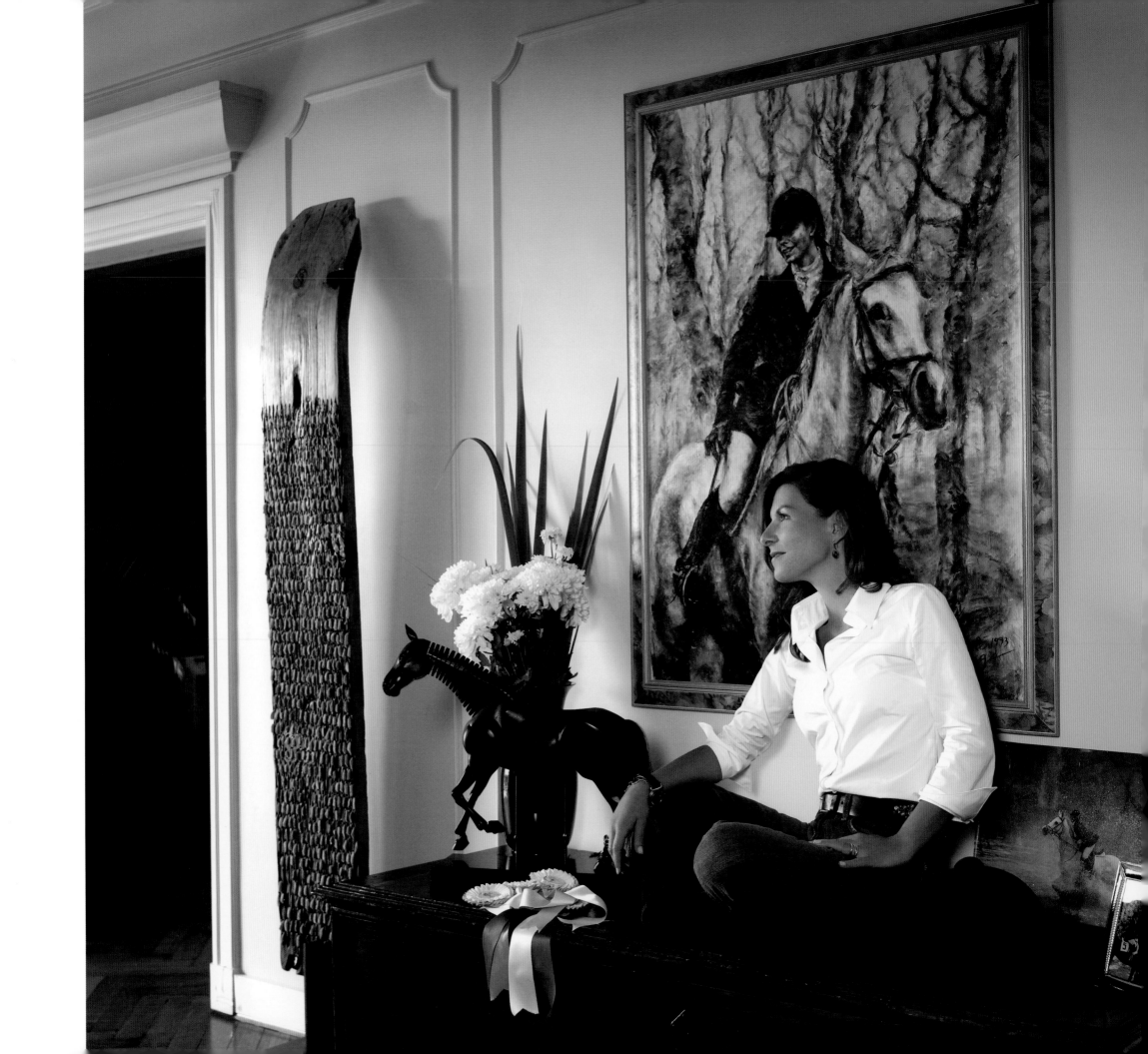

It would be more fun telling about what I did not learn from my parents, but maybe I better not. I learned from Mum and Dad everything that made me able to live my life now with my own family. But most of all, they taught me how to be simple, fair and honest. I thank my father, who taught me to appreciate being in nature, riding on a horse, which has ended up being the great issue that made my life richest emotionally, and the most balanced possible, psychologically.

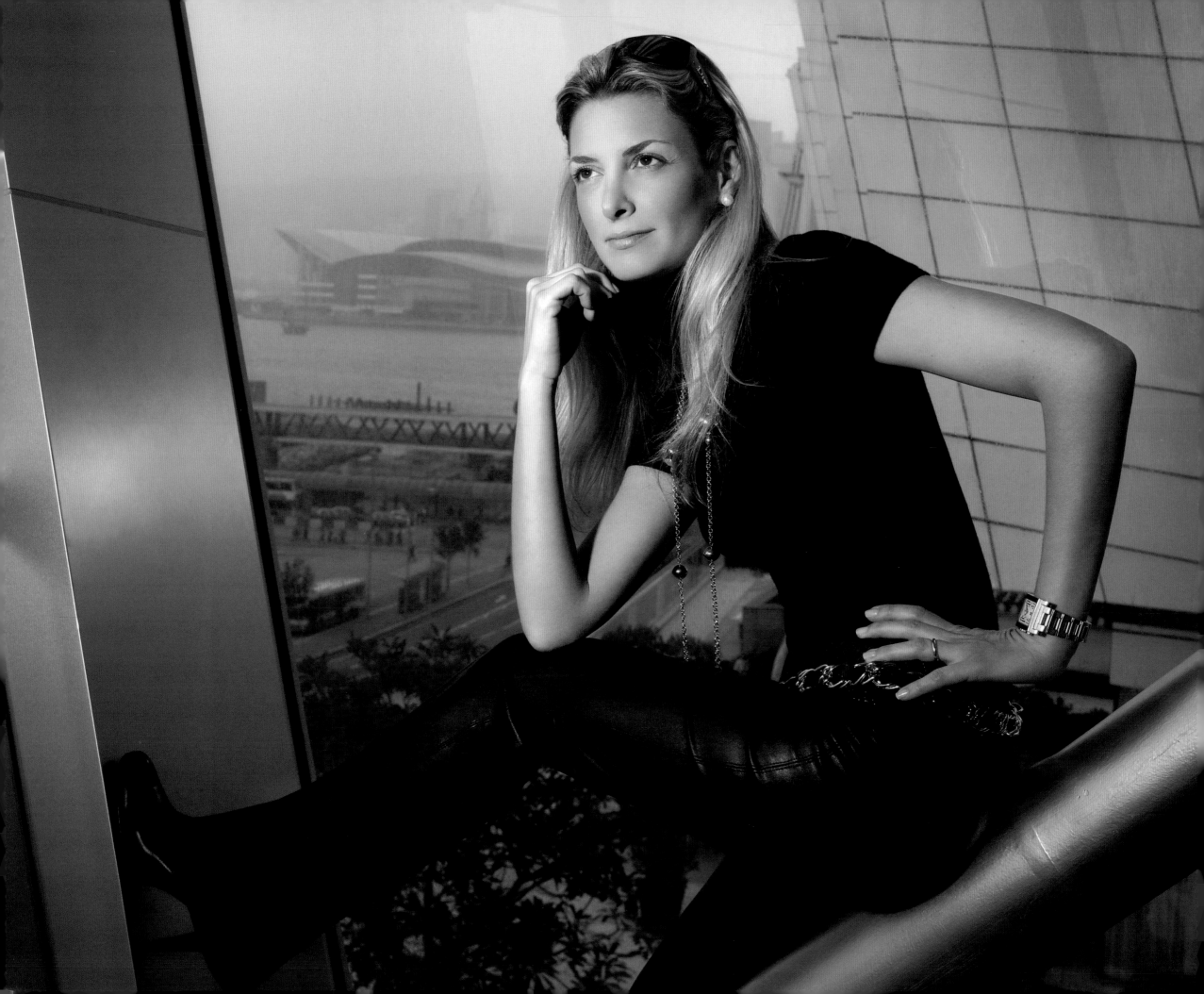

gioia nassetti

The daughter of an electromechanical tycoon whose family roots dig deep into the early 14th century, Gioia is a self-described aesthete who has worked as a consultant for Sotheby's using her knowledge of Italian Renaissance painting. She was born and raised in Milan, studied law, and eventually settled with her husband in Hong Kong, where she manages the family's Asian businesses. As an Italian in the East, Gioia misses the old-world aesthetics of her native Italy, but is captivated by the insular culture of the trading capital's unique energy and efficiency. In addition to caring for son Federico, she supports the Hong Kong Cancer Fund and contributes regularly to *Prestige* magazine.

Photographed in Hong Kong

Always be independent mentally and financially and try to follow your dreams. Help people less fortunate than yourself.

india hicks

India Hicks is the daughter of famed interior designer David Hicks and granddaughter to the Earl and Countess Mountbatten of Burma. At the age of 13, India was a bridesmaid at the wedding of her cousin Prince Charles to Diana Spencer. As a fashion model, she has been the face for many labels, including Ralph Lauren, Banana Republic and Bill Blass, often alongside partner David Flint Wood, a former advertising executive. The couple live on an island in the Bahamas with their three children. India is the author of two books, *Island Life* and *Island Beauty*, and has launched India Hicks Living, a line of home and beauty products in collaboration with Crabtree & Evelyn, for which she is a creative partner.

Photographed in New York City

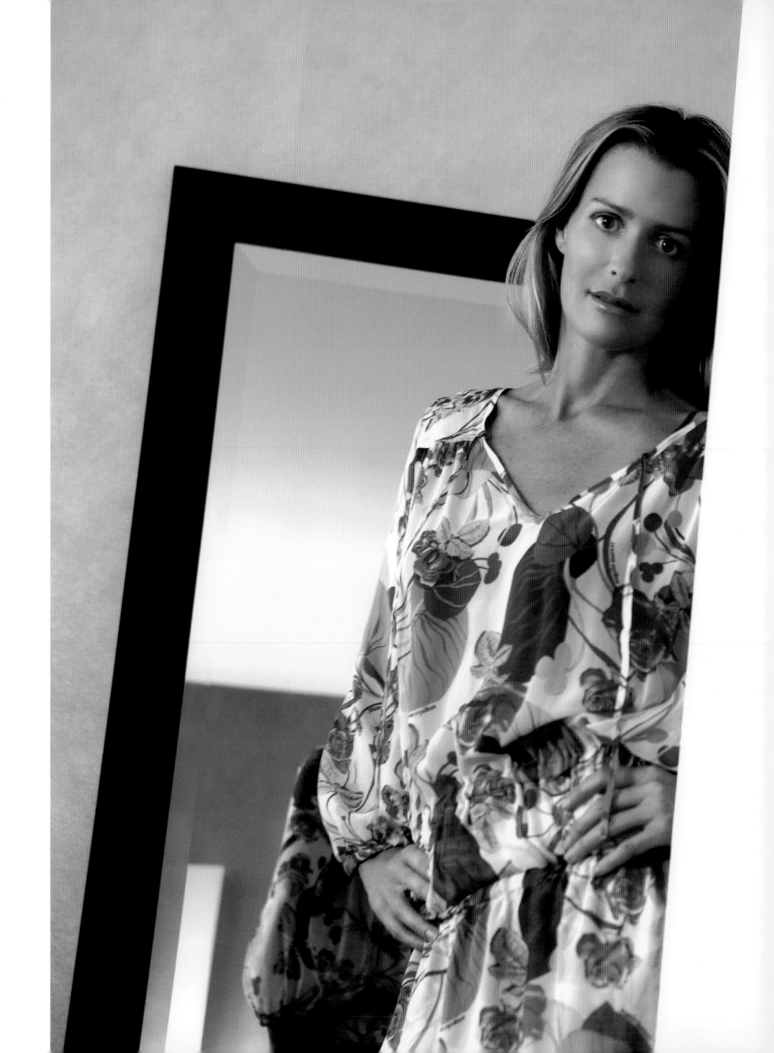

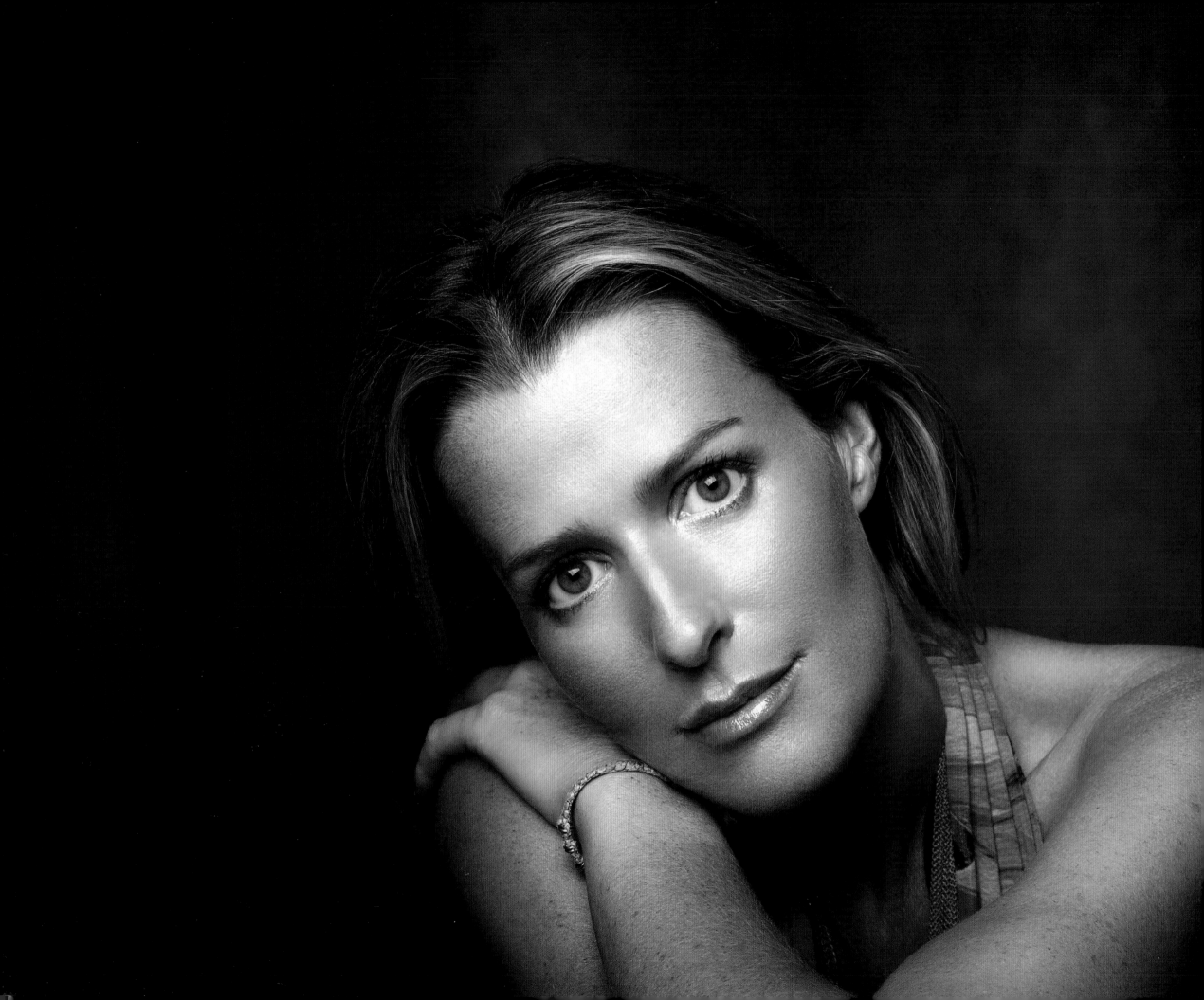

To be strong and individual.

jacqueline getty

In addition to working as a costume designer, Jacqui is a contributing editor and stylist for *Harper's Bazaar*. She is famous for her costume parties and every October masqueraders vie for an invitation to the famous Halloween soirée she hosts in her home for Hollywood friends. She is married to Peter Getty and is mother to Gia Coppola.

Photographed in Los Angeles

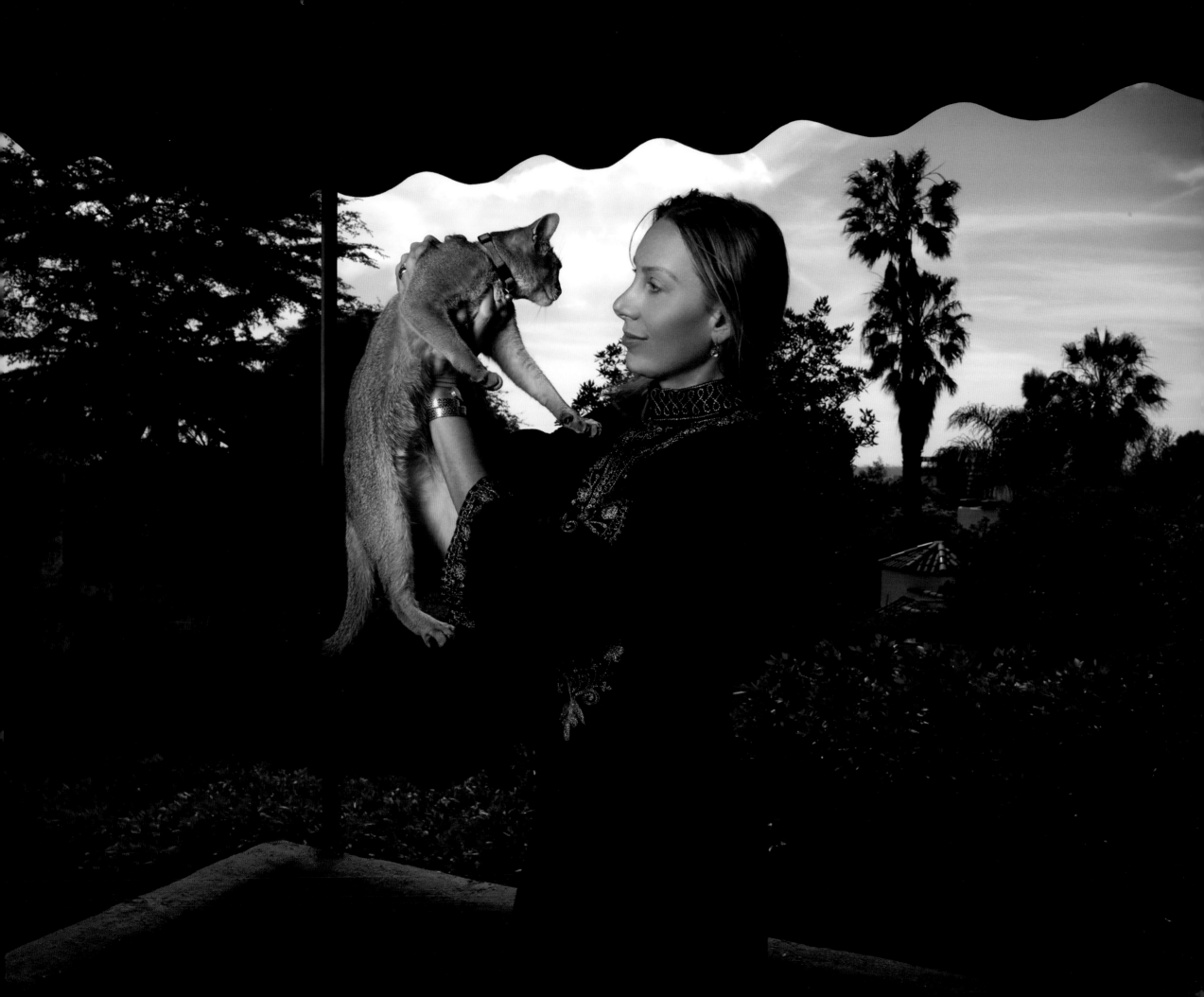

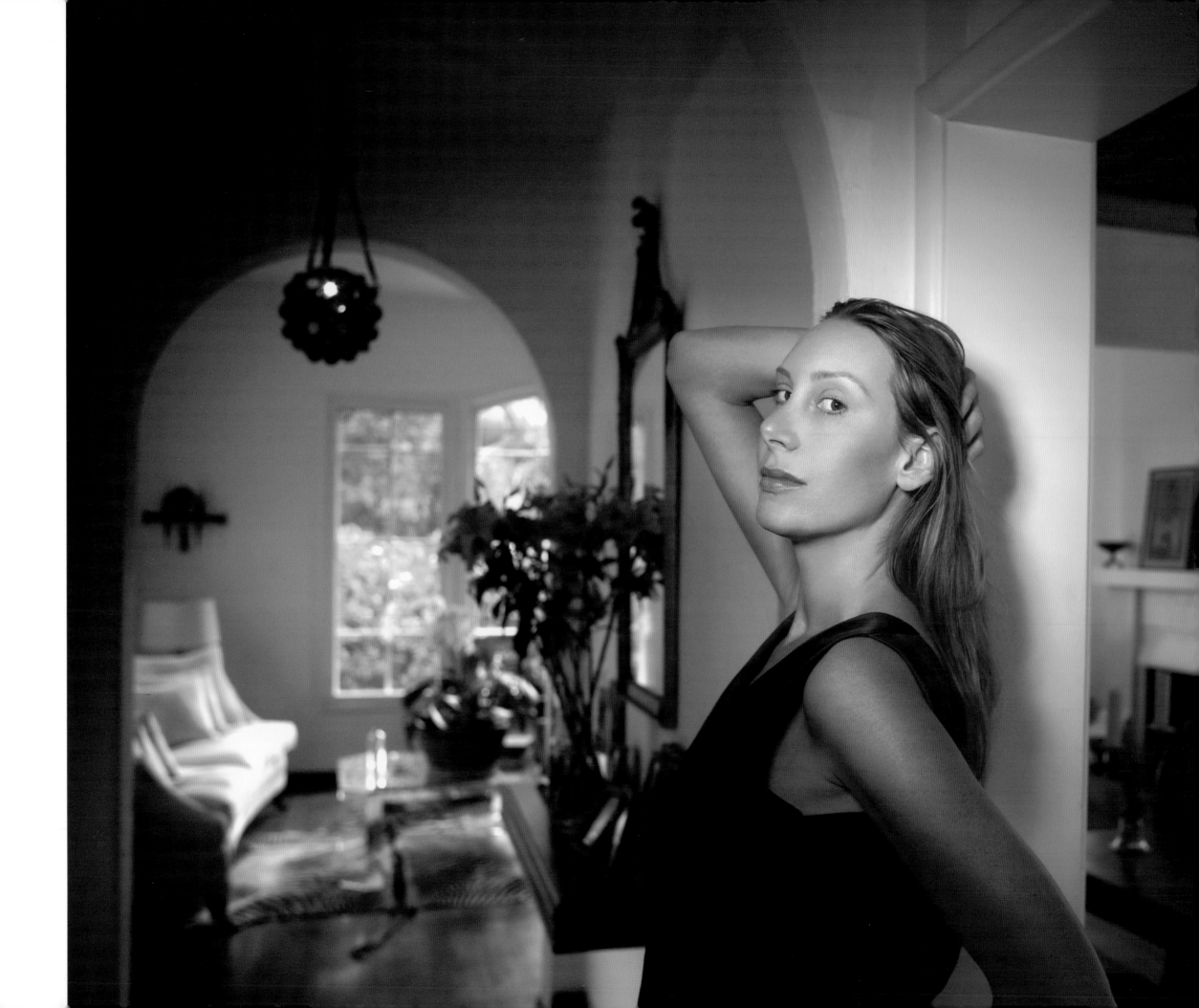

jennifer woo

The next generation to head Lane Crawford, Jennifer Woo has breathed new life into the 157-year-old Hong Kong-based luxury retailer. As its president, the Wellesley College graduate has been the driving force behind an ambitious modernization plan across Asia. The stores offer designer brands, unique services, breathtaking interiors and art exhibitions. Her accomplishments have been recognized by *Vogue* and the *International Herald Tribune*.

Photographed in Hong Kong

My parents taught me humility.

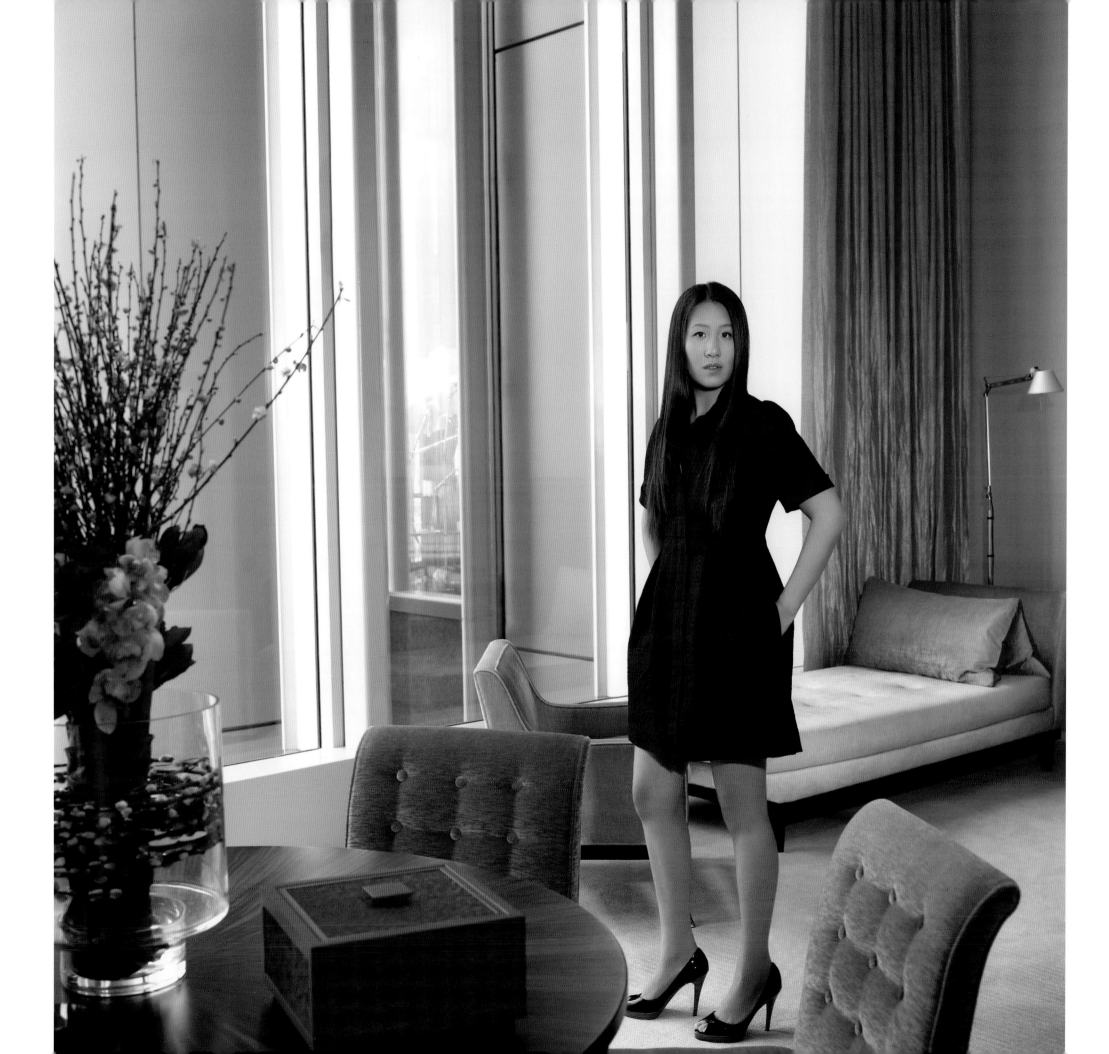

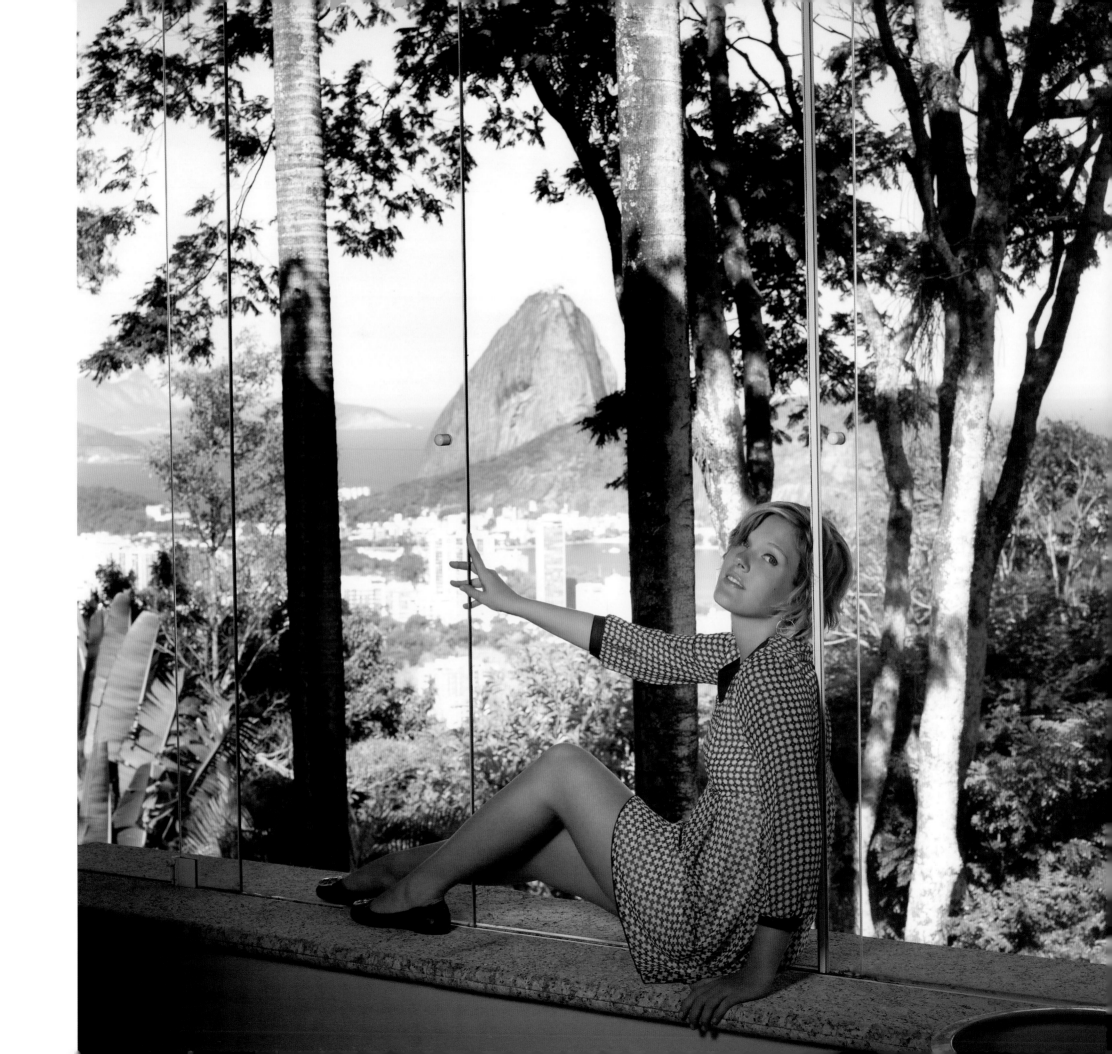

julia monteiro

Julia is the youngest of four daughters of Olavo and Betsy Monteiro, who own industrial development businesses in Brazil. Born in Rio de Janeiro, she moved to Paris at the age of five with her mother. She returned to Rio five years later and eventually studied advertising at Univercidade, and now works as a fashion designer.

Photographed in Rio de Janeiro

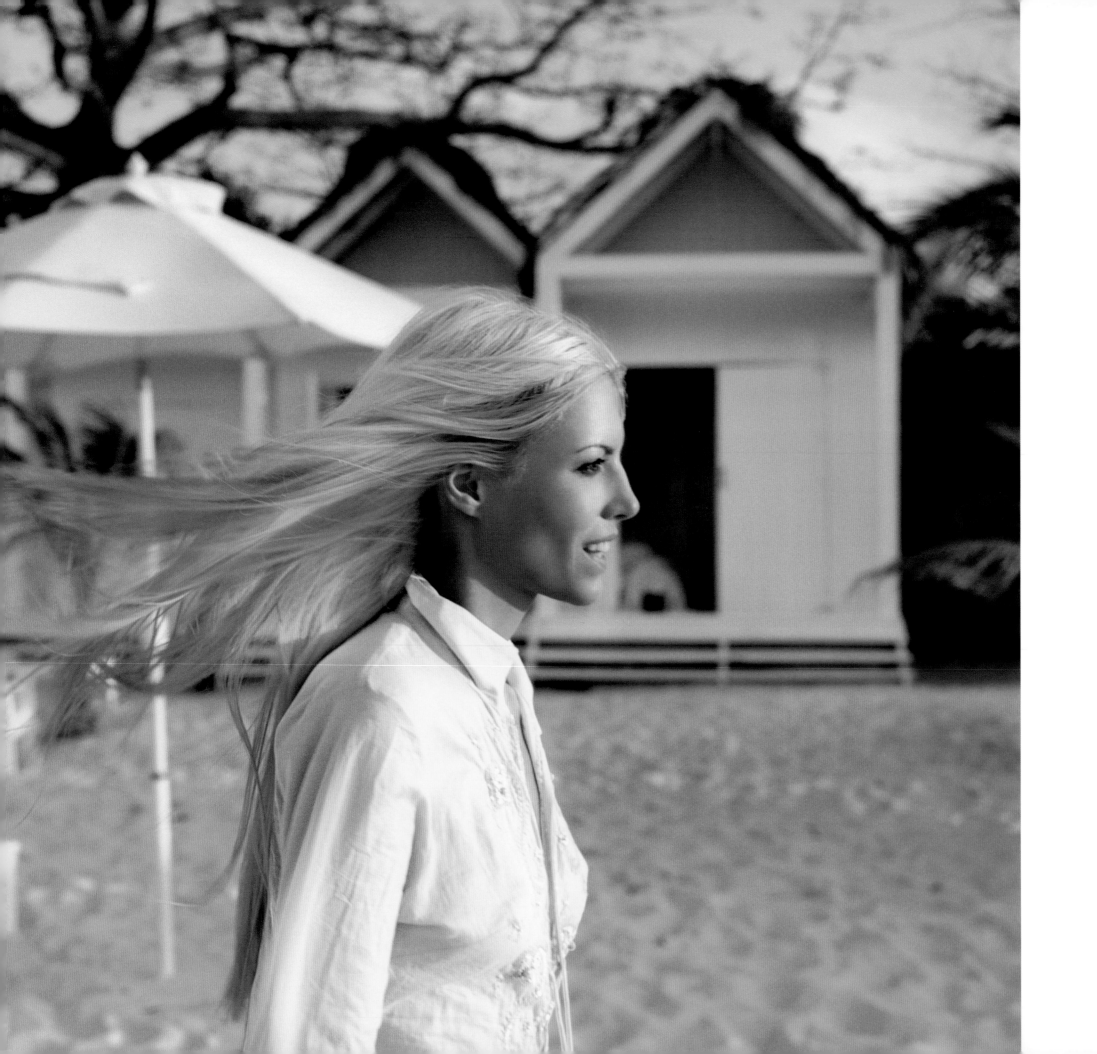

juliet hartford

As the only daughter of Huntington Hartford, the arts patron and founder and developer of Paradise Island in the Bahamas, Juliet is the heir to the A&P fortune. The family's John Hartford Foundation is the U.S.'s largest medical philanthropy dedicated to geriatric care. She was born in New York City and was educated at the Institut Le Rosey in Switzerland. She is an actress and model and has appeared in German *Vogue*.

Photographed in Lyford Cay

I learned patience, kindness, strength and commitment.

kiera chaplin

As the granddaughter of filmmaker Charlie Chaplin and the great-granddaughter of playwright Eugene O'Neill, Kiera Chaplin has acting in her blood. After being raised in Switzerland on her grandparents' estate, she began her professional life by pursuing acting and modeling in Paris, London and New York. She has appeared in numerous magazines including *Vogue*, *Vanity Fair*, and *Harper's Bazaar*, as well as ad campaigns for Armani Exchange and Tommy Hilfiger. She has been photographed by Peter Beard and Peter Lindbergh and appeared in the 2002 Pirelli calendar. Her film credits include roles in *The Year That Trembled* and *Yatna*. She was actively involved in the DVD release of *My Tribute to Charlie Chaplin*, which she narrated and produced with her father Eugene.

Photographed in Miami

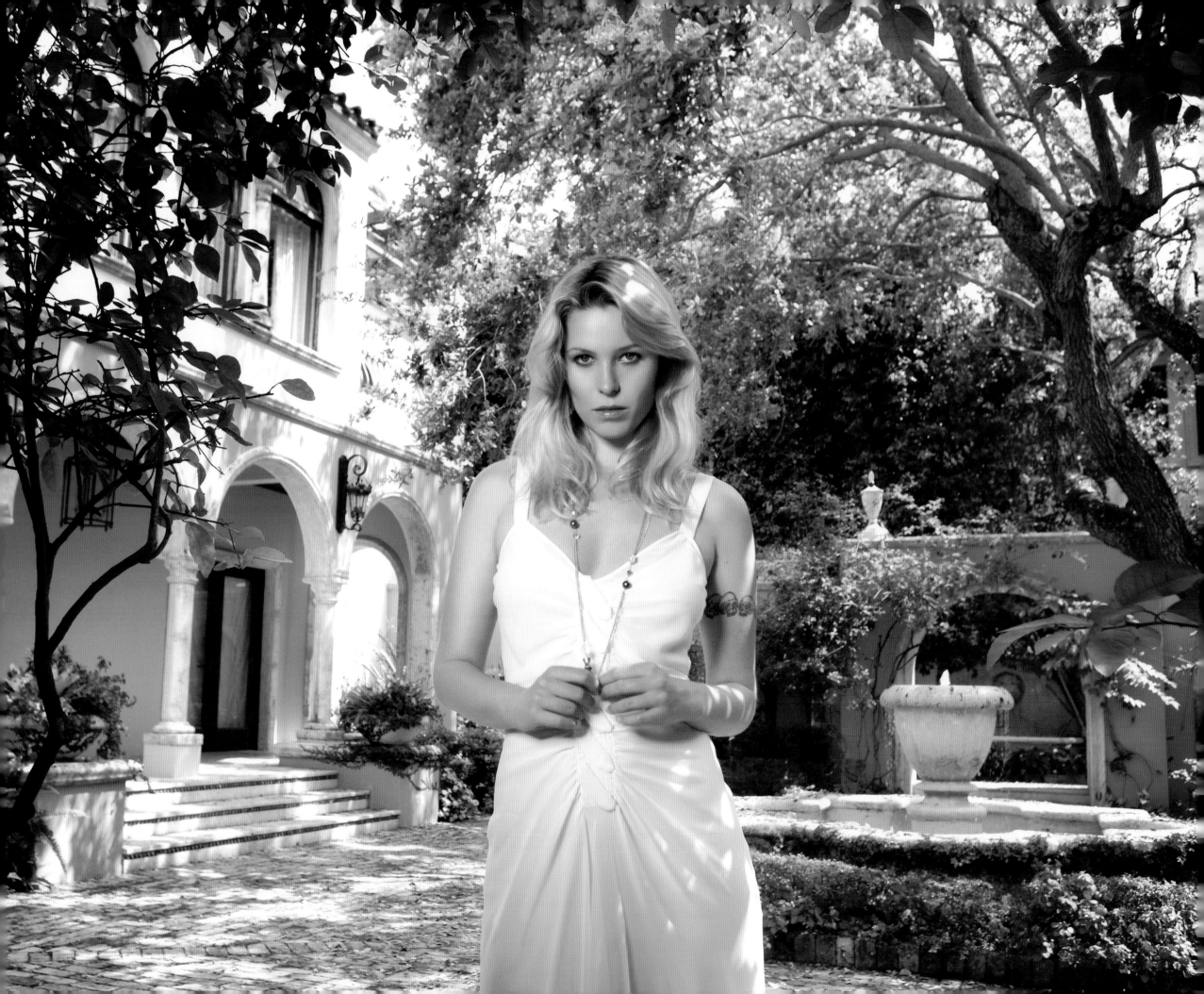

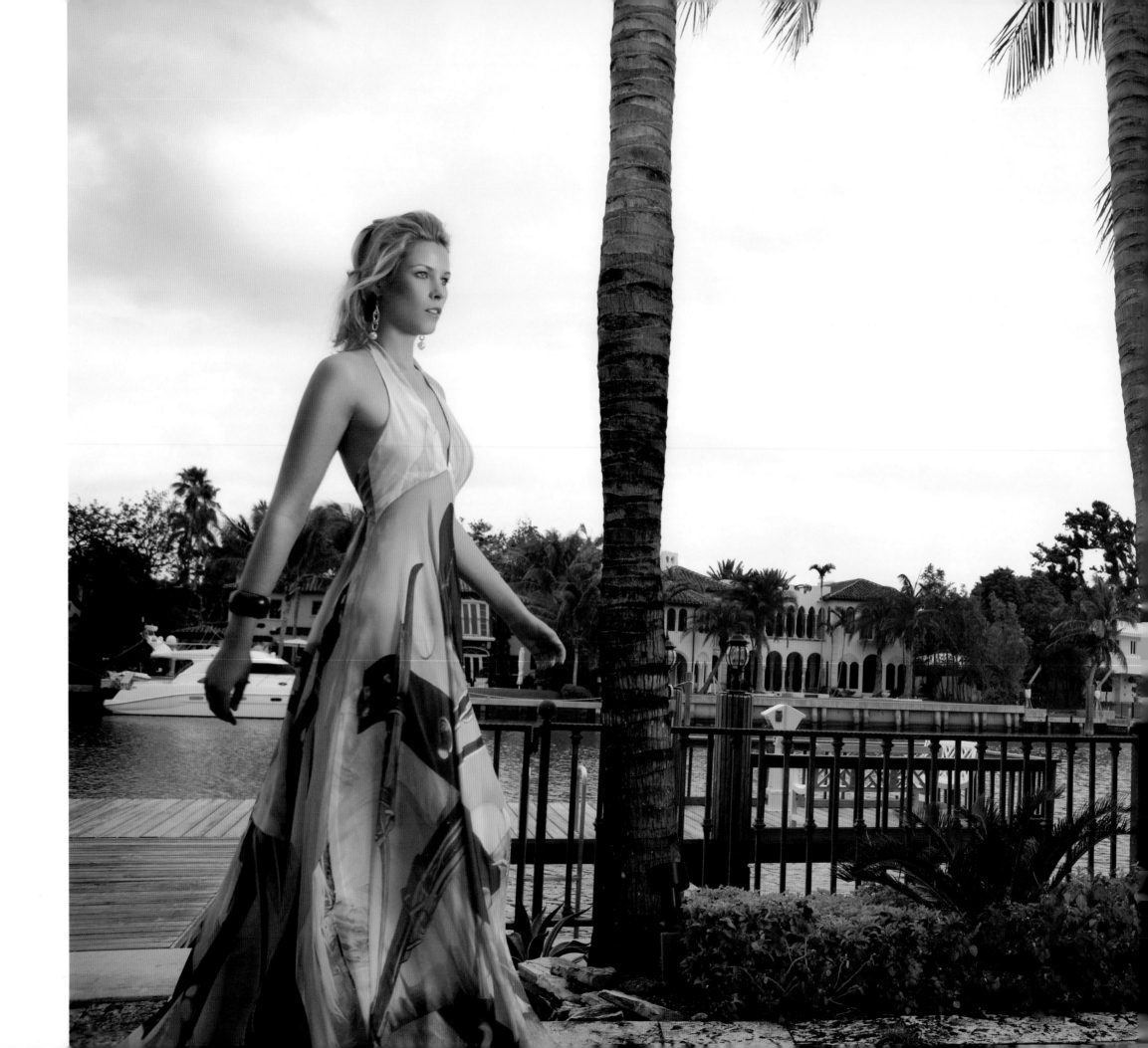

My parents taught me to be independent and responsible for my actions. They also taught me to be opened-minded, not to judge and to love simple things. From my dad I learned to be grounded and patient and see creativity in everything, and how to stay a child forever. My mom taught me to be strong and passionate, to fight for what you love and not take any shit. She also taught me strong family values; I don't look back and don't regret. I like to push buttons and limits and play with people's minds.

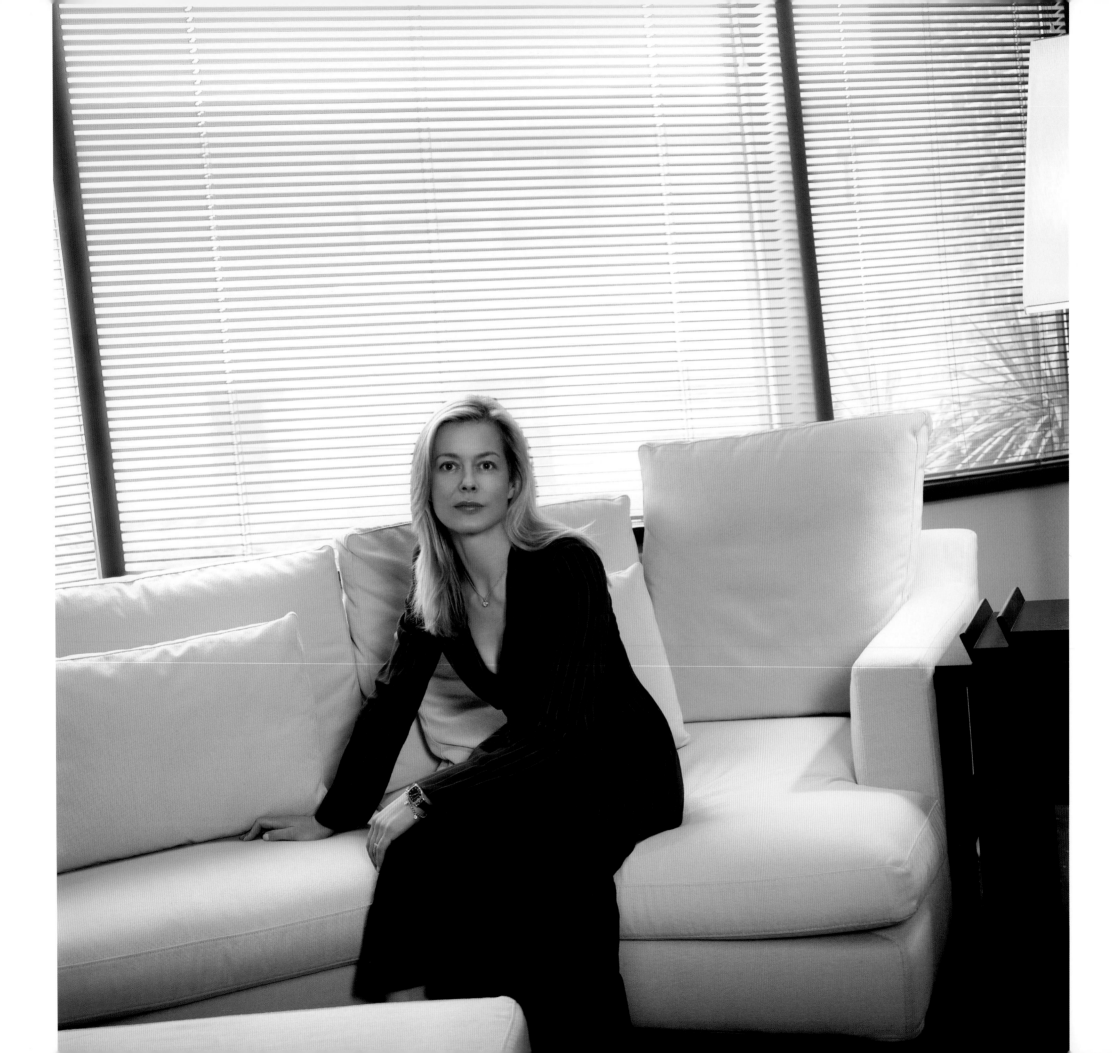

lady helen taylor

roger moenks
137

Lady Helen Taylor is the daughter of the Duke and Duchess of Kent. She was born in Buckinghamshire and attended Gordonstoun School in Scotland. She spent 10 years working in the contemporary art world, first at Christie's and then with cutting-edge London gallerist Karsten Schubert. In 1999, Lady Helen was invited by Giorgio Armani to become his ambassador in the United Kingdom. She is also a patron of CLIC Sargent, a children's cancer charity, and was recently made a trustee of the Glyndebourne Opera House. Lady Helen is married to Timothy Taylor, whose Mayfair gallery is now one of the most respected in the world of contemporary art. They have four children.

Photographed in London

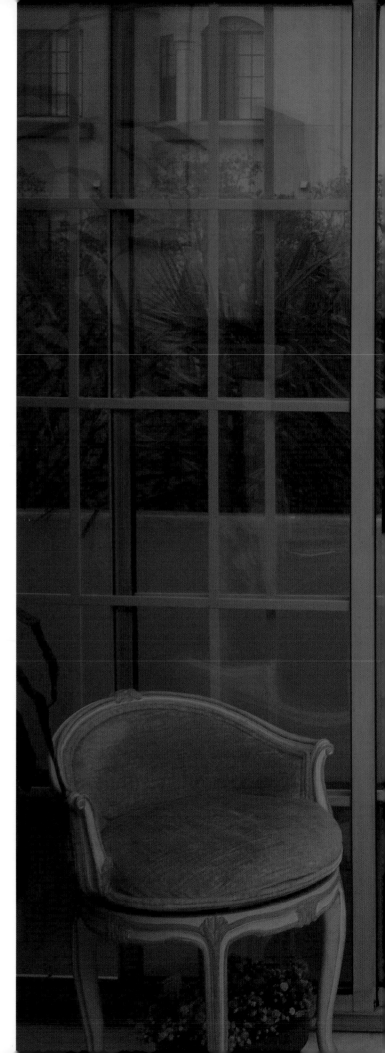

lady victoria hervey

The British It-girl and tabloid subject is the elder daughter of the sixth Marquess of Bristol. After studying at Benenden School in Kent, Victoria decided not to continue her studies at Bristol University so she could become a model for Christian Dior. She briefly operated Akademi, a London boutique, and has written about her social life for *The Sunday Times*. In 2004 she moved to Los Angeles to pursue an acting career.

Photographed in Los Angeles

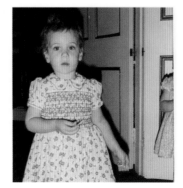

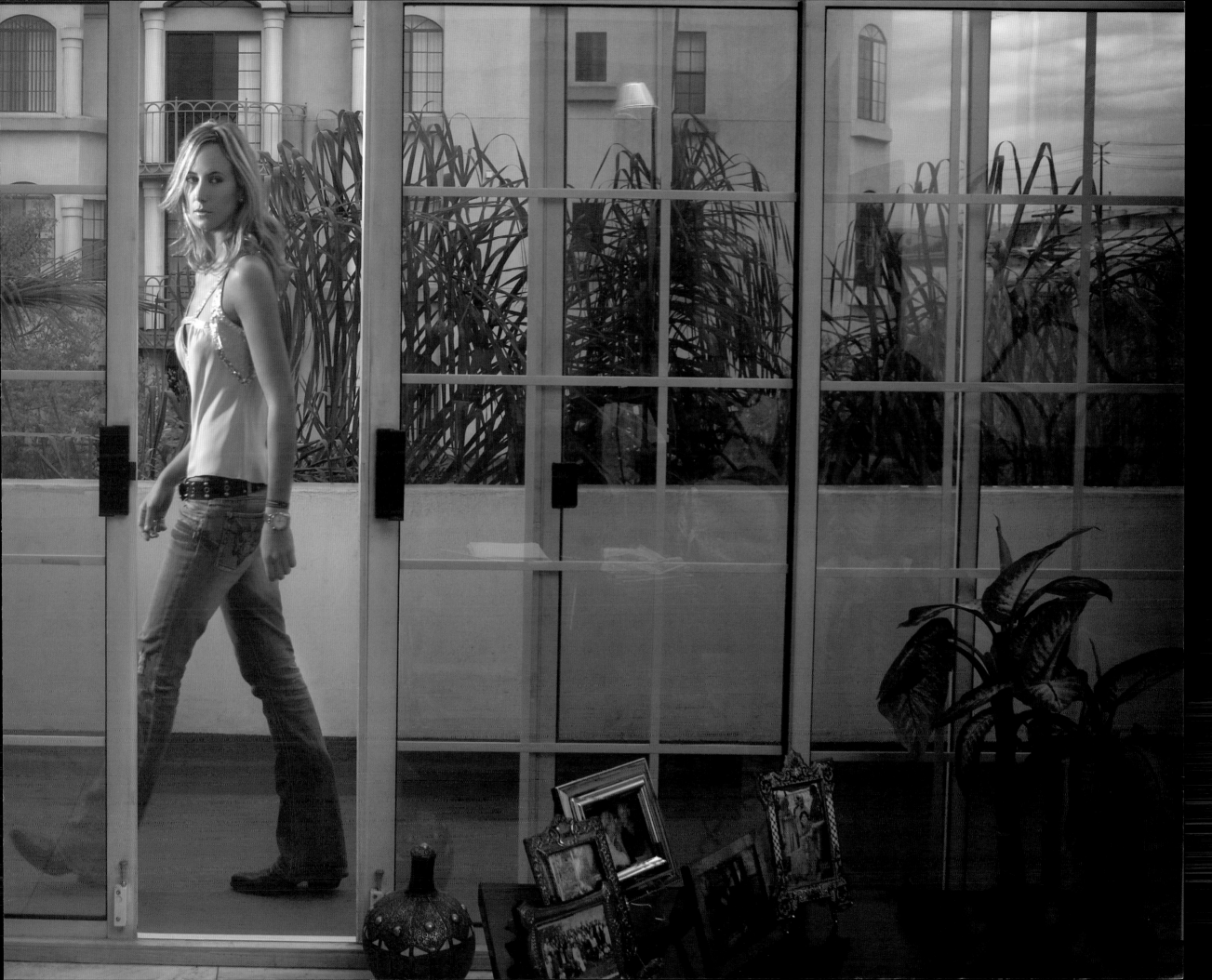

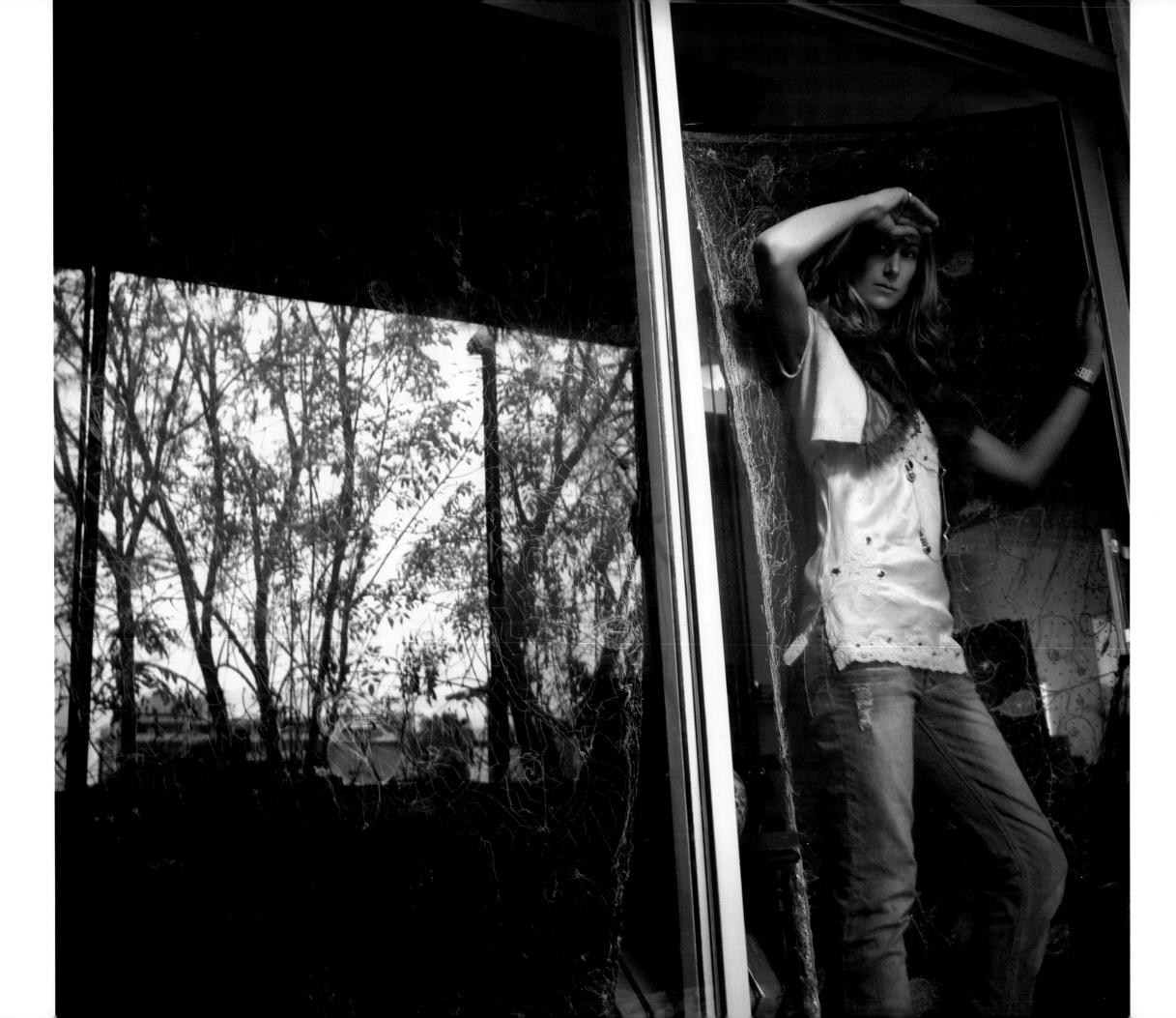

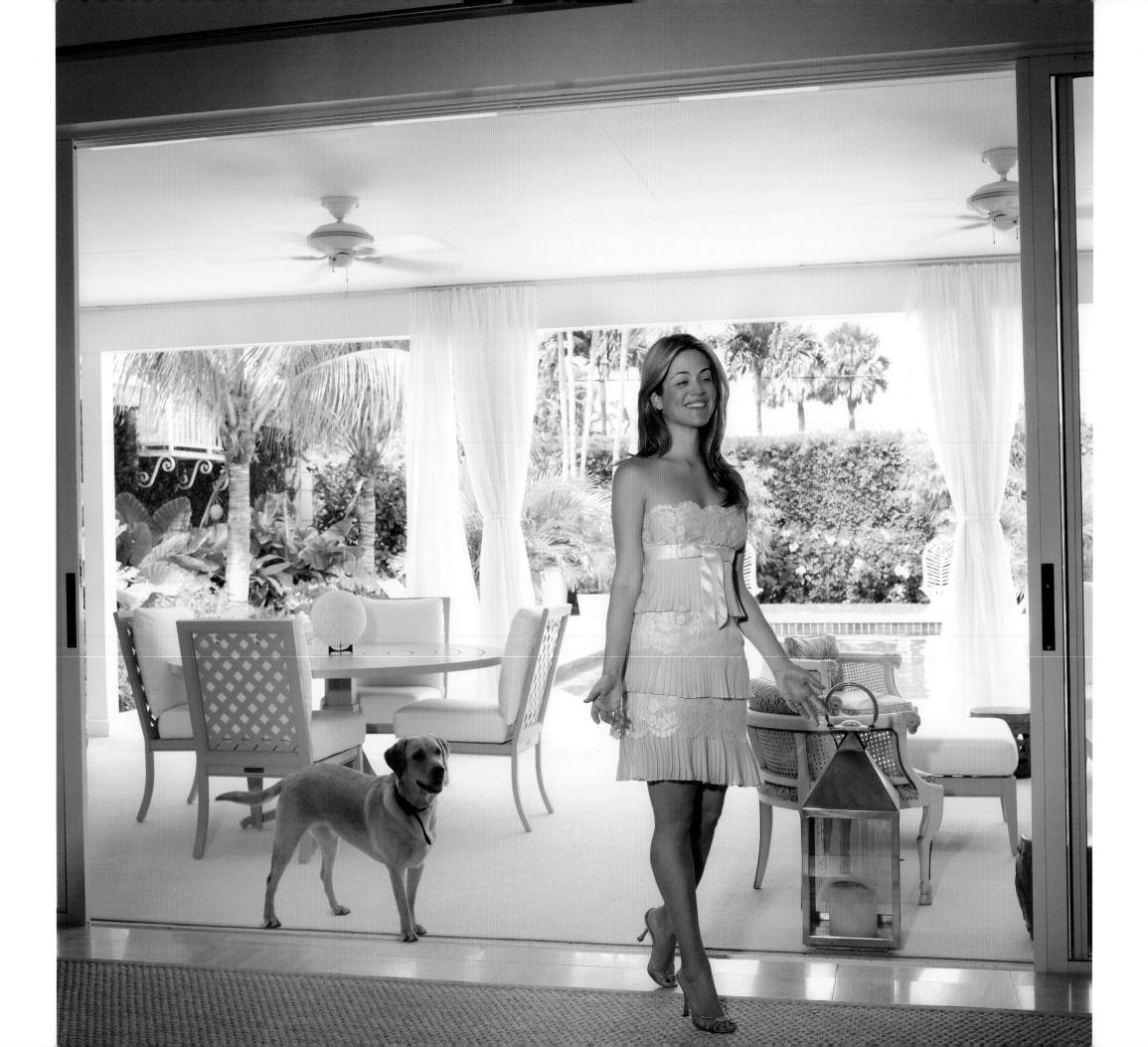

lourdes fanjul

Lourdes was born and raised in Coral Gables to Cuban-American parents. She studied elementary education and psychology at the University of Miami and has taught at Sunset Elementary in Miami and at the Nightingale Bamford School in New York. An active parent and educator, Lourdes also serves on the boards of the Palm Beach Day Academy and The Playground Theater, and works with local charities, including St. Jude's Children's Research Hospital. She is married to Pepe Fanjul Jr.

Photographed in Palm Beach

My parents taught me strong Christian values. I learned to always help others and give back, to not judge people and to always see the good in everyone. I also learned the importance of family and always bringing family together.

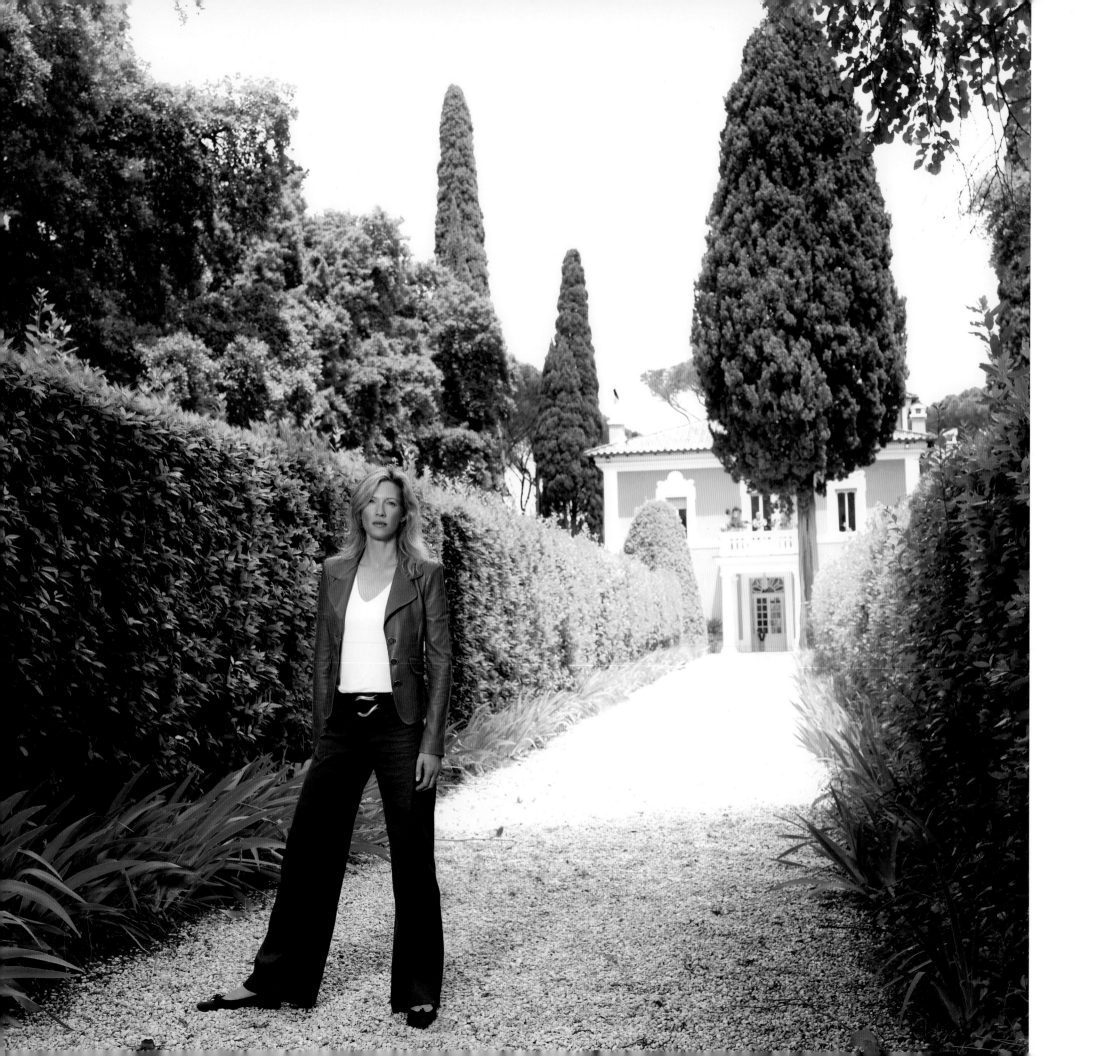

mafalda von hessen

Born in Kiel, Germany, as the first of four children, Mafalda studied in London and then moved to
New York to earn a masters degree in fine arts from New York University. She then transferred to
Rome to pursue a career as a painter. She is partnered with Ferdinando Brachetti-Peretti and has four
children.

Photographed in Rome

*My parents taught me that it's better to see the world with positive eyes
and not to see things negatively right away. They also taught me
patience and discipline.*

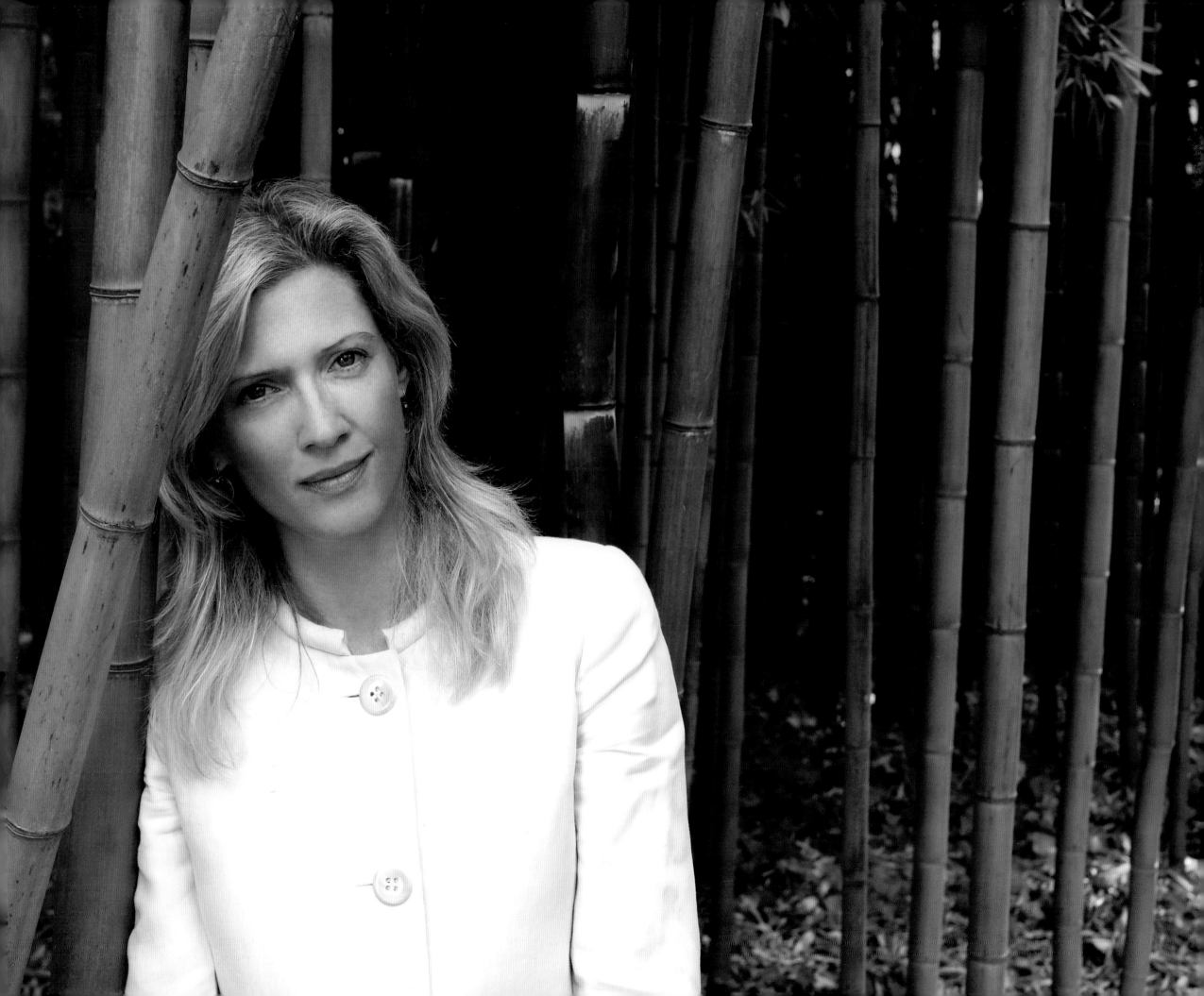

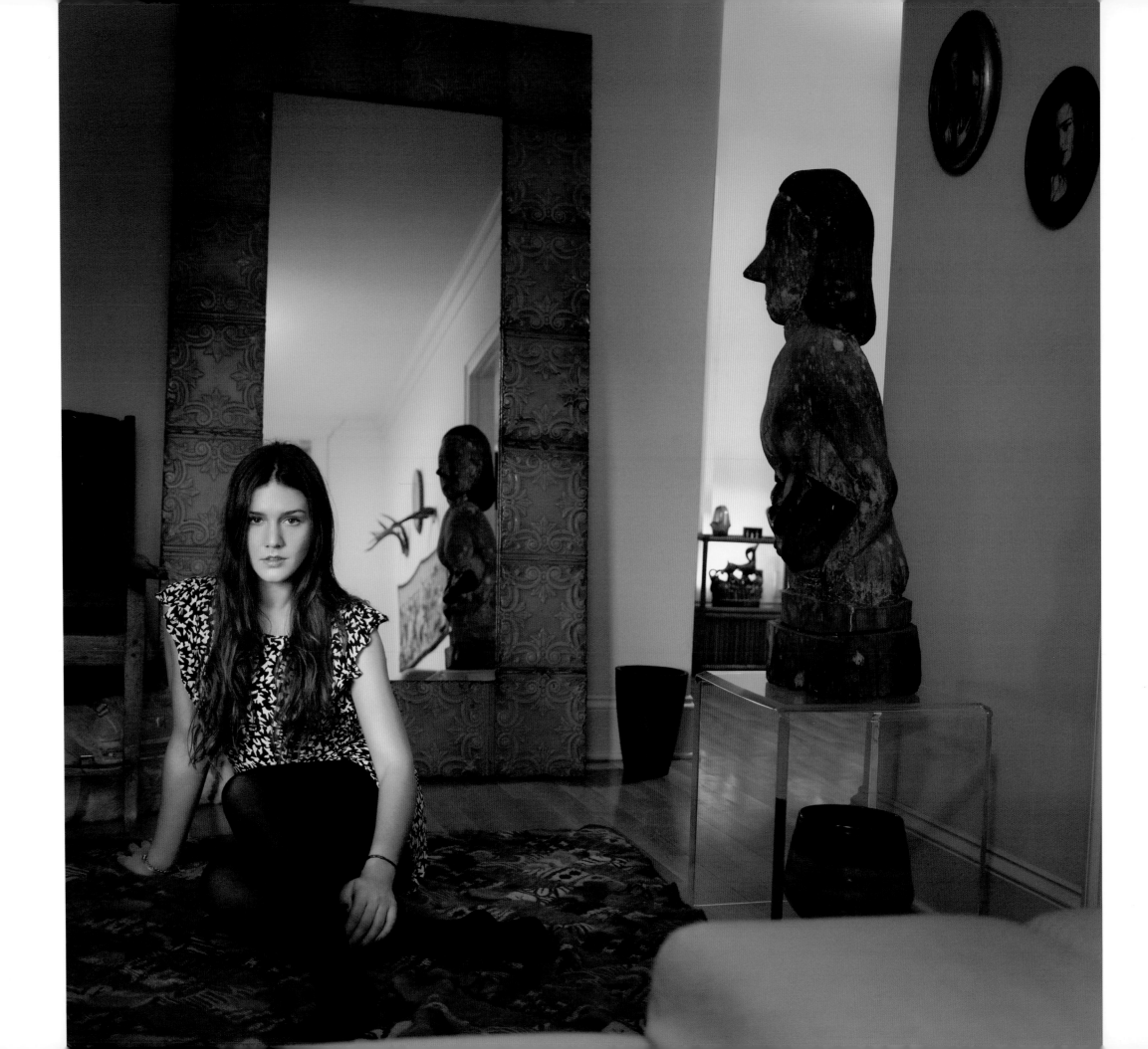

margherita maccapani missoni

Though she bears the name of a well-known Italian fashion house, Margherita isn't just a gown-modeling ambassador who appears as the face of the company fragrance. Instead, she's a perpetual student, cultivating many varied interests: studying philosophy at the University of Milan, Spanish courses at the University of Barcelona and taking seminars in philosophy at Columbia University. She has also studied acting at the Lee Strasberg Institute in New York with the desire to start a stage career.

Photographed in New York

What did I learn from my parents? LOVE.

margot poniatowski

Margot was born in Toulouse to Prince and Princess Axel Poniatowski and raised in Virginia and Saudi Arabia. Her father is a member of French Parliament and her grandfather Michel Poniatowski had a long political career alongside President Valery Giscard d'Estaing. Her mother Anne, a former financial journalist, runs the family's vineyard in Provence. Margot studied architecture and design in Paris and now lives in New York and works as a designer and interior architect for Robert Couturier.

Photographed in New York

My parents taught me to be independent, to assume my choices and to be myself. I had the chance to live in foreign countries when I was young, which gave me the opportunity to meet people from different backgrounds, and which gave me a different look on life. I think my parents are open-minded giving me this same vision of others. My father has always pushed us to practice sports, to develop qualities such as strong will, physical effort, and discipline.

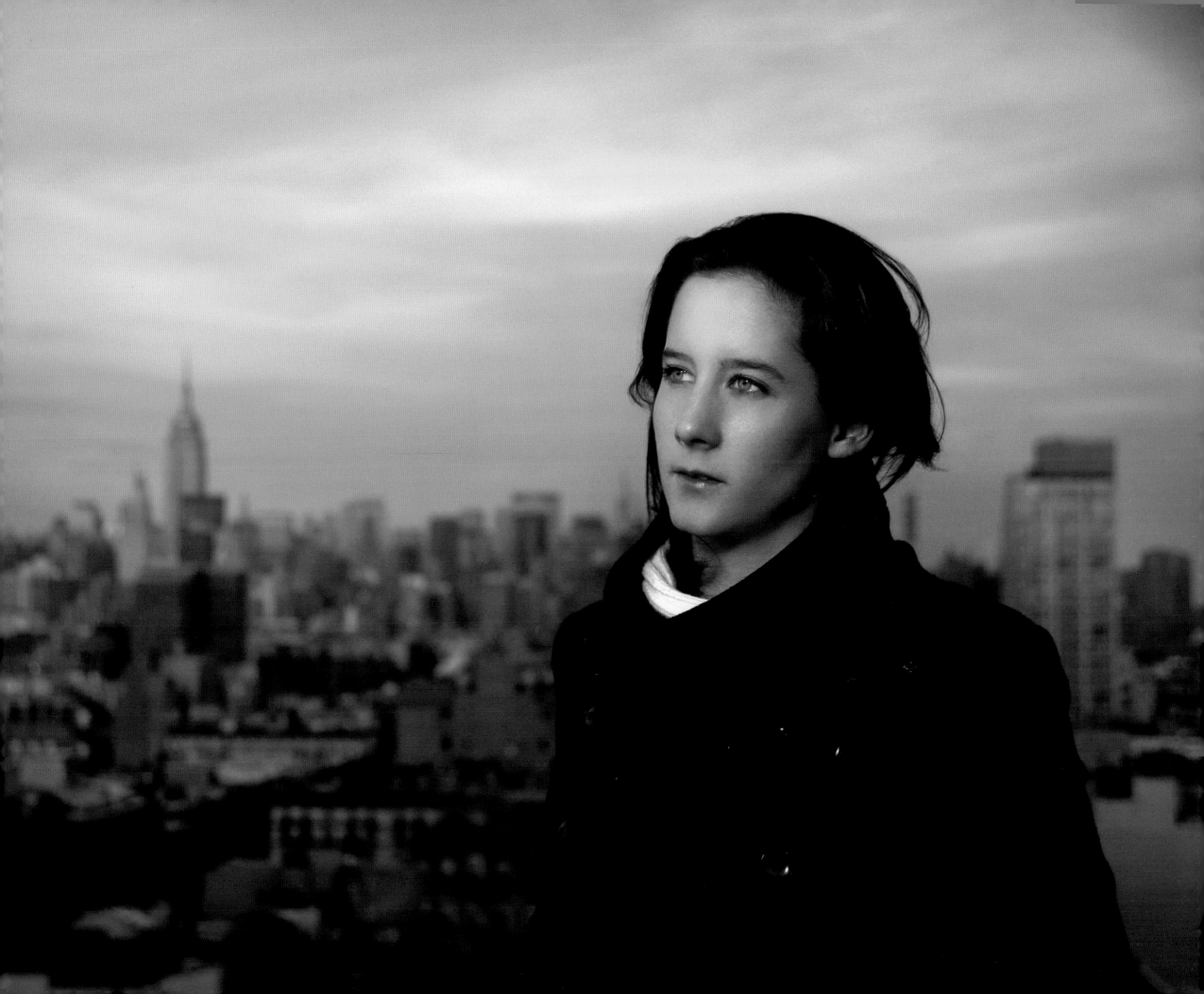

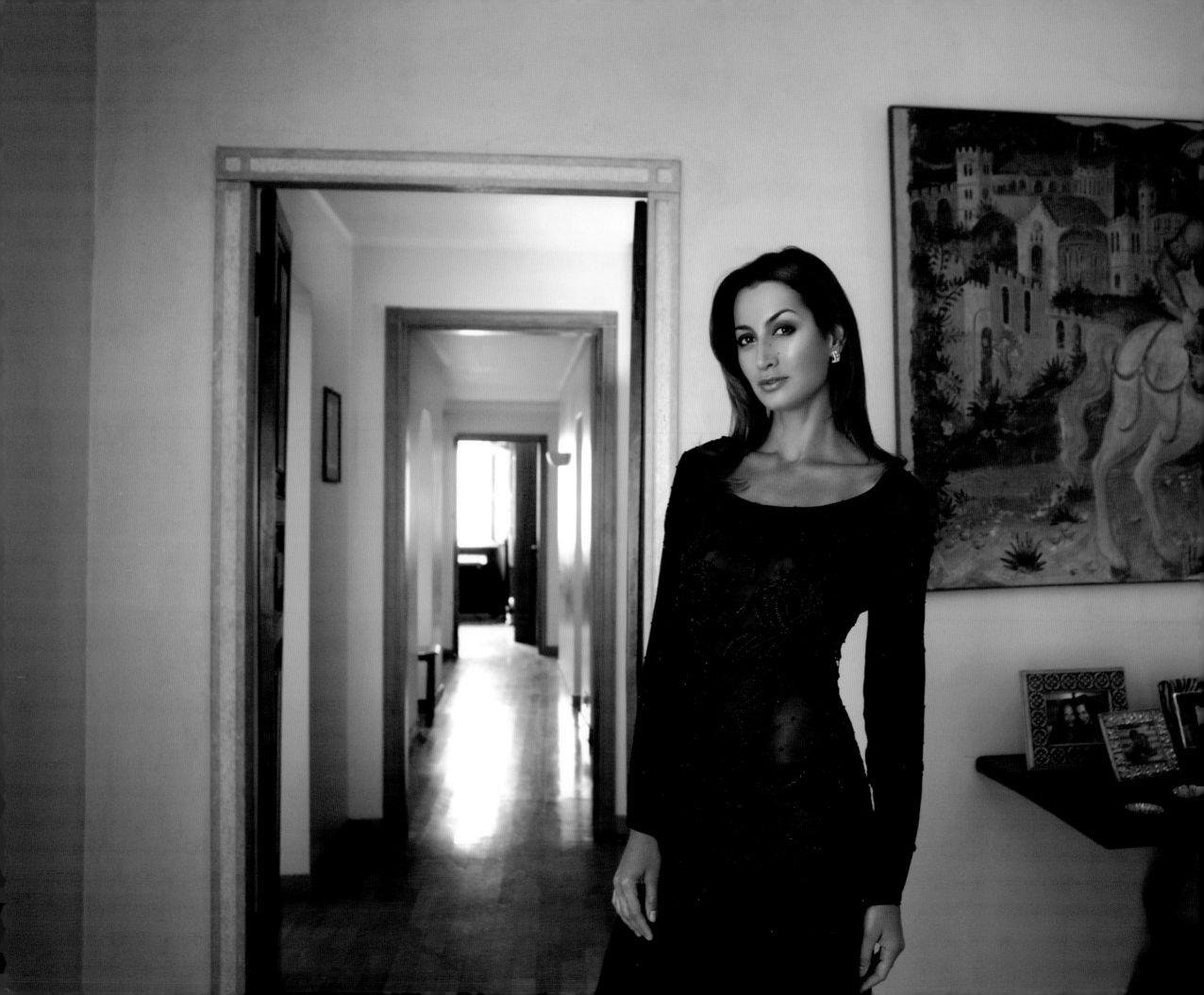

maria buccelatti

Born in New York and raised in Miami by a Spanish father and Cuban mother, Maria studied business at the University of Miami for one year before transferring to the Miami International University of Art and Design. Under the mentorship of Charlene Parsons, Maria studied design, business and marketing, but then delayed a design career for a stint in modeling. She was seen for eight years as the face of Dolce & Gabbana and appeared in *Vogue* and *Harper's Bazaar*. Inspired by her travels as a model, in 2001, Maria began designing a line of gem-encrusted swimwear and eventually expanded it to beachwear and knits under the MB BeachCouture and MB IceCouture labels. She is married to jewelry heir Andrea Buccellati. They have two children and live in Milan.

Photographed in Miami

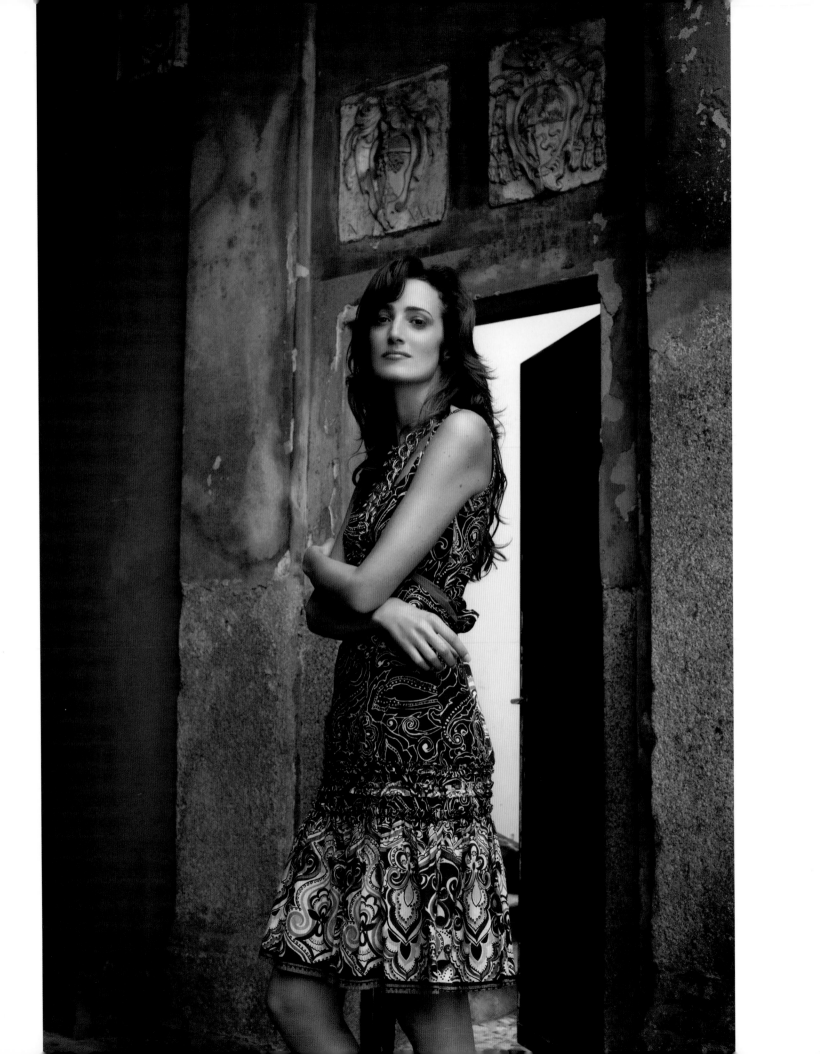

mariasole brivio sforza

Mariasole was born and raised in Milan, where her family has a long history in government and politics. She has studied law and psychology at the Università degli Studi and eventually plans to pursue a career in public service. Aside from her political life, she has worked as a model, owns The NewArs Italica art gallery and writes regularly for Italian magazines under a pseudonym.

Photographed in Milan

From my father: that things are not black or white. From my mother: that money is not something to waste.

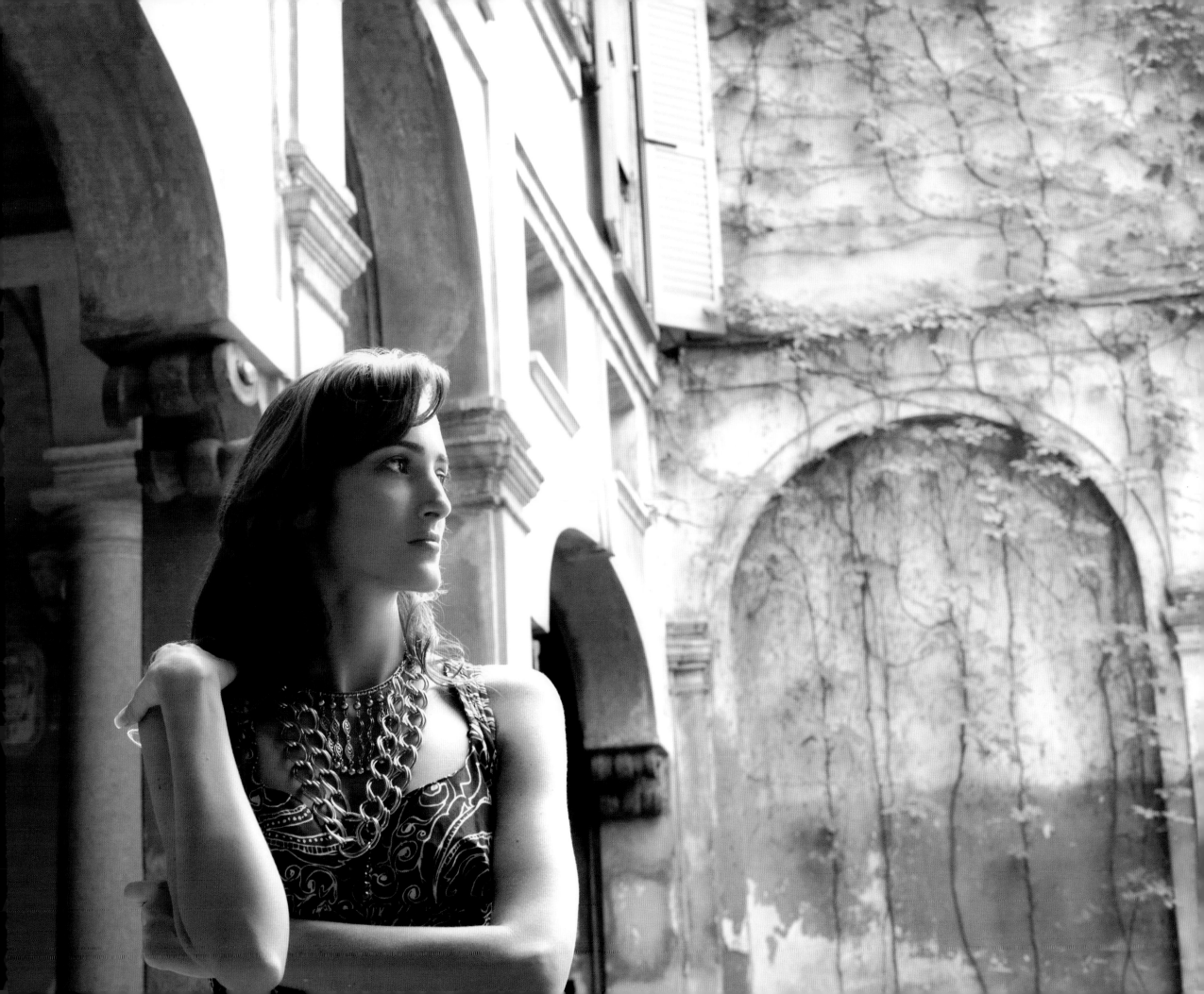

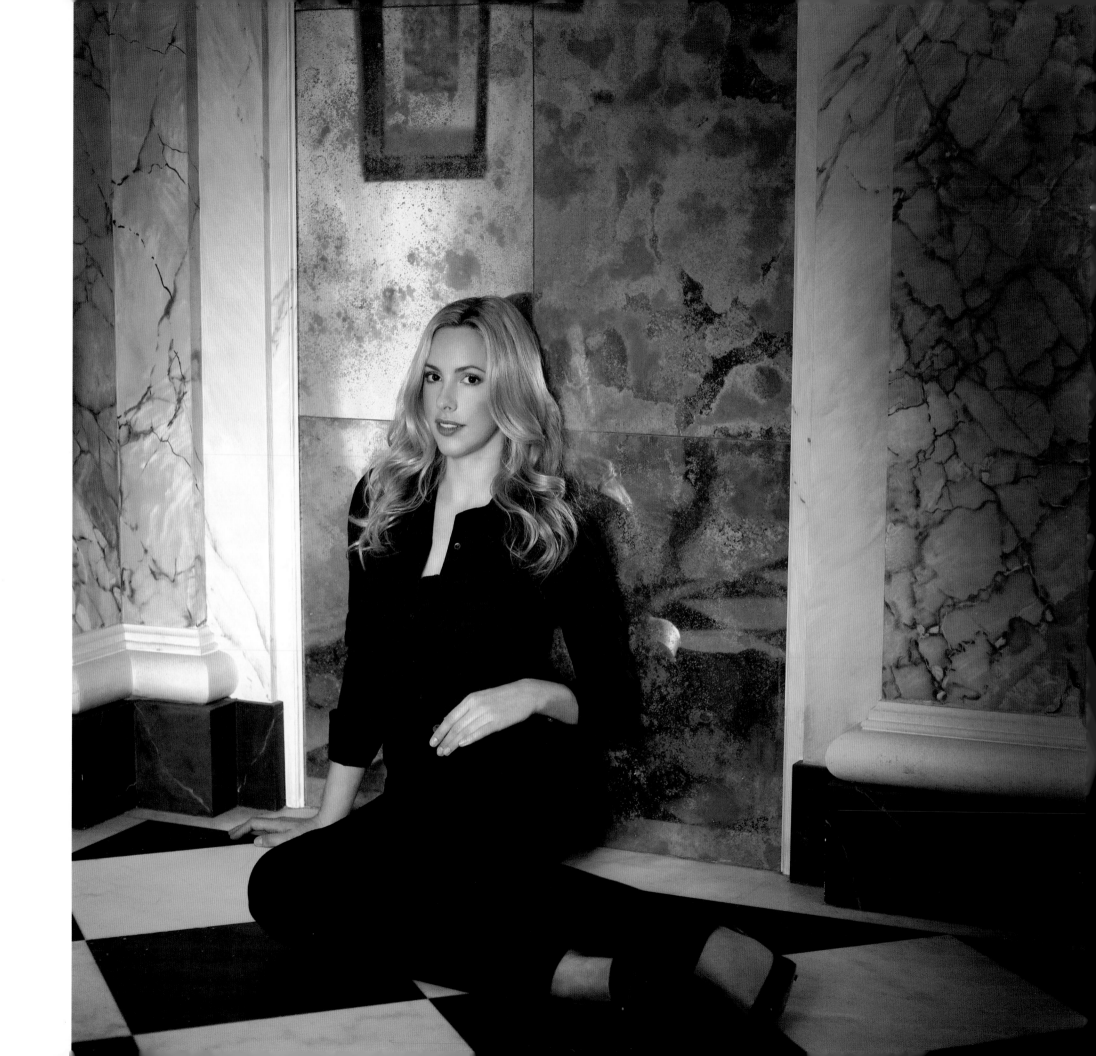

marina livanos

As the granddaughter of the late philanthropist and Greek shipping magnate Stavros G. Livanos, Marina is one of the younger members of a much storied family. Marina, one of five siblings, was raised in England and later studied literature at Georgetown University. She now divides her time between New York and London, while helping with the family business.

Photographed in New York

marisa noel brown

Marisa Noel Brown was born in Greenwich, Connecticut, to a Brazilian mother and an American father. She studied at Greenwich Academy and then Harvard University. Her first job after college was running Monica Noel, a children's clothing label started by her mother and sister and carried by Saks Fifth Avenue, Harrods, and specialty boutiques in the United States. She has worked in sales and public relations for other designers, including Allegra Hicks. She lives in New York with her husband Matt and their two children Ford and Luke.

Photographed in New York

I have learned so much from my parents; from my father — how to be a compassionate and understanding human being. He taught me how to treat others, really how to compassionately and thoughtfully relate to my friends and peers — to the people around me. My mother has taught me about generosity and selflessness, and about how one must always think of one's family and friends before oneself — that was a huge life lesson for me.

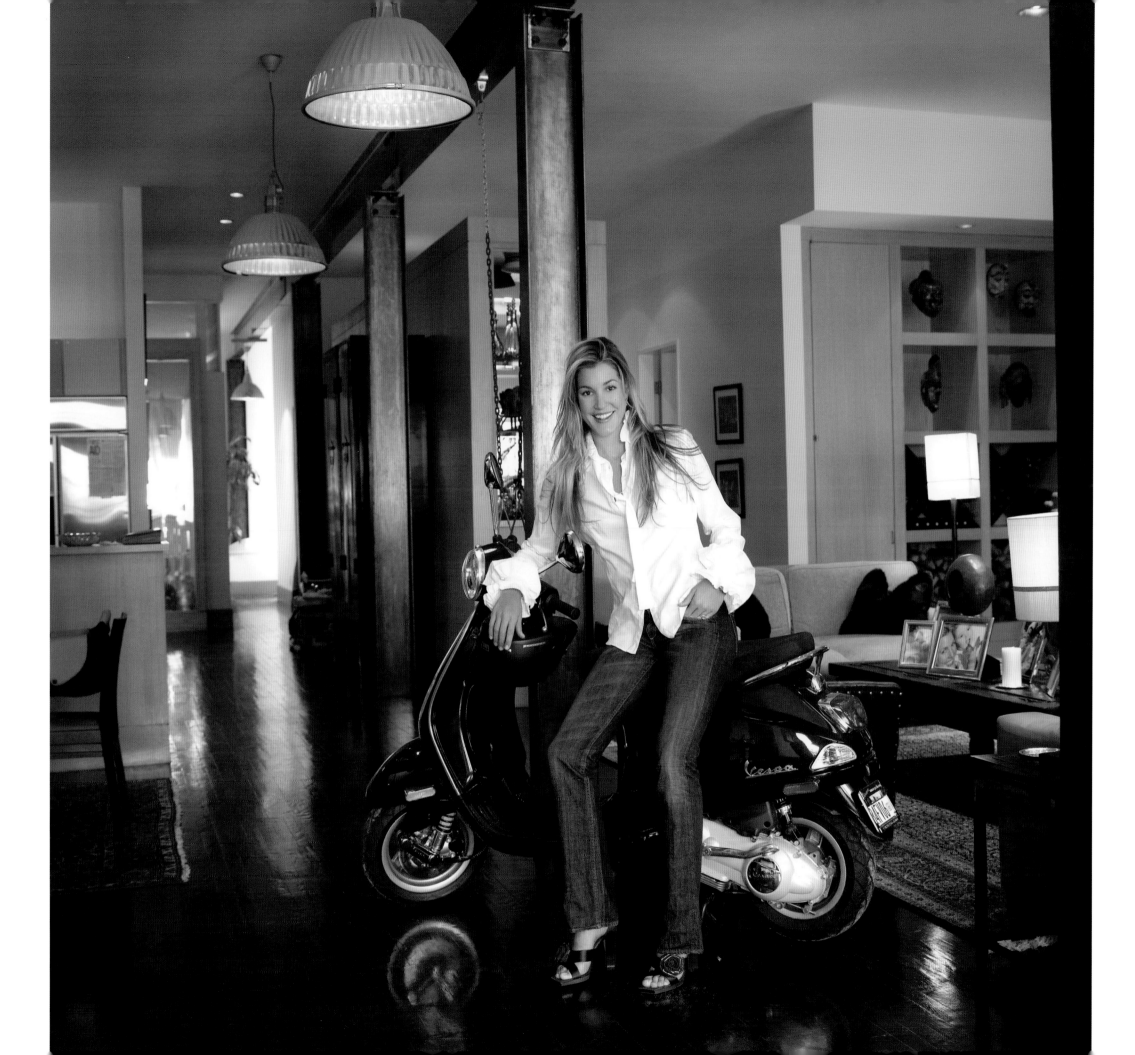

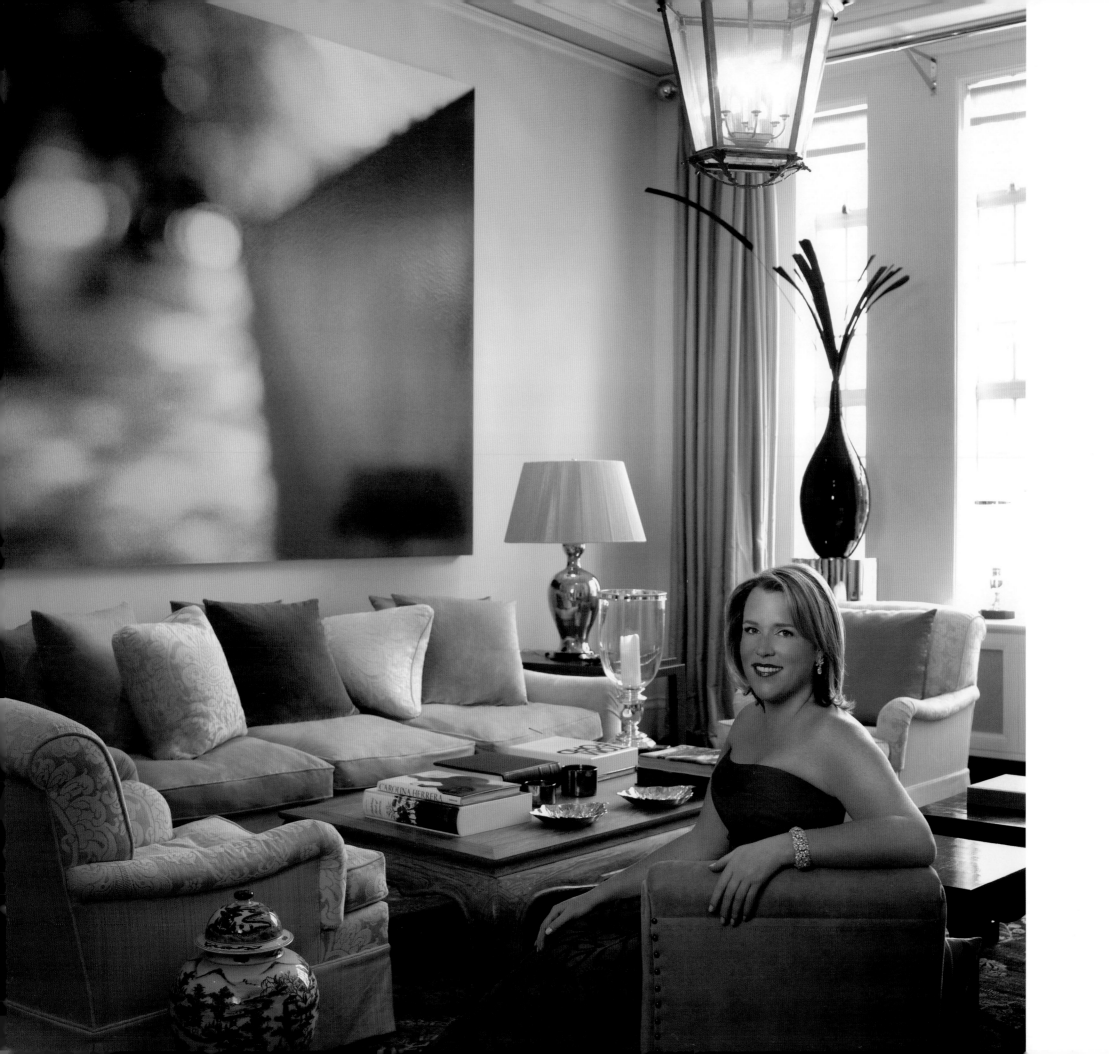

marjorie gubelmann

Marjorie grew up a jet-setter, traveling between Newport and Palm Beach and Europe. In 2004 she cofounded with friend Daniel Benedict a company named Vie Luxe, selling luxury home goods such as candles, room mists, and bath products in a variety of scents named for their favorite travel destinations: Palm Beach, Capri, Maldives, Tuileries and St. Moritz. She lives in New York with her son Cyrus.

Photographed in New York

My parents taught me to be brave and to look people in the eye when you shake hands with them and say please and thank you to everyone. More importantly, I learned that nothing comes with guarantees and not to take anything for granted — not to feel sorry for yourself, if you do not like something you cannot expect someone else to fix it. You have to do it yourself. There will always be someone who has more than you. Live within your means.

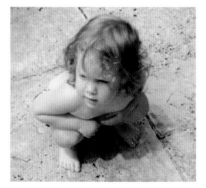

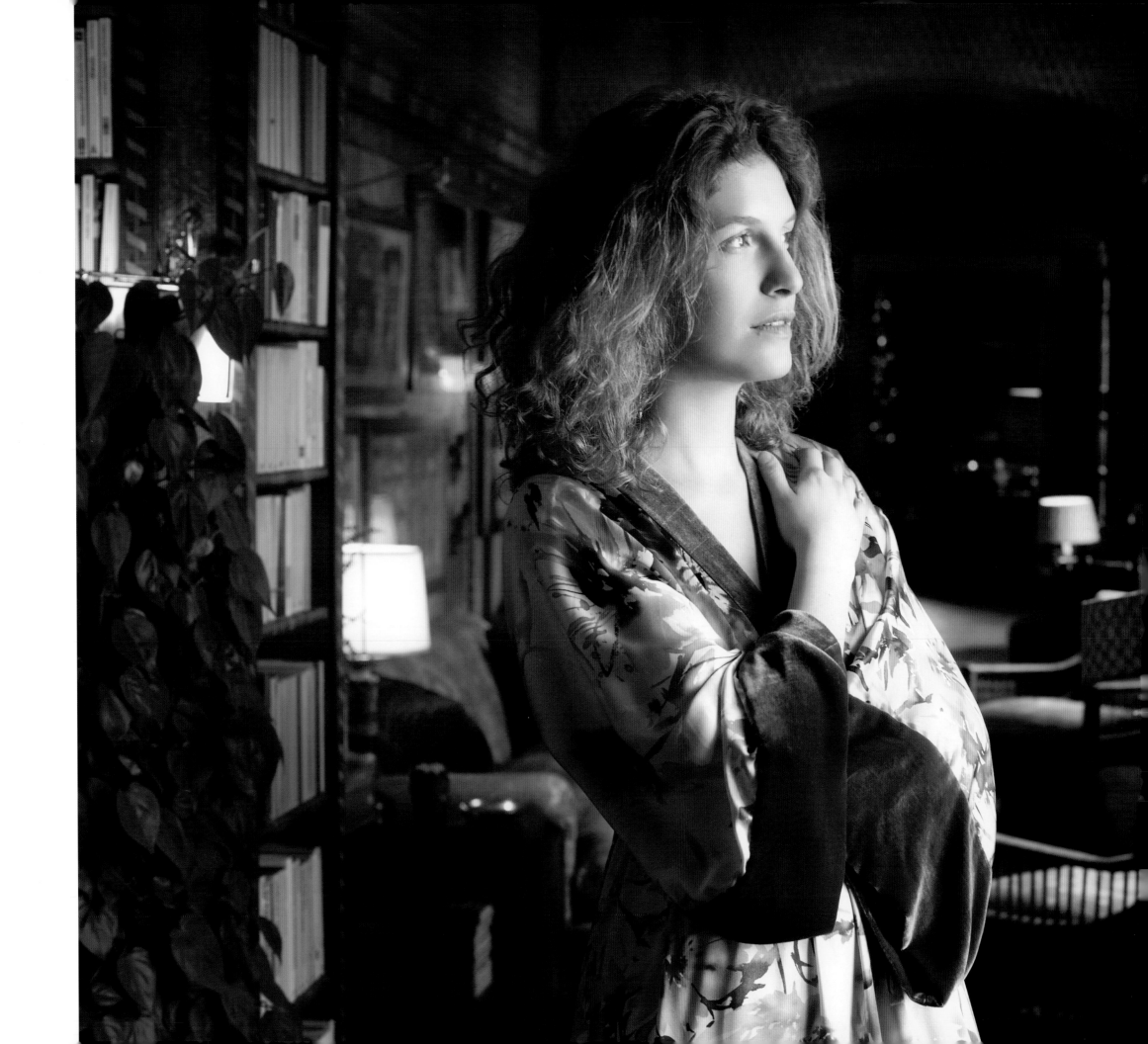

martina mondadori

Martina Mondadori was born in Milan into an Italian publishing family. She attended English schools and then studied philosophy at University of Milan and at La Sorbonne in Paris. Following school, she worked for Doubleday Books in New York and then returned to Milan to focus her attention on art book publishing. She sits on the board of Arnoldo Mondadori Editore, the family's publishing house, and is a cofounder of the communications company Memoria. She is married to banker Peter Sartogo and divides her time between Milan and London.

Photographed in Milan

mathilde agostinelli

The niece of designer Gilles Dufour is the head of communications for Prada and Miu Miu in Paris, where she attended at the Institut de L'Assomption de Lubeck. Her sisters are Pauline Hénin and Victoire de Castellane, a jewelry designer for Dior. In 2006, Mathilde and Victoire appeared as extras in Sophia Coppola's film *Marie Antoinette*. She is married to the Italian-American financier Robeto Agostinelli, and they have two children, Heloise and Carlo.

Photographed in Paris

My parents gave me so much love and attention. They built my équilibre, *and also taught me how to feel as at ease with the doorman as with the Queen!*

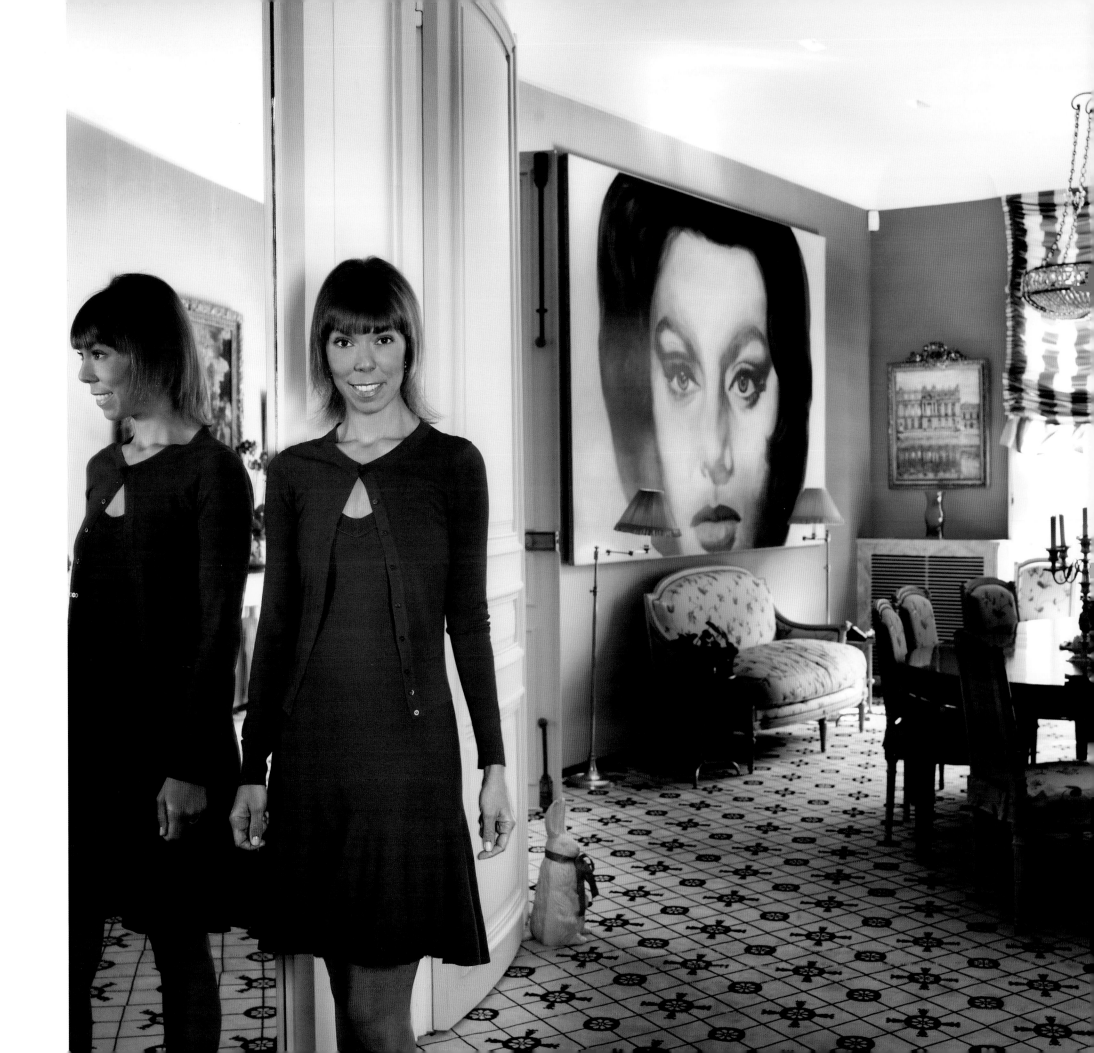

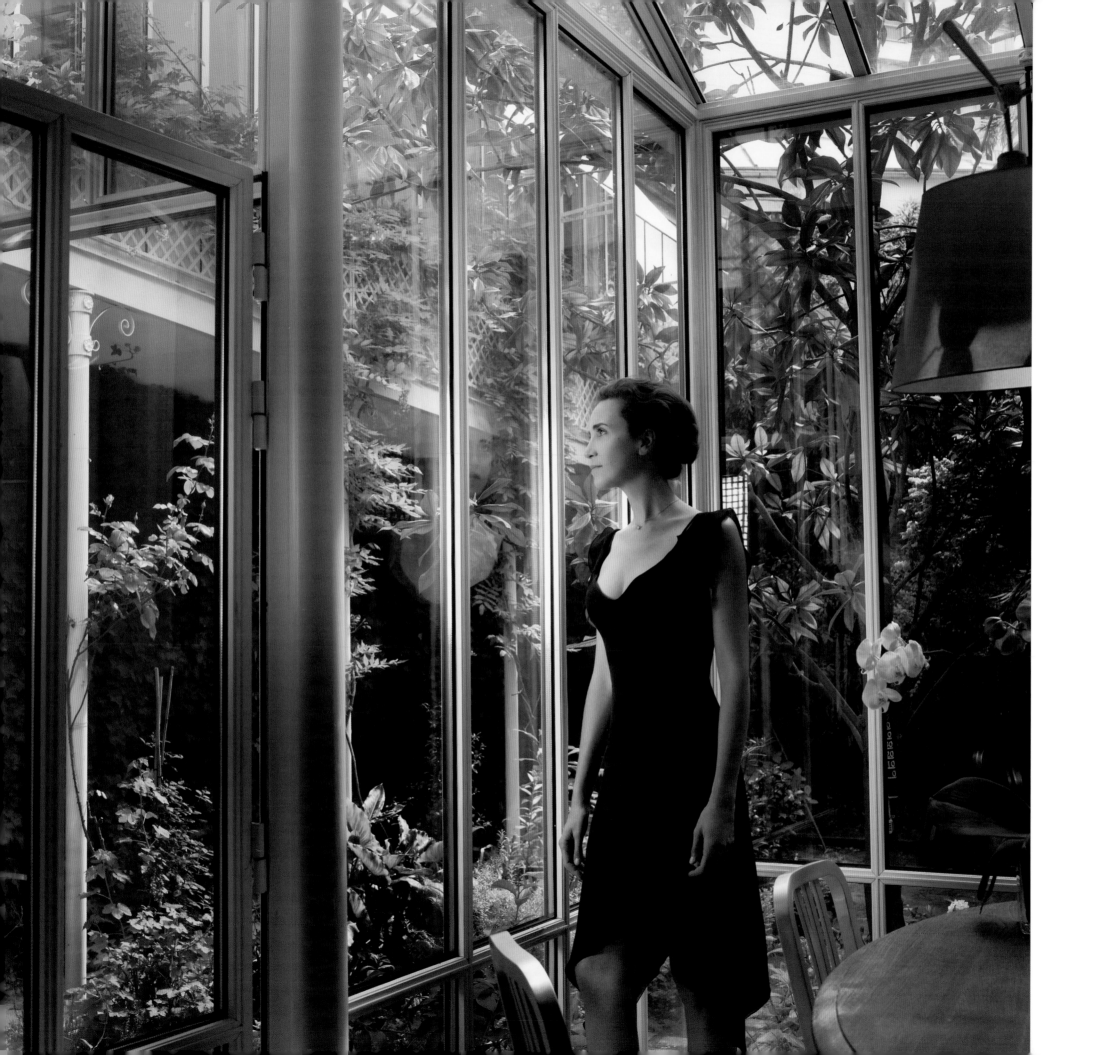

mathilde cathiard thomas

Mathilde studied marketing at the Ecole Supérieure de Commerce de Nice. In 1994, she and her husband Bertrand Thomas began a quiet revolution in beauty care called vinotherapy when they created Caudalie, a line of cosmetics that uses wine as a main ingredient. Sources de Caudalie, a Vinothérapie® spa , opened five years later in Bordeaux, with treatments such as crushed cabernet scrubs, merlot wraps and pulp friction massages on the menu. Now they have three patents on grape extracts and six spas around the world.

Photographed in Paris

My parents taught me good values: they taught me honesty, how to work hard, to be modest and simple, and to be open-minded. They taught me to respect and to love Mother Nature. They taught me the love of doing sports on a regular basis, and to compete — I was on the Alpe d'Huezski team for six years. They also taught me generosity.

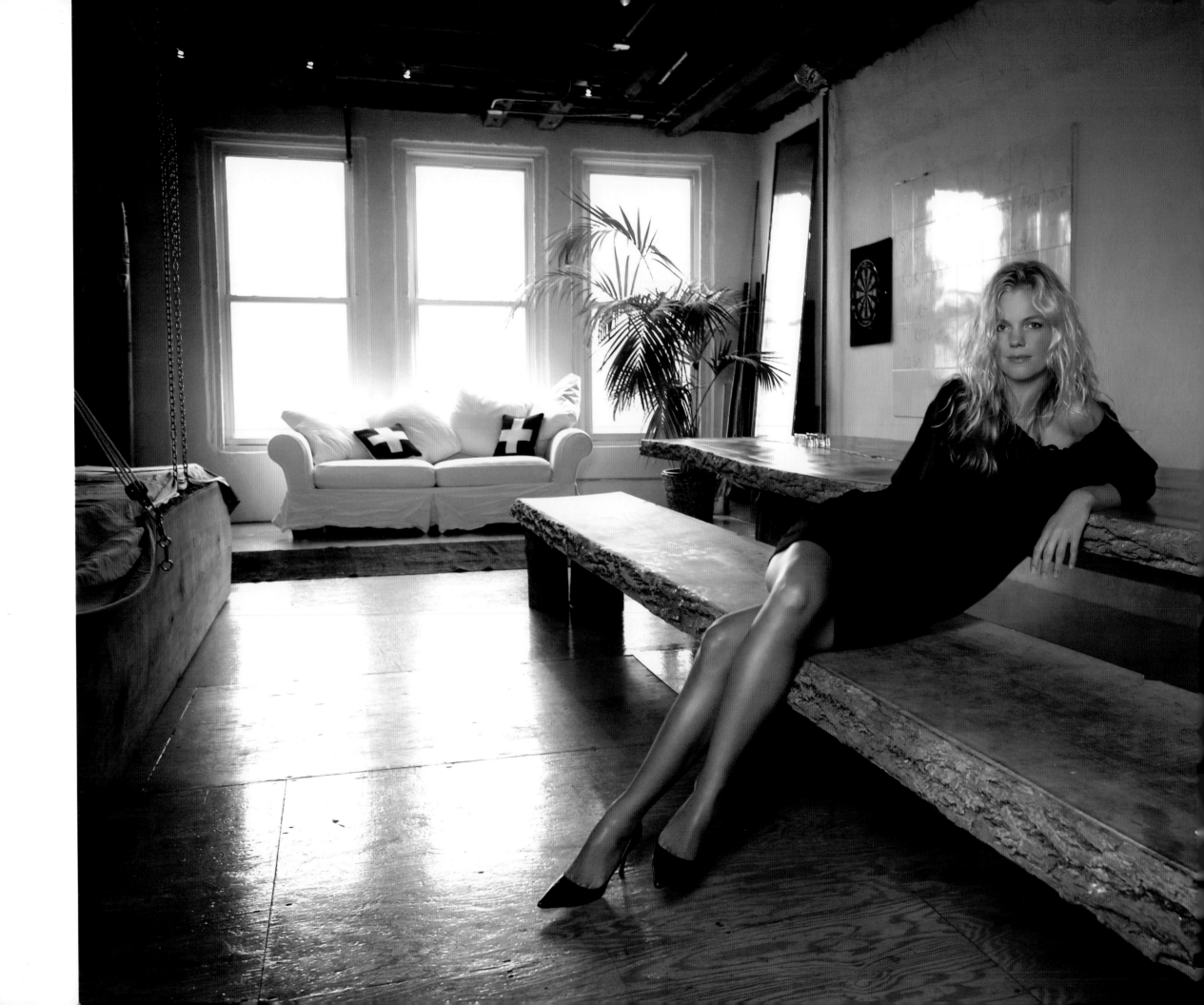

michaela *rickmers* cordes

Michaela Rickmers Cordes was born in Hamburg, Germany. Her mother Annette Siercke was the daughter of famed opera singer Hildegard Zeigner and stage designer Alfred Siercke. Her father Michael was born into the Cordes family, which founded the medical skin care company Ichthyol more than 110 years ago. Michaela decided to become a journalist and studied at Axel Springer in Hamburg. For her first big assignment, she was sent to Los Angeles to report on the film industry, which lead to a job at Gruner & Jahr as a correspondent. In 1998, she married Erck Rickmers, a German shipping heir, and returned to Hamburg, where she lives with their two daughters Athina and Georgina. She is the editor-in-chief of *GG — Global Guide to Lifestyle*, *People, and Real Estate*, which is published in 23 countries and four languages.

Photographed in New York

Having been raised in a multicultural family with two adopted siblings — my brother was half-African and my sister is from India — I learned from an very early age how very difficult it was, and still is, for many people to overcome their prejudice. By simply loving two children and raising them as their very own, my parents taught me the most important virtues in life: To always respect and admire all human beings and cultures equally.

marian mortimer

"Minnie" Mortimer is the daughter of John Jay Mortimer and Senga (Mucci)
Davis Mortimer, an editor at *House Beautiful* magazine. Minnie also is a
descendant of two American luminaries: Henry Morgan Tilford, the president of
Standard Oil at the turn of the 20th century, and John Jay, the first Chief Justice
of the United States Supreme Court. She has studied at the International Center
of Photography and is married to Oscar-winning filmmaker Stephen Gaghan.

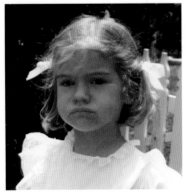

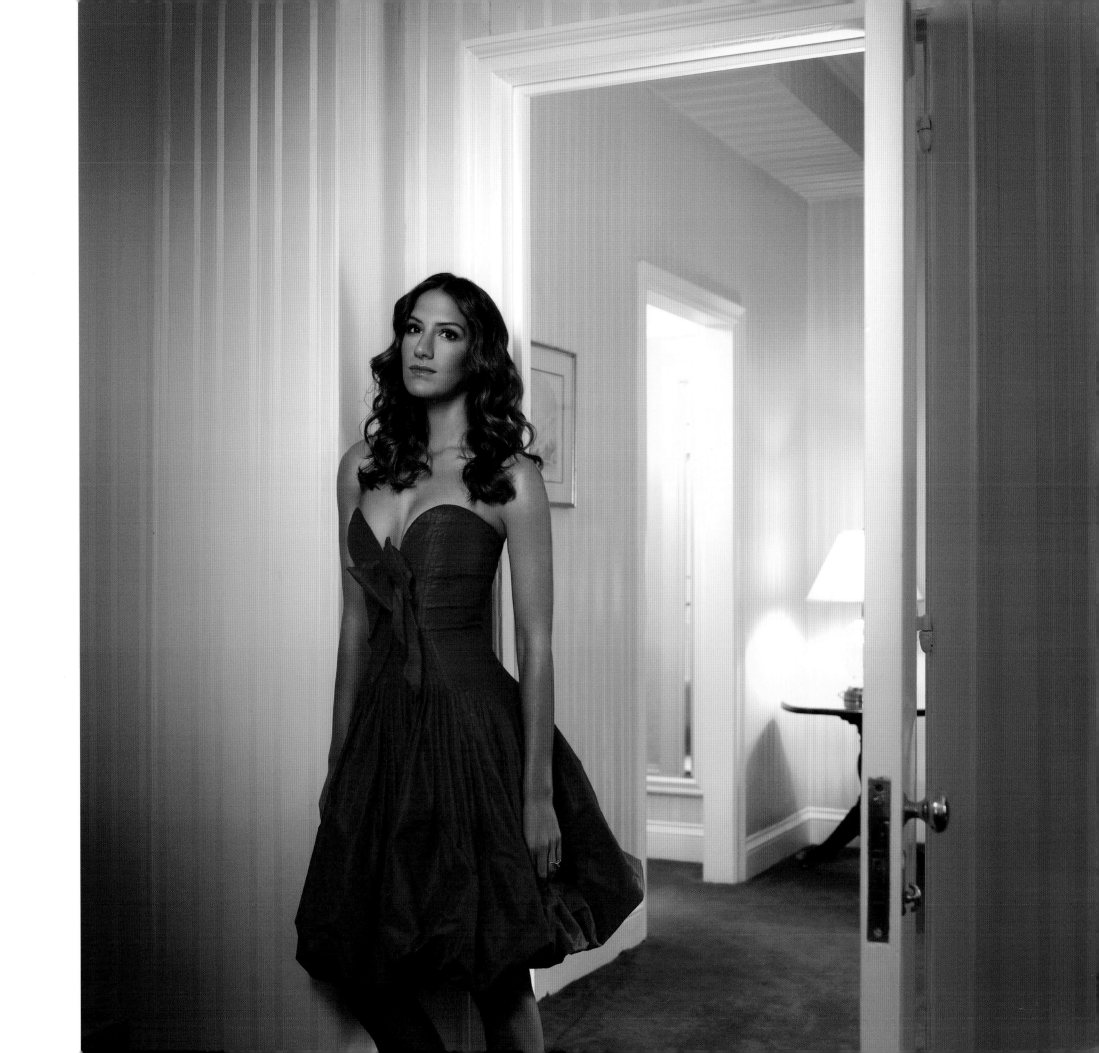

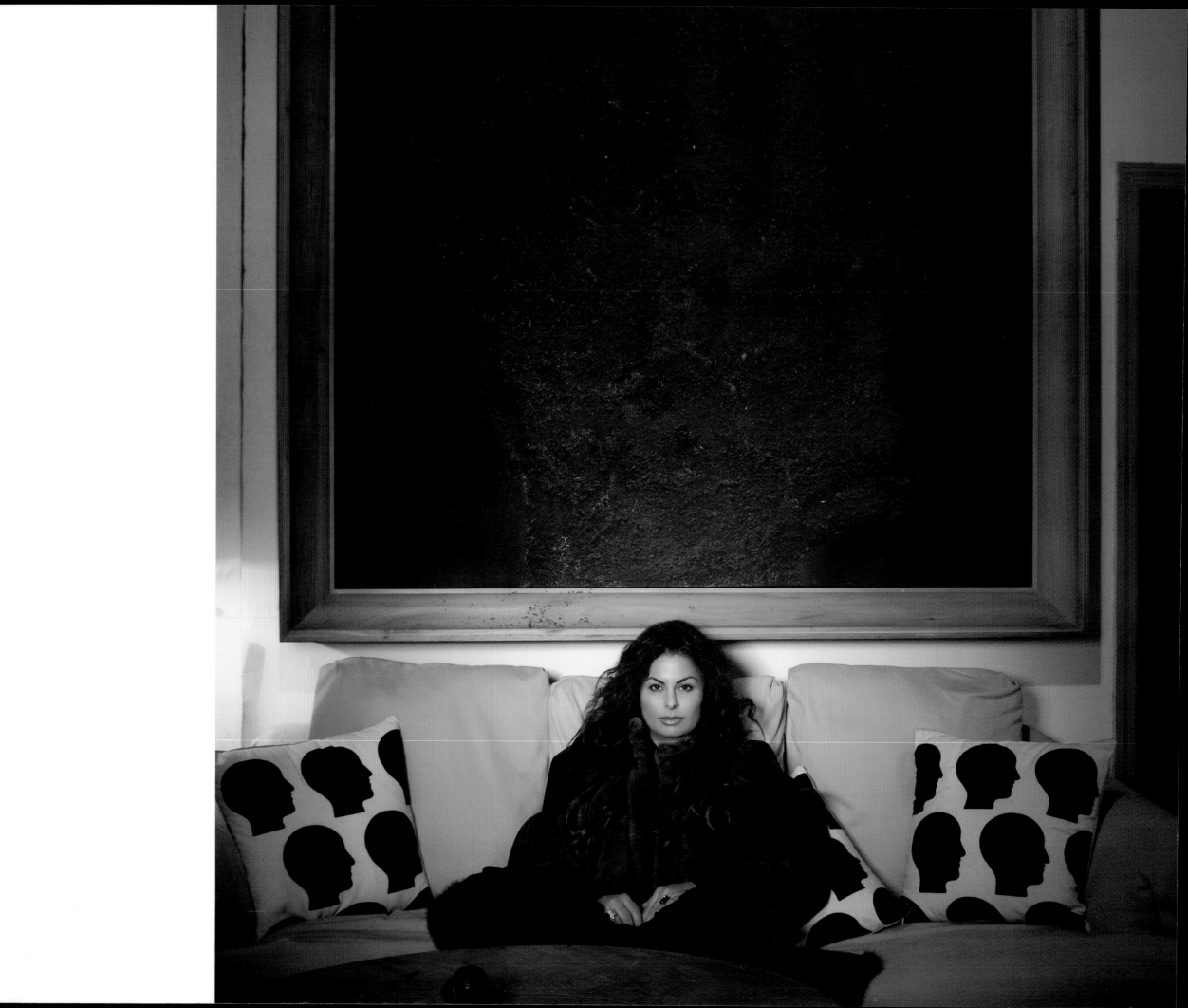

nabila khashoggi

As the eldest child of Saudi businessman Adnan Khashoggi, Nabila grew up in the Mediterranean and Europe. She began a career in the public relations department of Triad, an international trading and finance company. As vice-president of Al-Nasr Trading in the 1990s, she managed development projects for integrated agriculture complexes in the Middle East, Africa, and Asia. In addition to her corporate life, Nabila has earned raves in London and Scotland for her stage appearances in *Everything in the Garden*, *The Taming of the Shrew*, *Private Lives*, and *Waiting for Lefty*, among others.

Photographed in New York

My parents taught me: Make the most of time. Enjoy yourself. Be productive, be interested in things, places, history, tradition, people, activities. Be informed. Consider other points of view. There are many more sides of a story to regard. A good debate can be enlightening. Keep your manners in check. I express my creativity by trying as many things as possible even if I'm not particularly good at some of them. From my childhood, I most remember the Mediterranean. I have strong memories of family, happiness, good food and some rebellion.

nadja swarovski

Austrian-born Nadja received bachelor's degrees in art history and languages from Southern Methodist University in Texas and then moved to New York to work in the art and fashion industries. She then returned to Europe to begin working in the family's global crystal business. As the company's vice-president, she has become its public face and has worked to reposition it into the luxury niches of fashion, jewelry, and design.

Photographed in London

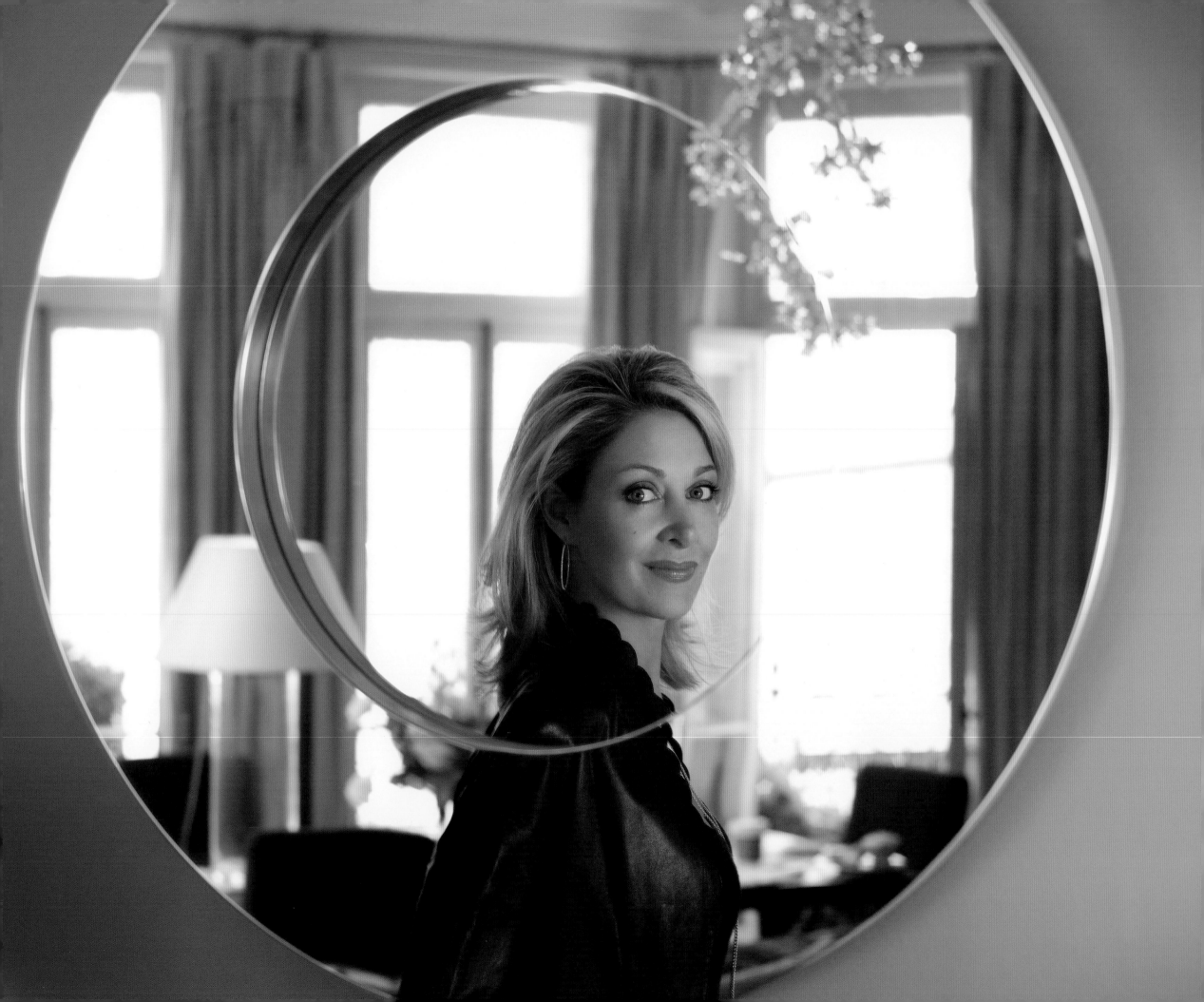

olivia chantecaille

As the daughter of legendary cosmetics veteran Sylvie Chantecaille, Olivia has a natural affinity for the business of beauty. In 1997, she and her mother, the former head of Estée Lauder-owned Prescriptives, lauched Chantecaille, a luxury brand of skin care, fragrances and cosmetics known for their use of natural botanicals, new technologies and the way they dovetail with the latest trends in fashion.

Photographed in New York

Everything I value I learned from my parents, such as family, hard work and the power of being positive.

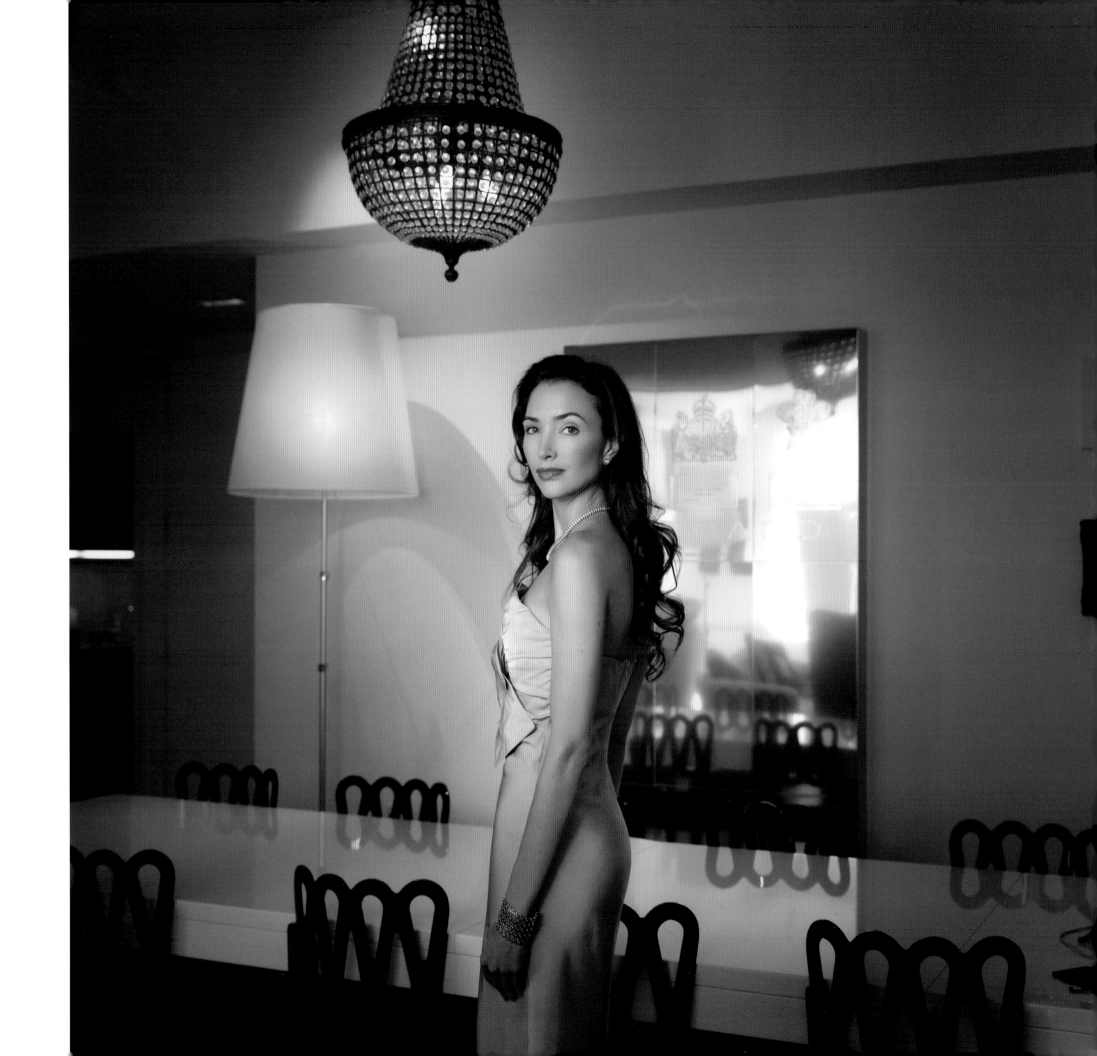

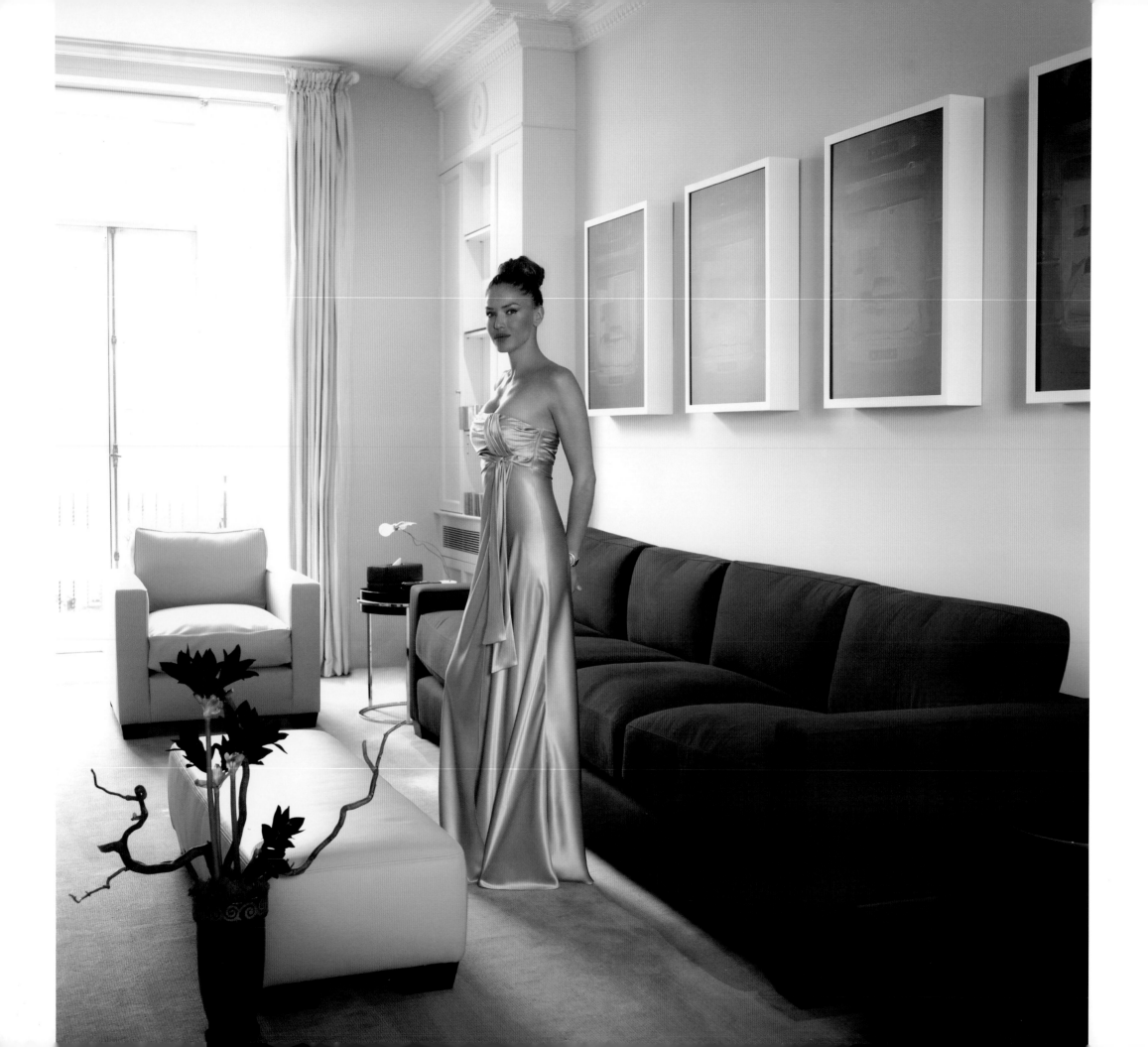

ozlem onal

Ozlem comes from a prominent Turkish family that owns Dedeman Holding Group, which includes one of the largest mining companies in Turkey and the country's largest hotel chain. She sits on the company's board of directors and is a shareholder. The family foundation is actively involved in social work and local charities. Ozlem has lived abroad, mainly in Switzerland, Italy, and New York. She holds a bachelor's degree in economics and a master's degree in hotel management. While living in New York, she worked at Andre Balasz's famous Mercer Hotel as resident manager. Since returning to Turkey, she plans to open a luxury boutique hotel in Istanbul.

Photographed in London

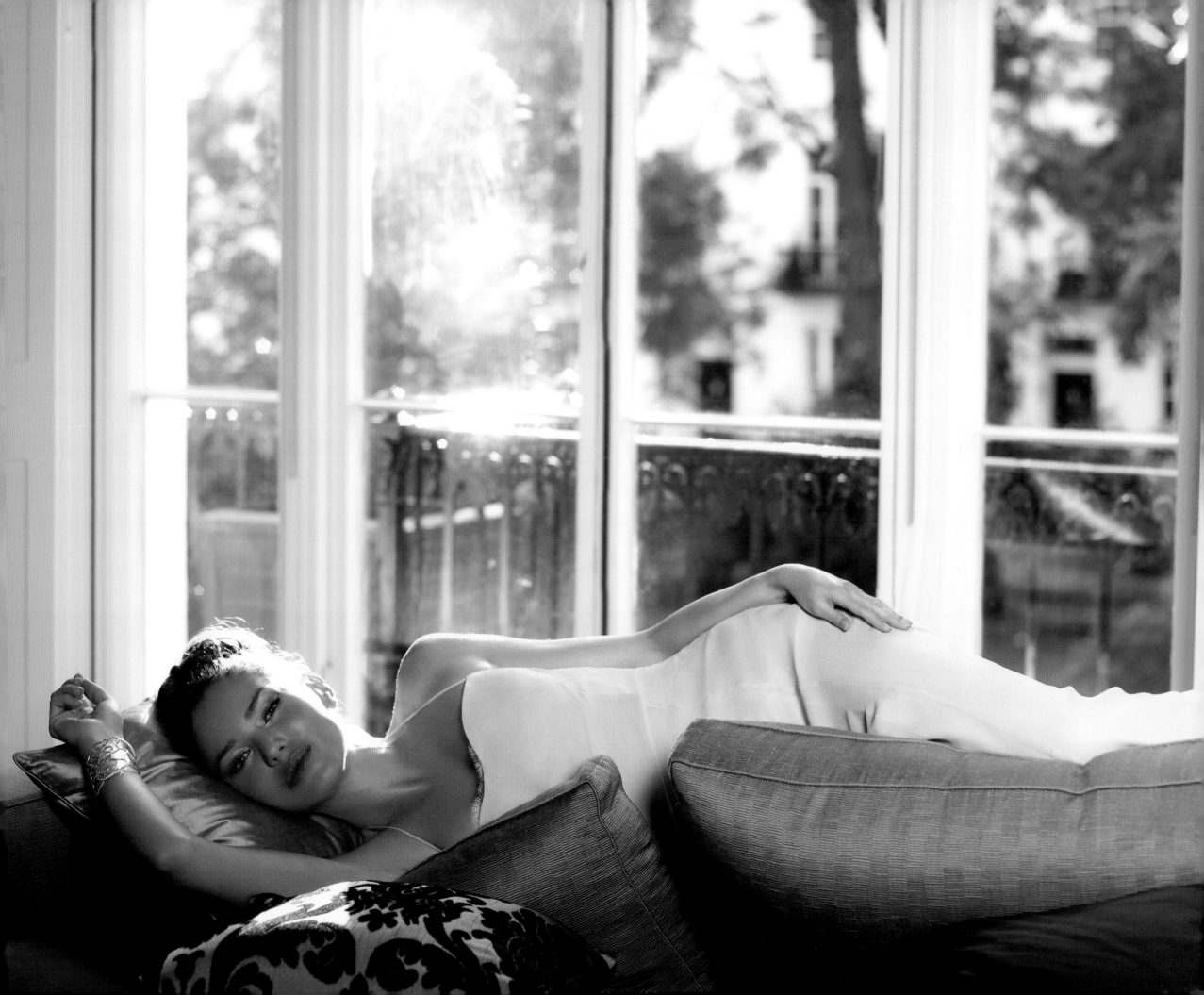

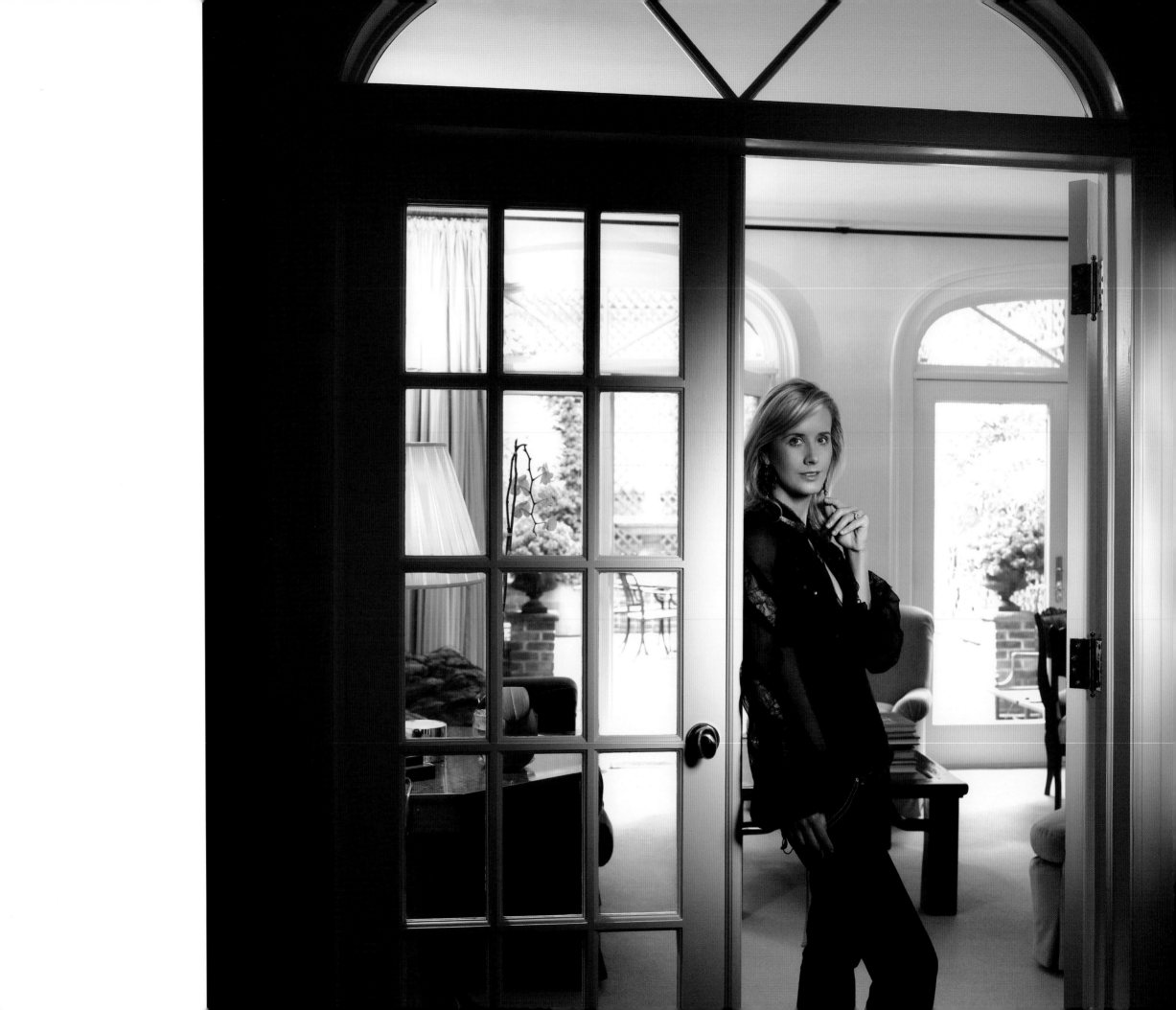

patricia cobiella

Patricia was born on Tenerife in the Canary Islands, where she attended the international school before moving to New York to study hotel management at New York University. She decided against working in the family's two businesses: Hospiten, a company that operates privately run hospitals in Spanish-speaking countries, and Dialte, a food and beverage distribution company. Instead, she and her sisters Maria and Carolina founded fashion label Pat's in 2000 and began designing jewelry and accessories. She is married to Fredrik Ulfsäter, a sports and entertainment marketing executive, and they live in New York and London.

Photographed in New York

From my parents I have learned the importance of family; to love, support, help and be there for each other. They have also taught me that you can achieve anything in life as long as you work hard.

patricia lansing

A contributor to *House & Garden* and a former fashion editor for *Vanity Fair*,
Patricia has also worked as a designer for her fashion icon mother Carolina Herrera.
She studied at Brown University and is married to Gerrity Lansing. They have two
children, Carolina and Gerrit.

Photographed in New York

I feel the most creative when I am by the water.

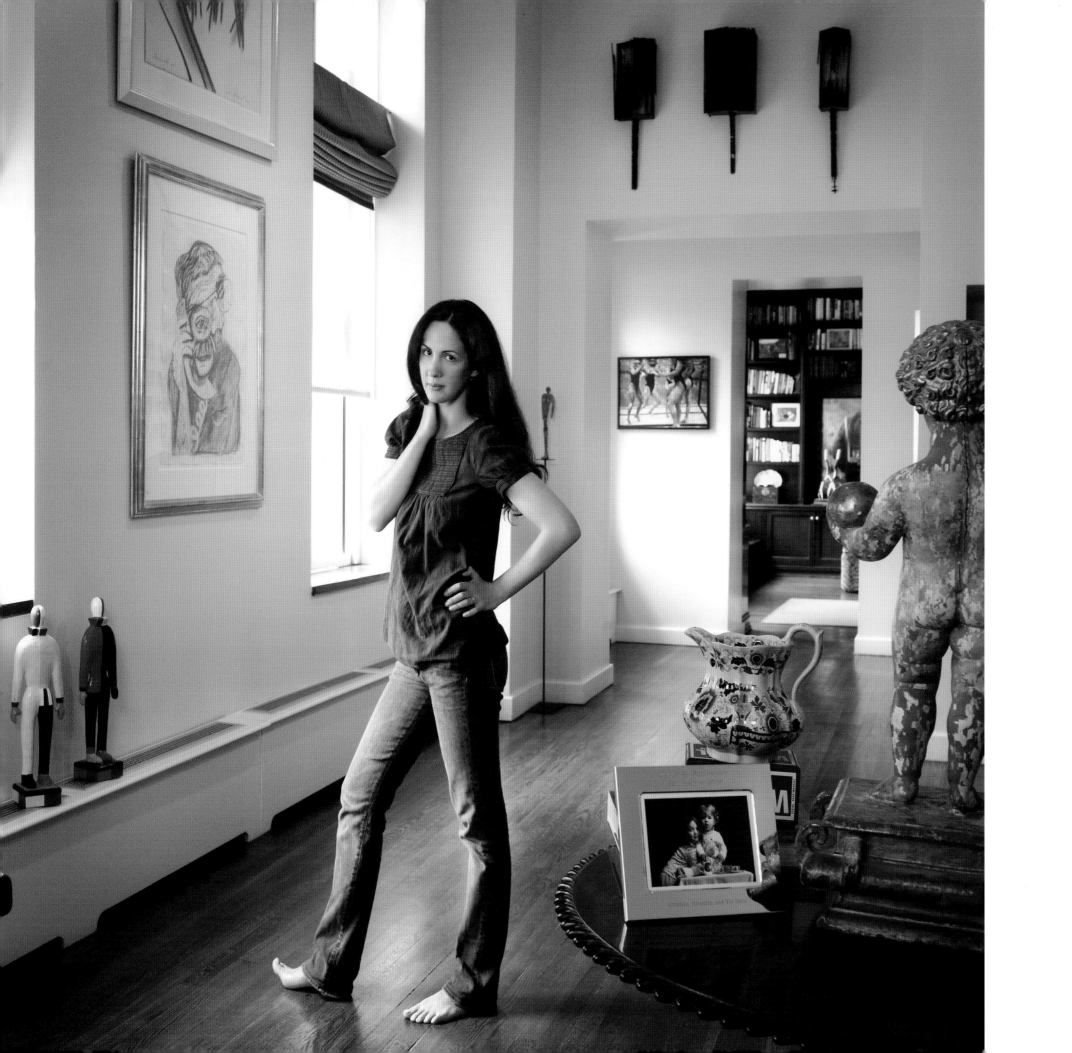

"By the time I show a dress is nothing more have already secretly I wish could wear it. on a hanger."

Isaac Mizrahi

dress I

cast the woman who

Without a woman, a

than something

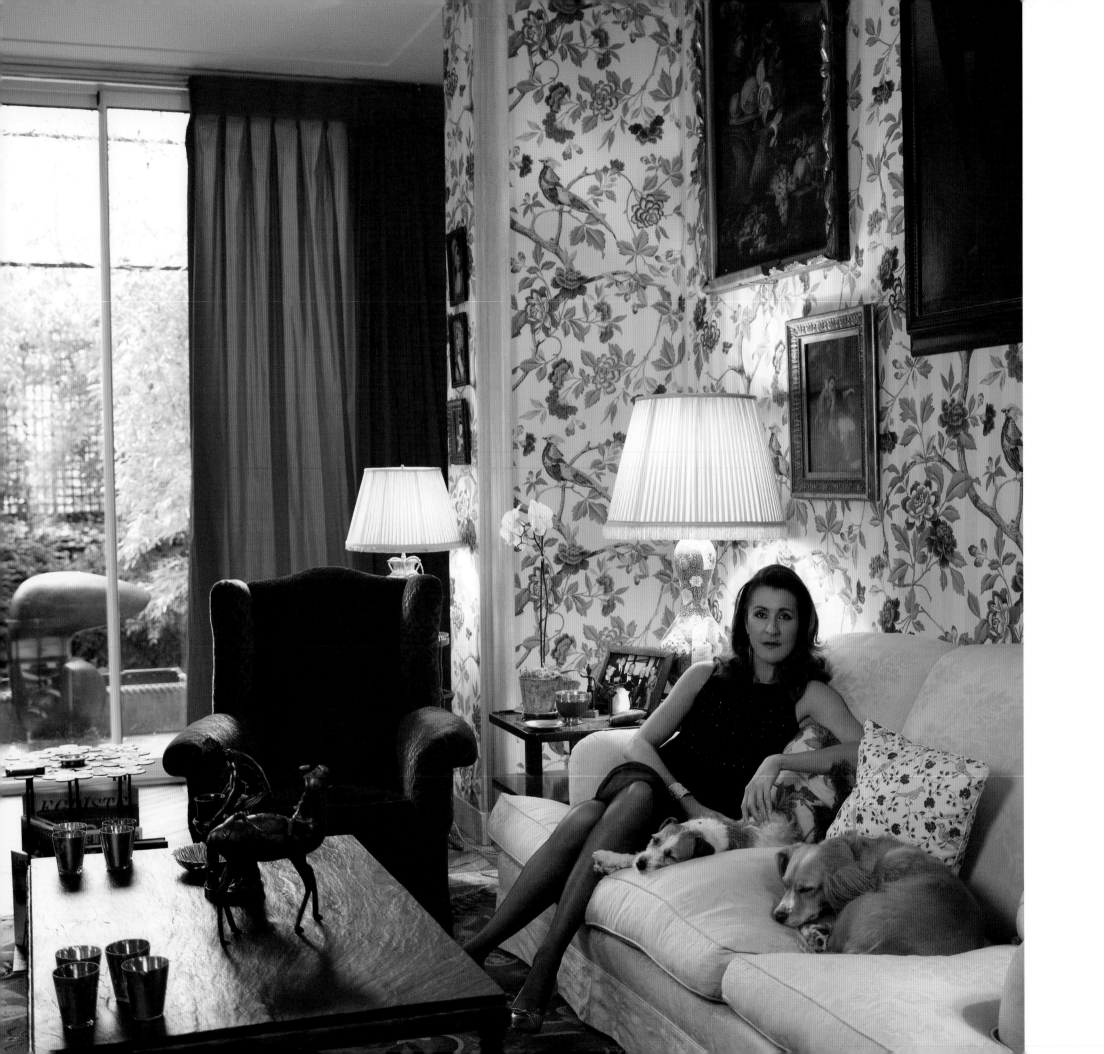

pia de brantes

Born in France and raised in New York, Pia attended the Lycée Français. She has lived in Paris since 1983 and is the head of a public relations firm, representing clients such as Gucci, Yves Saint Laurent, and Palazzo Grasszi, and is a recipient of the Chevalier de la Legion d'Honneur. She has three children with her first husband and has been married to Comte Philippe de Nicola since 2005.

Photographed in Paris

From my parents I learned elegance, discretion, happiness, family spirit, party spirit, the joys of traveling and helping others.

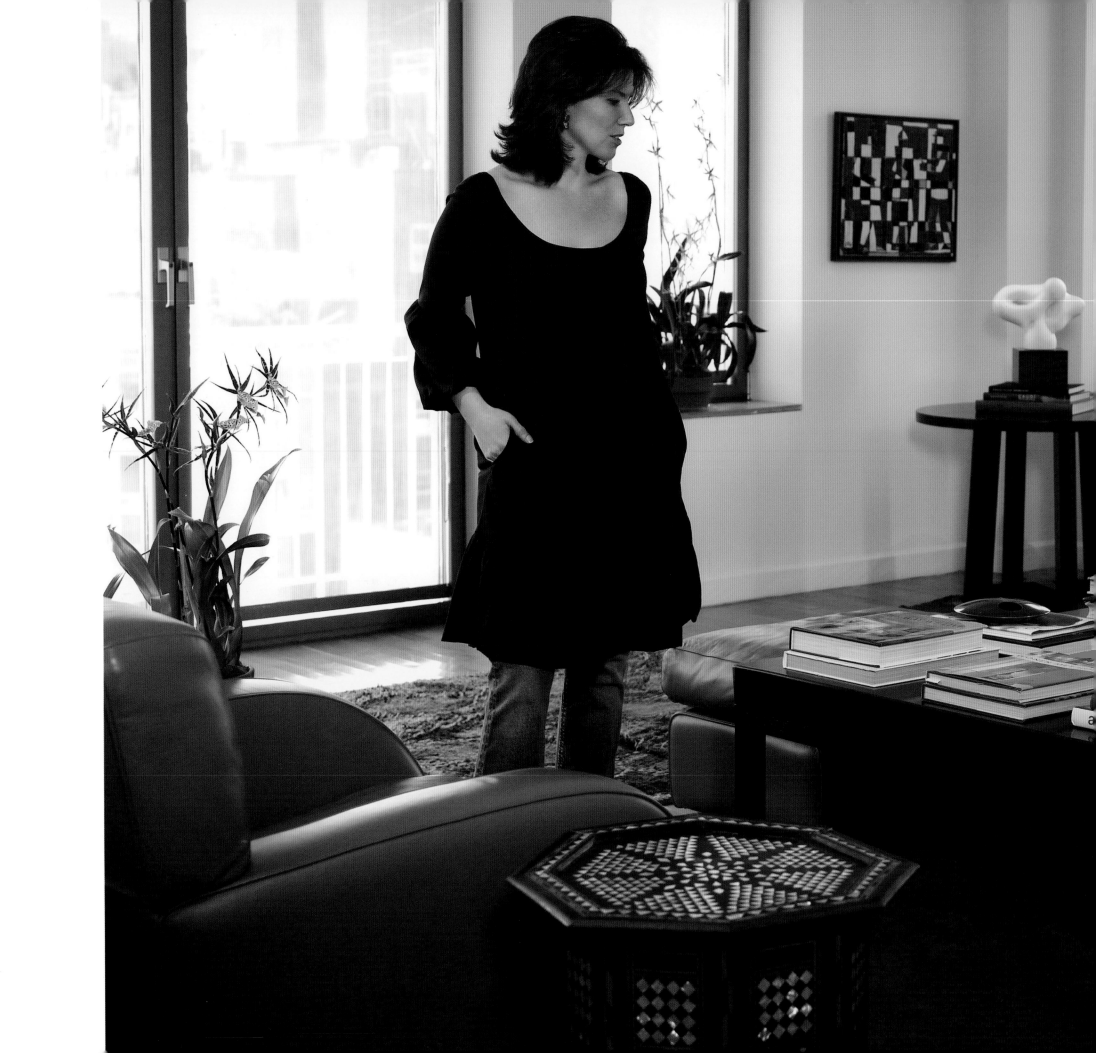

pilar quentin

A native of Guayaquil, Ecuador, Pilar was born into a philanthropic family that built hospitals and schools and worked to eradicate poverty while trying to attract foreign investors to their homeland. Following that tradition, Pilar works actively to win grants for Benefactors of Ecuador, a charity based in New York. She was educated in Massachusetts and Washington, D.C., where she studied business marketing. After settling briefly in Buenos Aires to start a family with her husband Alejandro, the couple moved their children Ilaria and Andrés to New York, where Pilar began collecting art.

Photographed in New York

The family lesson that has empowered me the most is to focus on how you can contribute. It's a simple lesson, and it's taken me till adulthood to be able to implement it — every day I ask myself, how can I add value? When you think this way, it's empowering. Helping others is its own reward.

rachel peters

The granddaughter of Irving Berlin, Rachel was born and raised in New York City and attended the Spence and Hewitt schools before completing Sotheby's fine art program in London. A stint in fashion as a freelance stylist and fashion editor for *Hamptons* magazine was short lived. She switched gears to work in film and was involved in the production of *You Can Count on Me* and *Boys Don't Cry*. Her production company Archer Entertainment has helmed projects made for cable television. She produced *New York City Serenade* in 2007 and is married to Patrick Thomas.

Photographed in New York

For better or worse — I have always navigated my life to the beat of my own drum and I hope that I am ultimately wiser for it. I find nothing more mundane than a life spent proving yourself to others. I think I get that from the women in my family. I have a very strong and creative family and amazing parents. I am very fortunate to have the life that I have had so far.

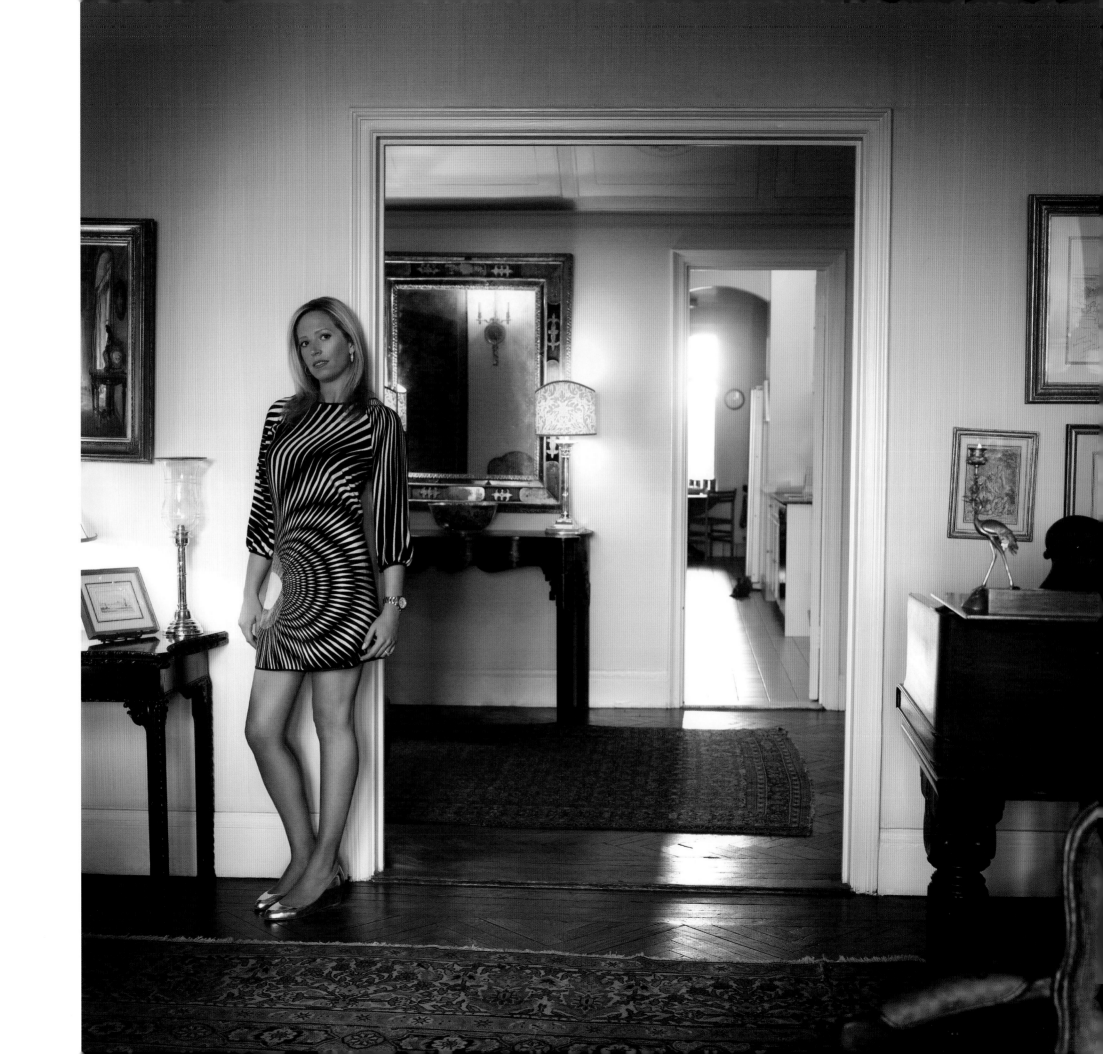

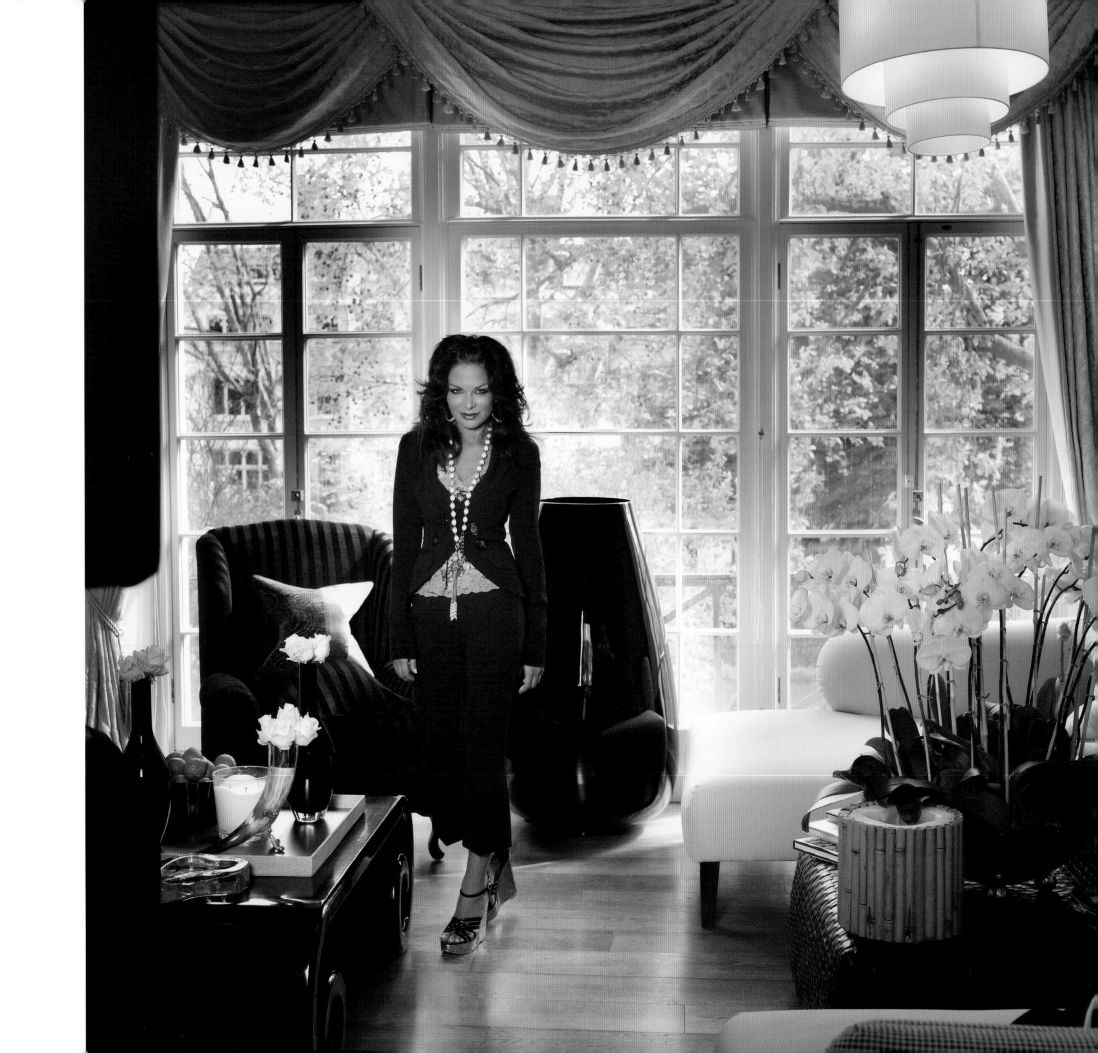

rena kirdar sindi

A renowned party-giver, the Baghdad-born Rena Sindi often is a host of charity events and fashion celebrations on either side of the Atlantic and can be found at the center of many different social circles. With a master's degree in international affairs from Columbia University, the entrepreneurial Rena has turned her social panache into a business, operating dual event-planning businesses in New York and London, and has written *Be My Guest*, a guide to hosting practical theme parties. She has two daughters and lives in London.

Photographed in London

renee rockefeller

Born in Poland, and then immigrating to the United States with her parents, Renee Rockefeller studied at Lehigh University and received her law degree cum laude from Temple University before working as a corporate attorney at the Wall Street firm Cadwalader, Wickersham & Taft. She later practiced law at Sotheby's in New York. She is married to Mark Rockefeller, whose father was a three-term governor of New York State and then Vice-President of the United States under Gerald Ford. They have four children and live in New York.

Photographed in New York

My parents taught me integrity, compassion and to have a "hunger in your belly."

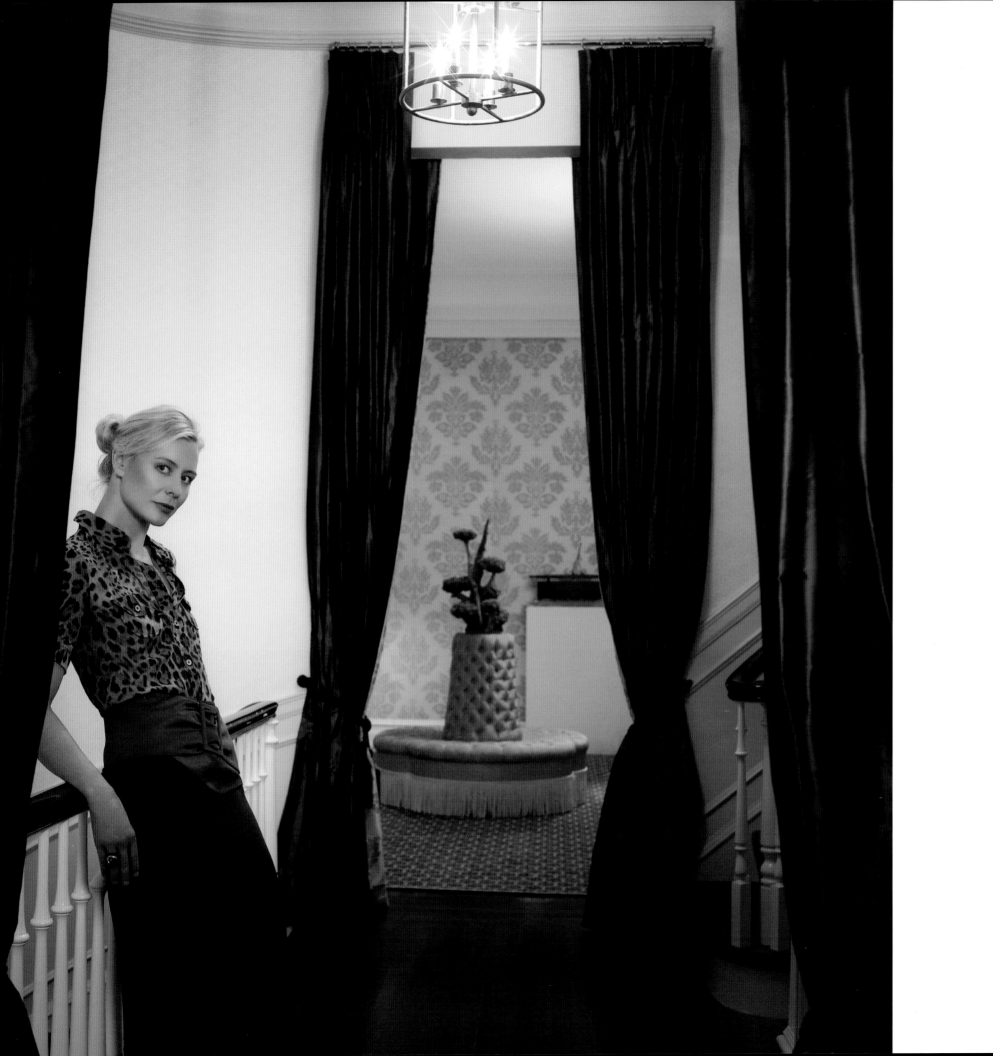

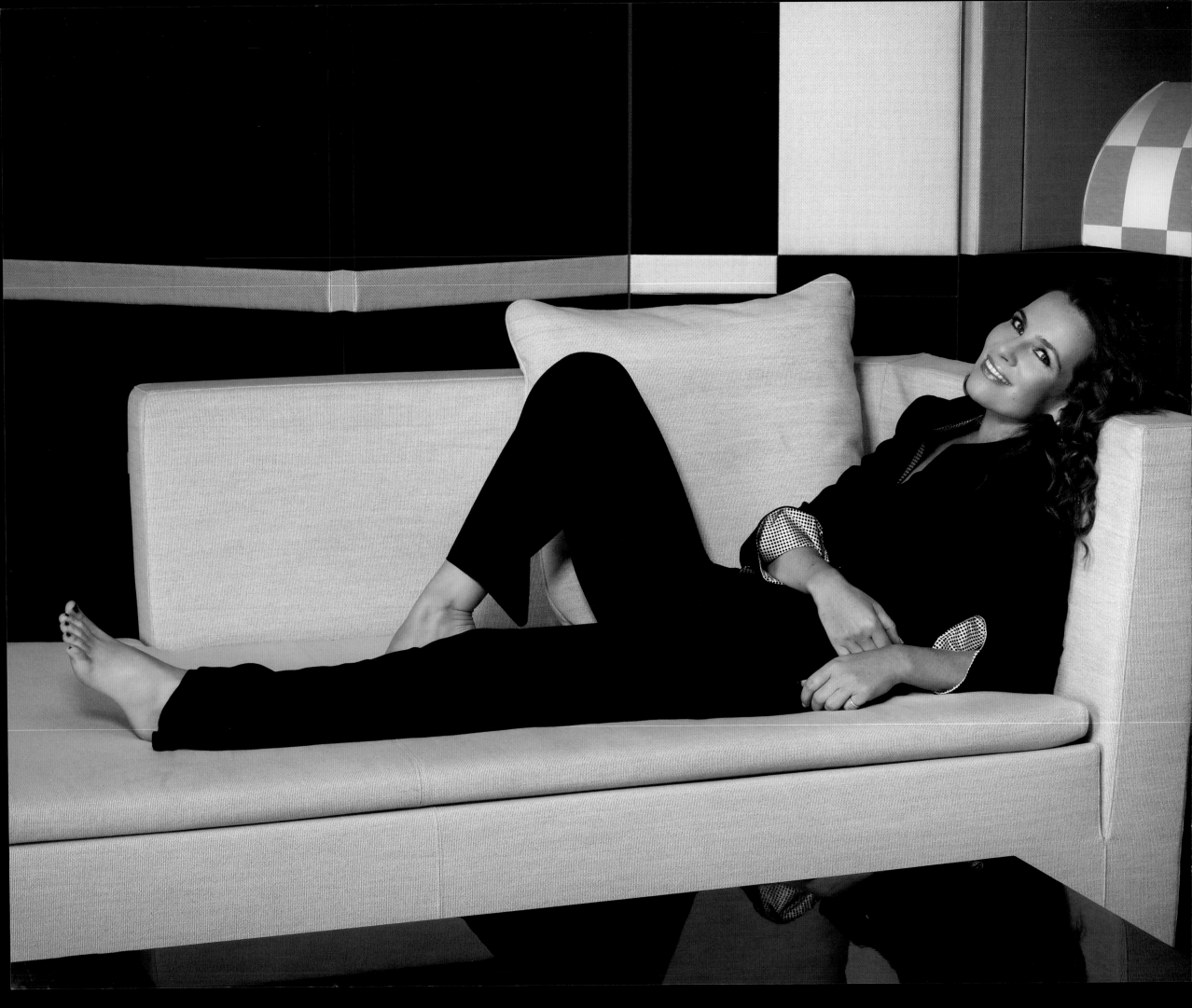

roberta armani

Setting aside aspirations for a career as an actress, the niece of legendary fashion icon Giorgio Armani has dedicated herself to work in the family business alongside her sister Silvana and cousin Andrea. For the past 10 years, her role has steadily evolved to become a director of the company with worldwide responsibility for entertainment industry public relations, often representing her uncle at signature events. Roberta is the epitome of Italian sophistication and hospitality, combining business acumen with an innate sense of style, while always paying attention to the details — a trait her uncle has mastered as he has created one of the world's best-known fashion and lifestyle brands.

Photographed in Milan

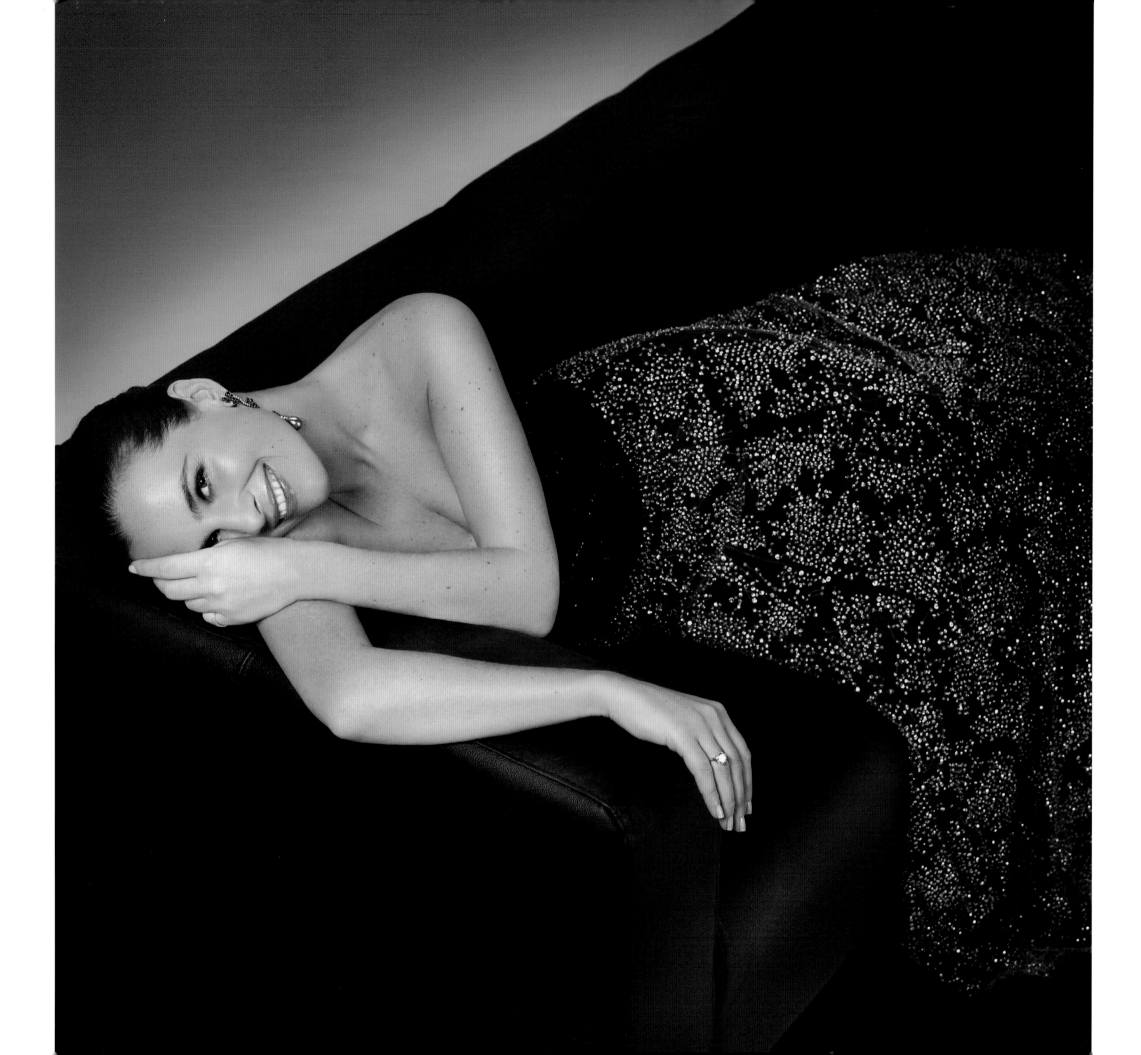

sabrina fung

Sabrina was born into the 100-year old Li & Fung Group, a Hong Kong-based trading and exporting business. She studied at Harvard College before working as an investment manager for Brown Brothers Harriman, one of the oldest privately held banks in the United States, and then returned to the family business in 2000 as a senior vice president, overseeing the company's investment portfolio. She sits on the board of the task force on academic resources for Harvard Unviersity and the Fung Foundation. She is married to Kevin Lam and has twin girls.

Photographed in Hong Kong

It's always the details that set a person apart. Since my two brothers and I went to different schools, the summer holidays were always good bonding times. One of our favorite childhood acts would be putting on Mom's high heels, mascara, lipstick and eyeshadow when our parents went out for dinner.

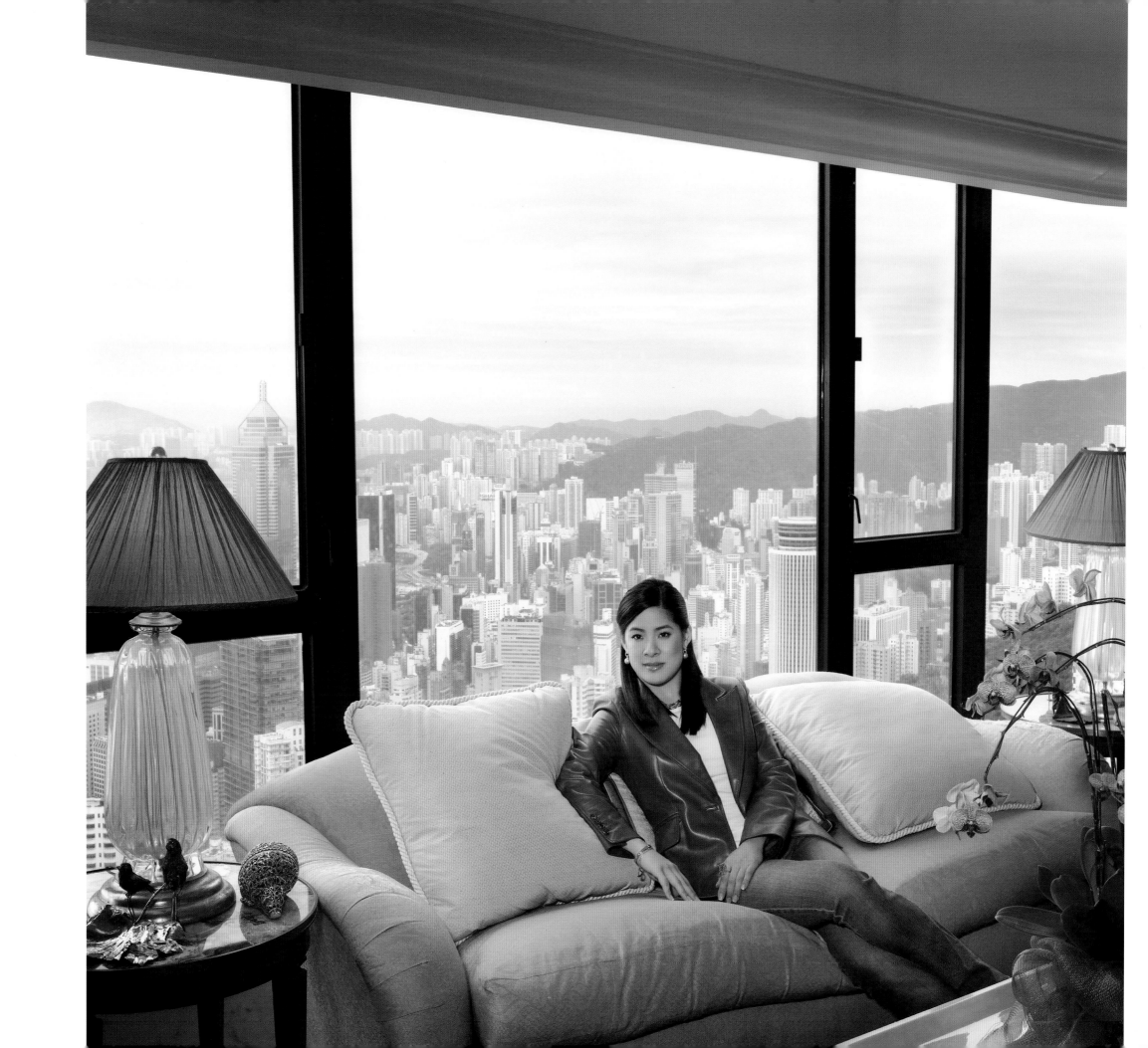

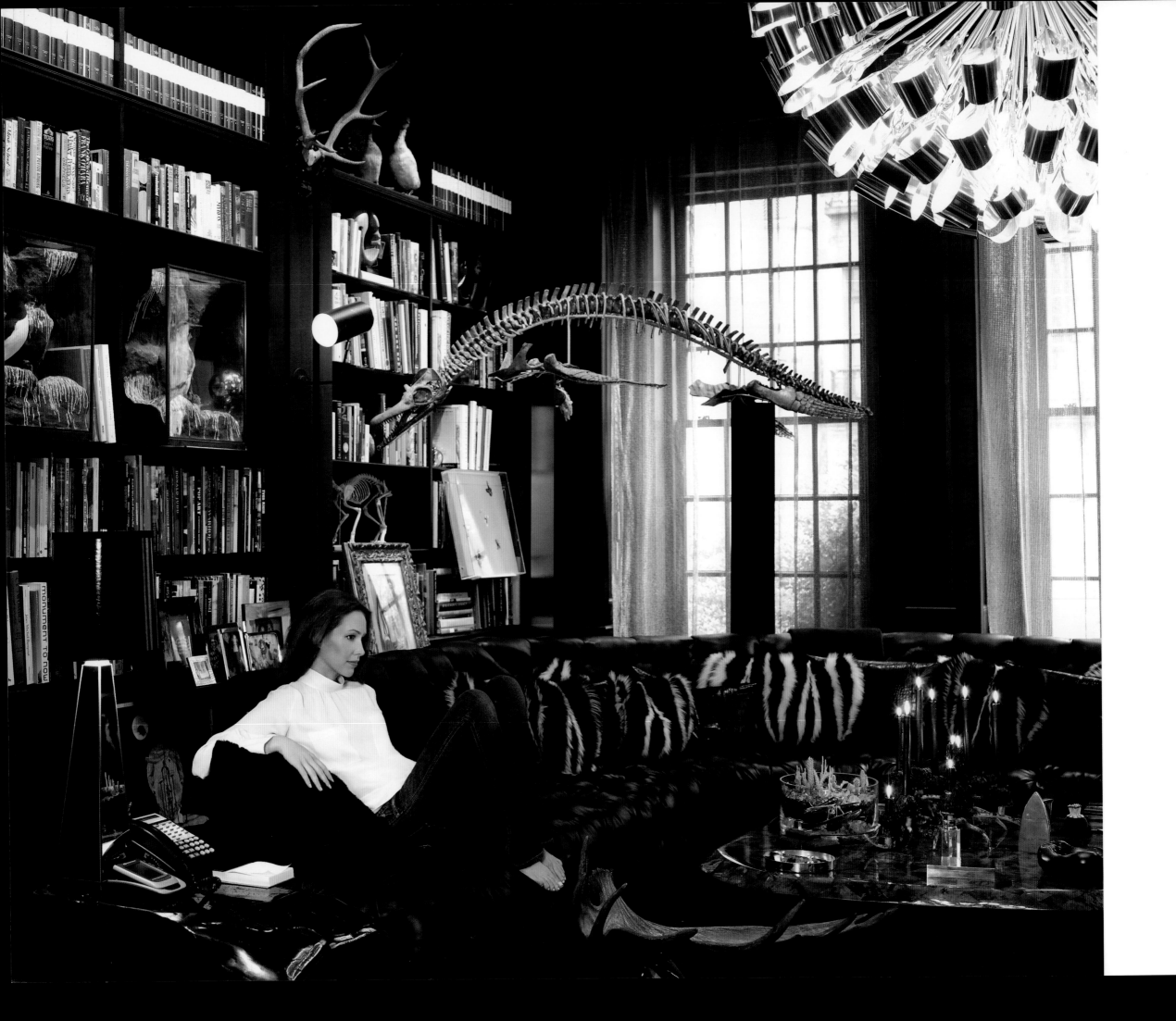

samantha boardman

The daughter of banking heiress Pauline Pitt and Dixon Boardman, Samantha was born in South Africa and has lived in London and New York. She graduated from Cornell Medical College with a residency in psychiatry, and works at New York Presbyterian Hospital's department of public health and maintains a private practice. She is involved with Women and Science at Rockefeller University, the Lying-In Hospital at New York Presbyterian Hospital, and Citymeals on Wheels. She was named one of the 50 sexiest New Yorkers by *New York* magazine in 2003.

Photographed in New York

I learned everything from my parents: to always say please and thank you, to sit up straight, and to curtsey — a habit so ingrained I am still having a hard time letting go of it.

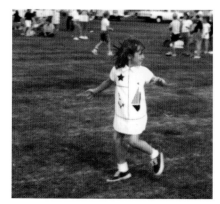

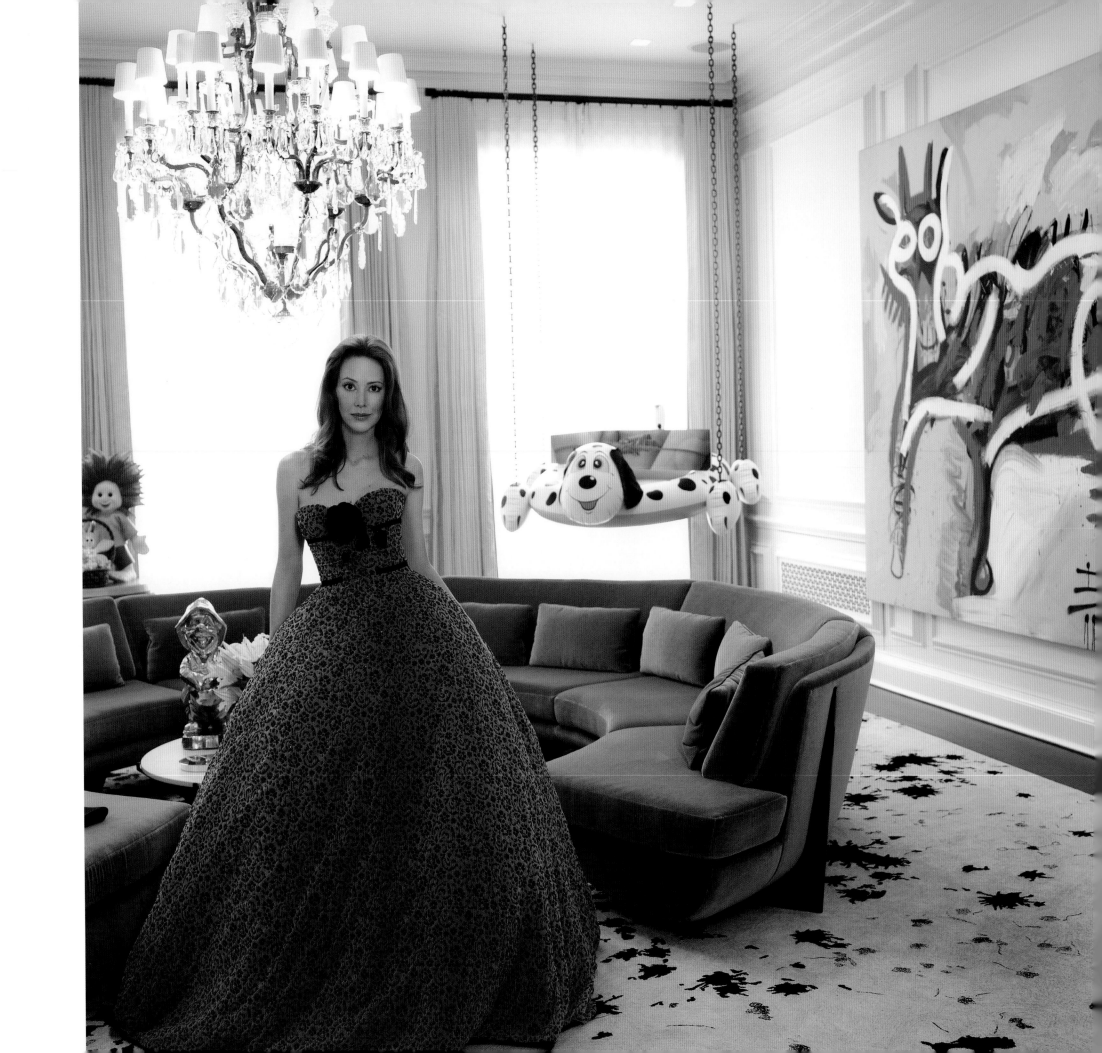

serra kirdar-meliti

Serra Kirdar-Meliti studied Middle Eastern culture at the University of Oxford, where she also earned a master's degree in comparative and international education. She then completed a PhD at Oxford's St. Anthony's College with a dissertation titled "Gender and Cross-Cultural Experience with Reference to Elite Arab Women." She is the founder and director of the Muthabara Foundation, which aims to maximize Arab women's potential to achieve managerial and leadership positions in the private sector. Based in Dubai, the foundation partners with Oxford University's Middle East Center, where she also founded the Life Fellow Foundation. Serra is a founding board member of the New Leaders Group at the Institute for International Education.

Photographed in London

My parents taught me to be trusted, needed and respected.

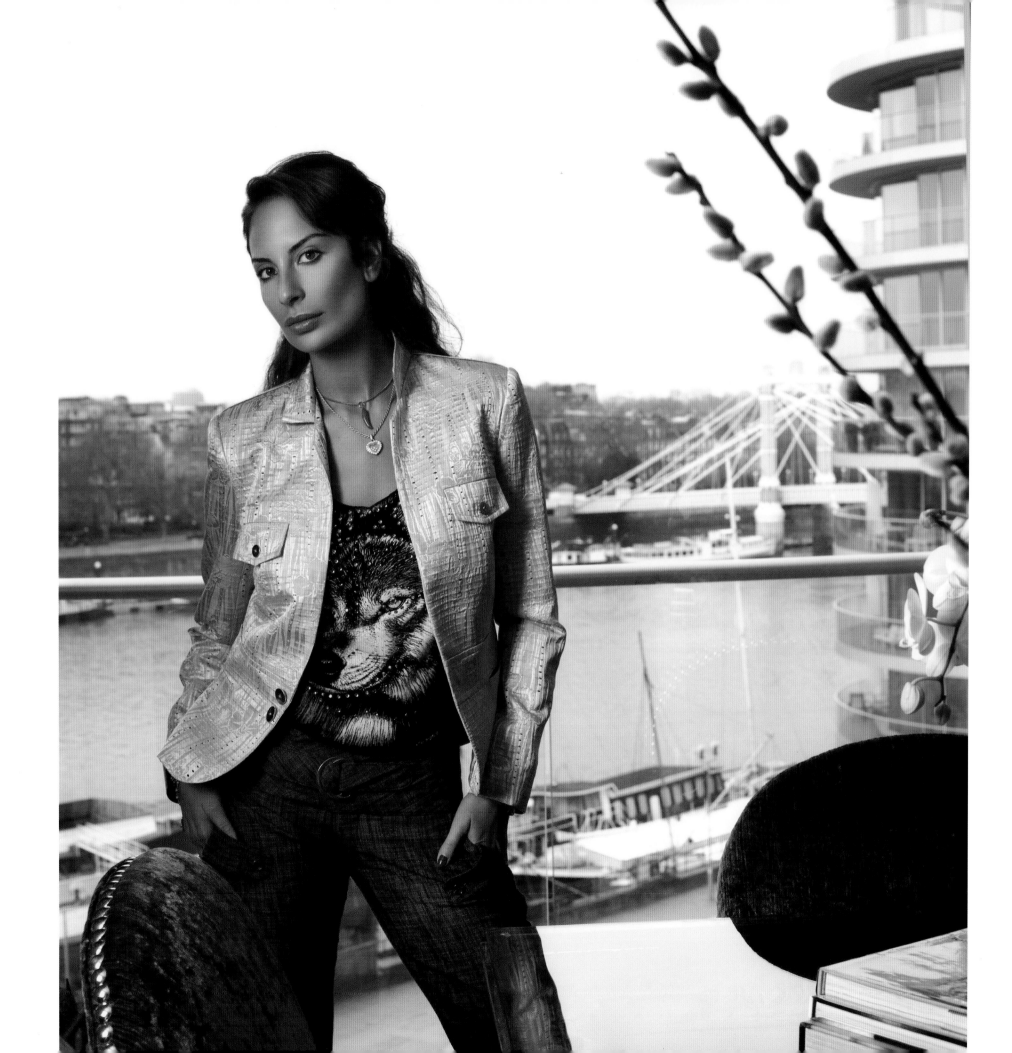

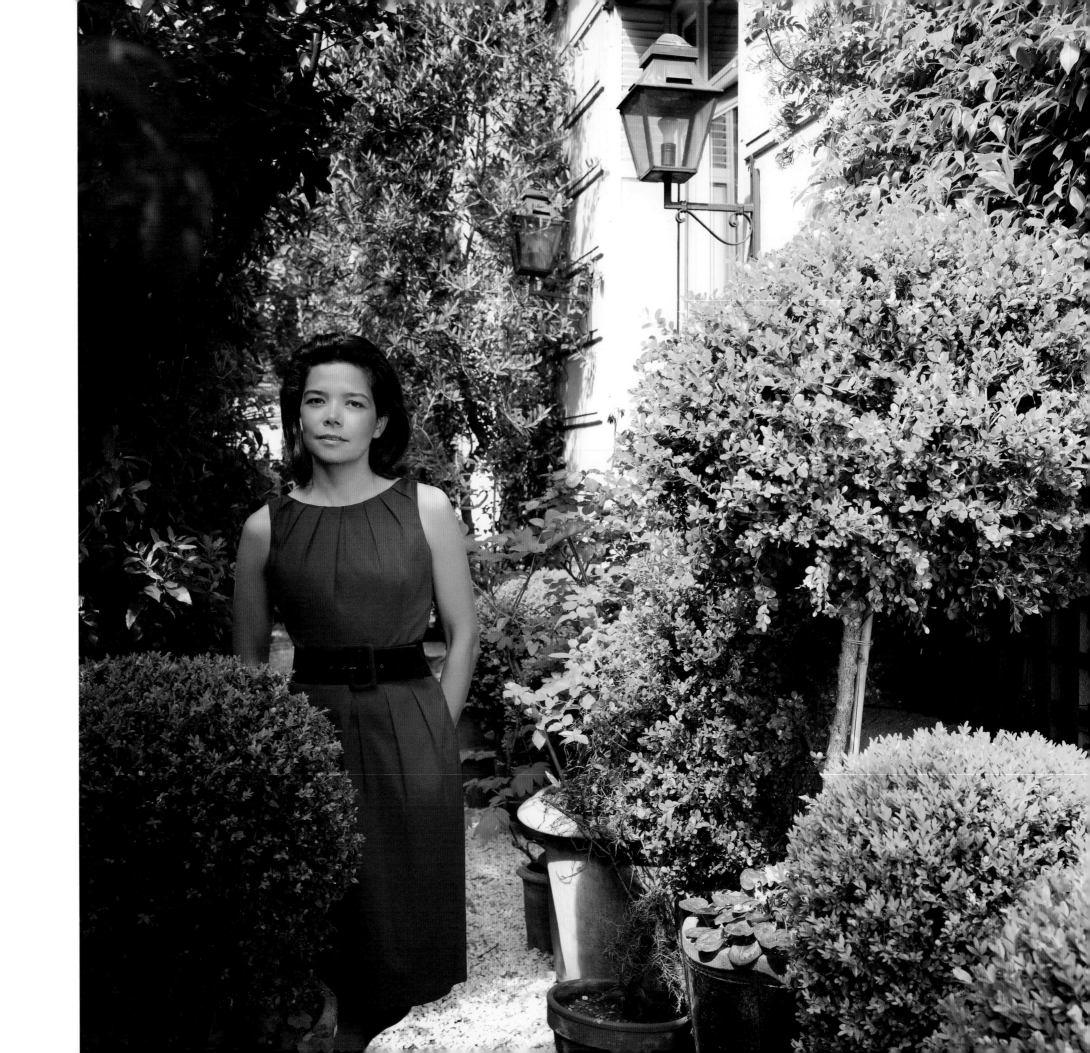

sophie douzal-sarkozy

The public relations doyenne of Paris joined Marie Sauvage-Gallois to form the communications firm Douzal Sauvage in 1997. They count among their fashion, jewelry, and travel clients such luminary brands as Tiffany & Co, Champagnes Charles Heidseick, Hôtel Plaza Athénée, Hotel Guanahani in St. Barth, and Comité Colbert. Sophie is the sister-in-law of French President Nicolas Sarkozy and the daughter of the owner of Auxey Duress, the famous Burgundy vineyard. She has two children, Arpad and Anastasia.

Photographed in Paris

My parents taught me to have a sense of humor.

tamara beckwith

The daughter of real estate mogul Peter Beckwith has many talents. As a journalist, Tamara has written columns for *OK!*, *Harpers Bazaar* Australia, *LA Confidential* and *Esquire*, and has contributed stories to *Marie Claire*, *Tatler* and *The Evening Standard*. Her work for television and radio is plentiful, including appearances on MTV, VHI, *The Casting Couch*, *Celebrities Under Pressure*, and *Dancing on Ice*. She has performed onstage in *The Vagina Monologues* and *An Ideal Husband*. As a model, she has been seen in advertising campaigns and on the catwalk. Her line of jewelry Diamonique by Tamara Beckwith is available exclusively on the QVC television network. She is married to Giorgio Veroni and they live in London.

Photographed in New York

I have always grown up knowing family is very important. The giving back is just as fun as the taking.

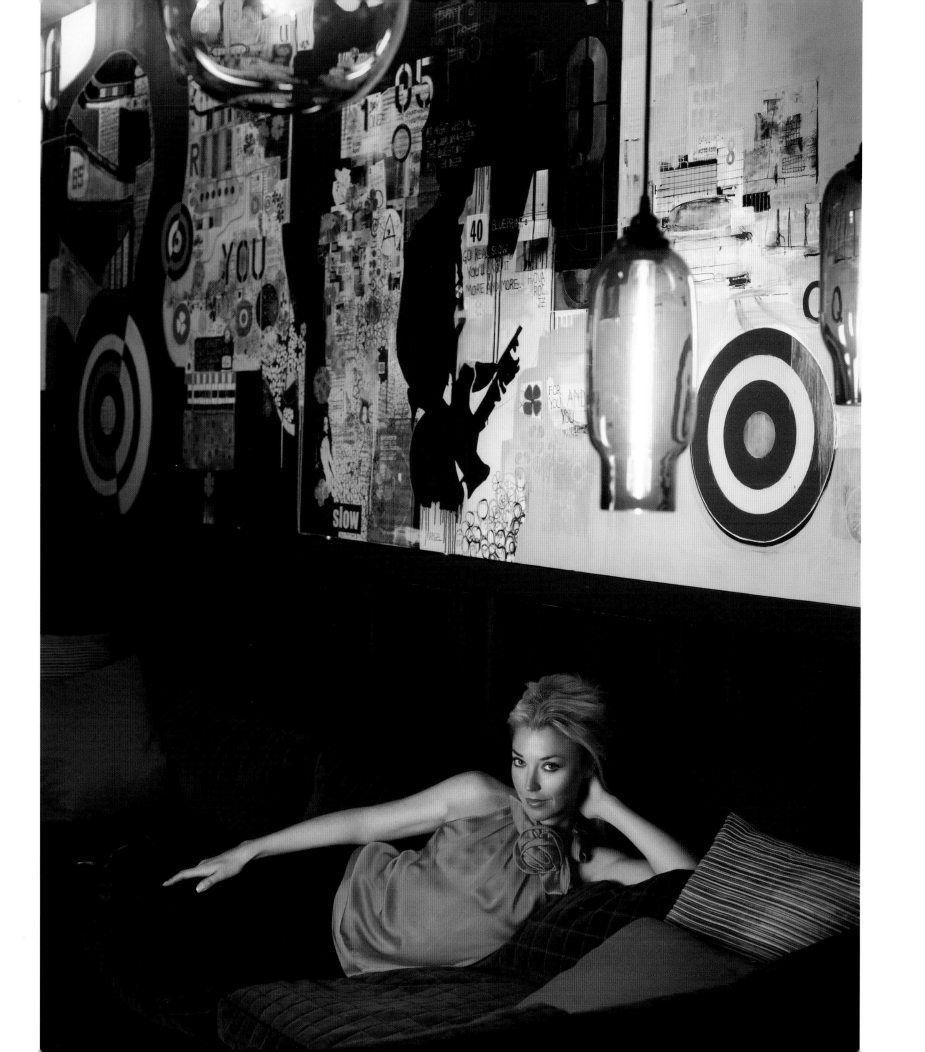

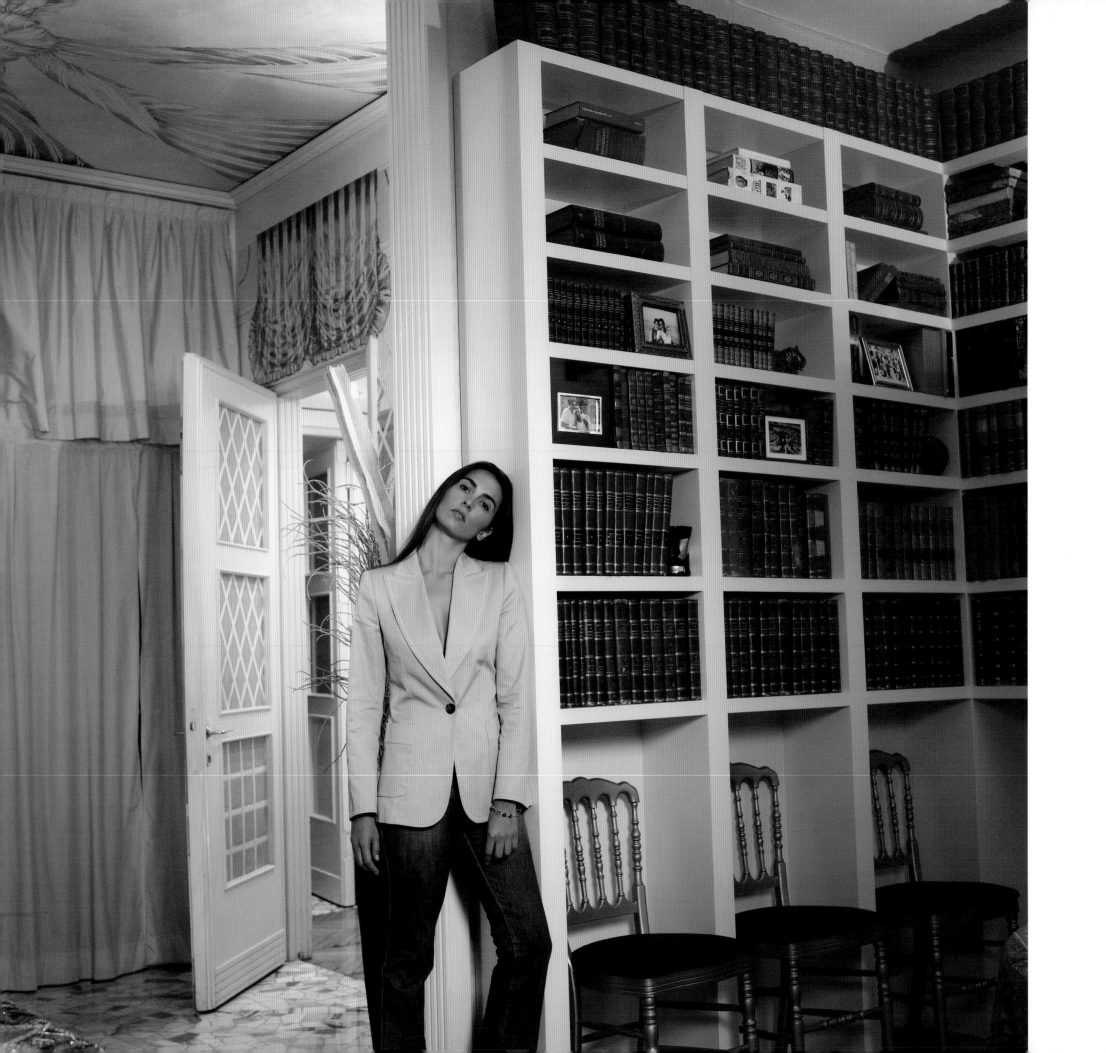

tatiana von gecmen-waldeck

As a baroness, Tatiana is a descendant of William the Conqueror and falls under the royal house of Bourbon-Parma. She was born in Paris to French and Austrian parents. In addition to her work as a luxury fashion consultant, she plans to launch her own label MOI C TOI in 2008. She has two sons, Alexander and Balthazar.

Photographed in Milan

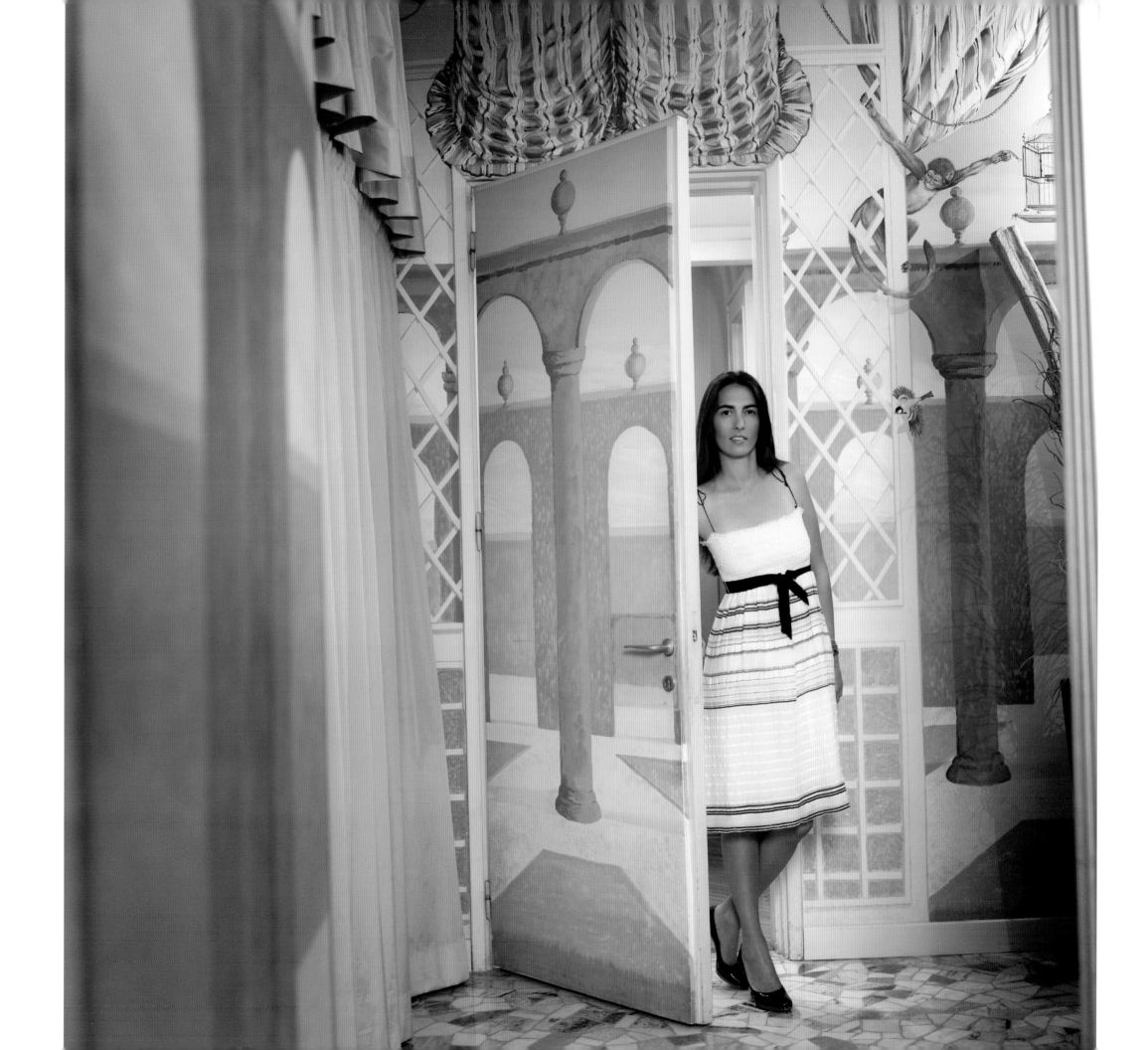

tinsley mortimer

Oft-photographed society column sensation Tinsley Mortimer is the daughter of George and Dale Mercer of Richmond, Virginia. She studied at the Bollettieri Tennis Academy in Florida and later attended The Lawrenceville School in New Jersey, where she met Robert Livingston "Topper" Mortimer, who she married in 2002. She has a degree in art history from Columbia University and worked briefly for *Vogue* and the public relations agency Harrison & Shriftman before starting a line of handbags for the Japanese fashion label Samantha Thavasa.

Photographed in New York

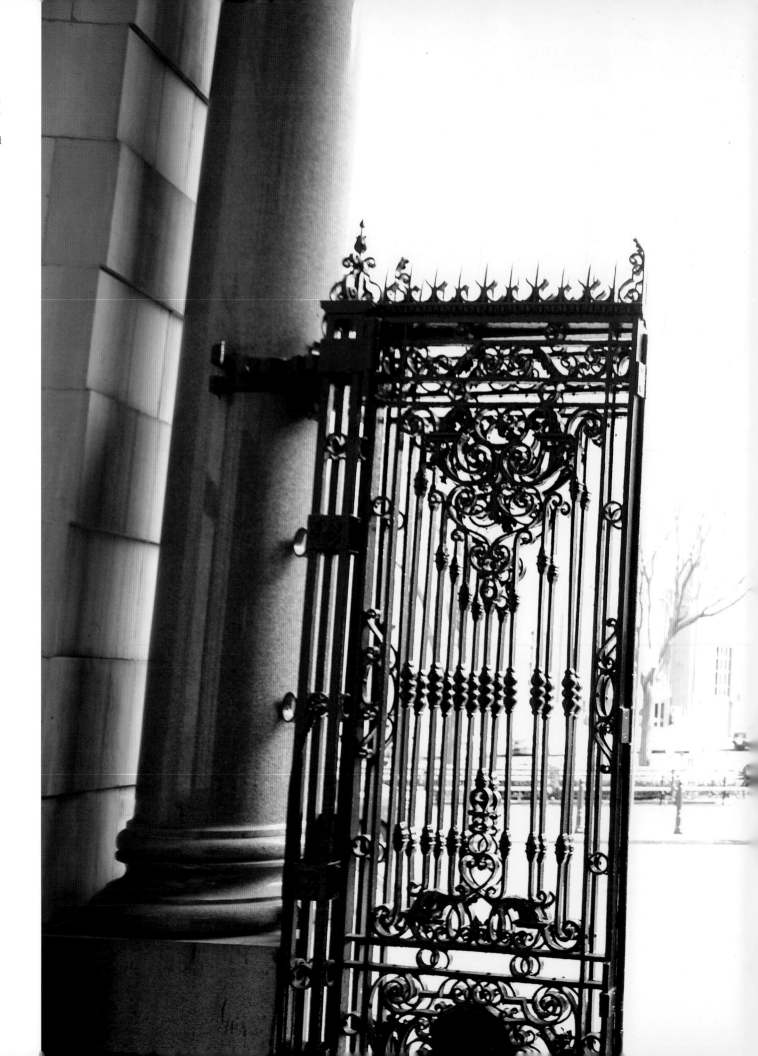

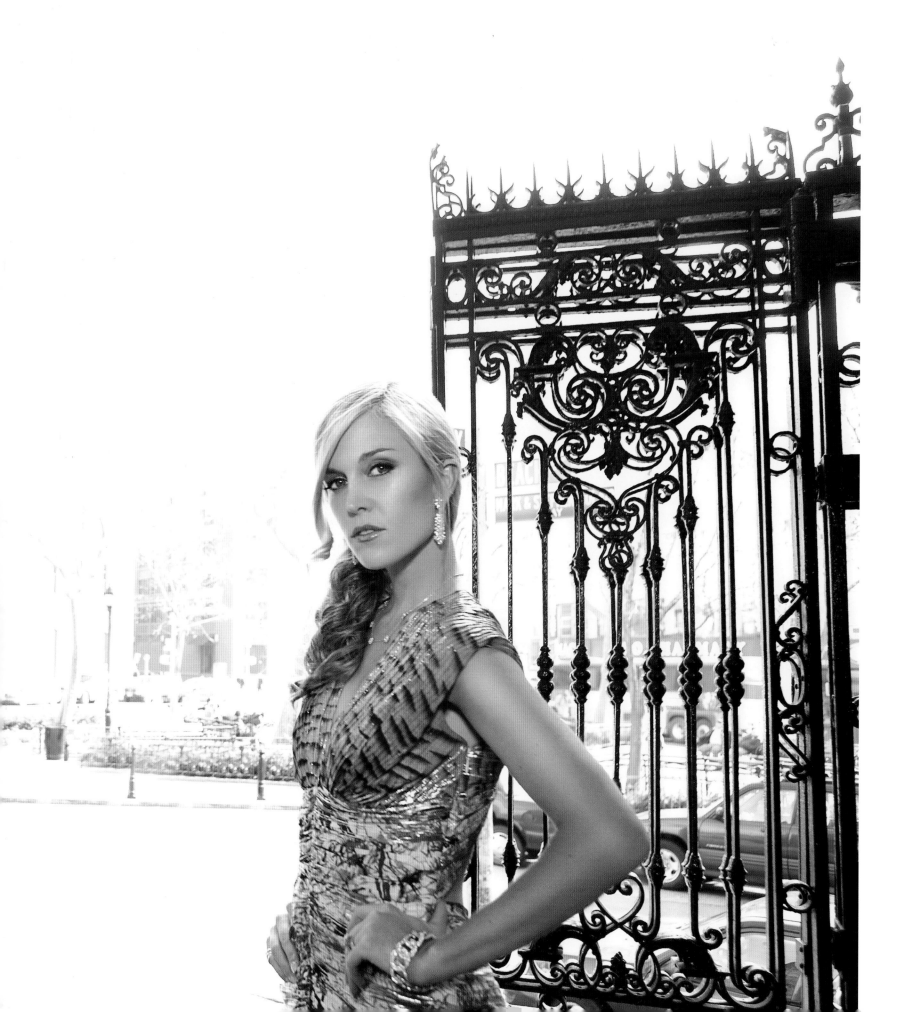

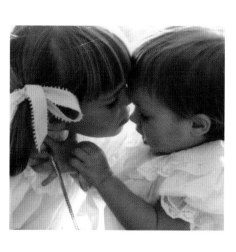

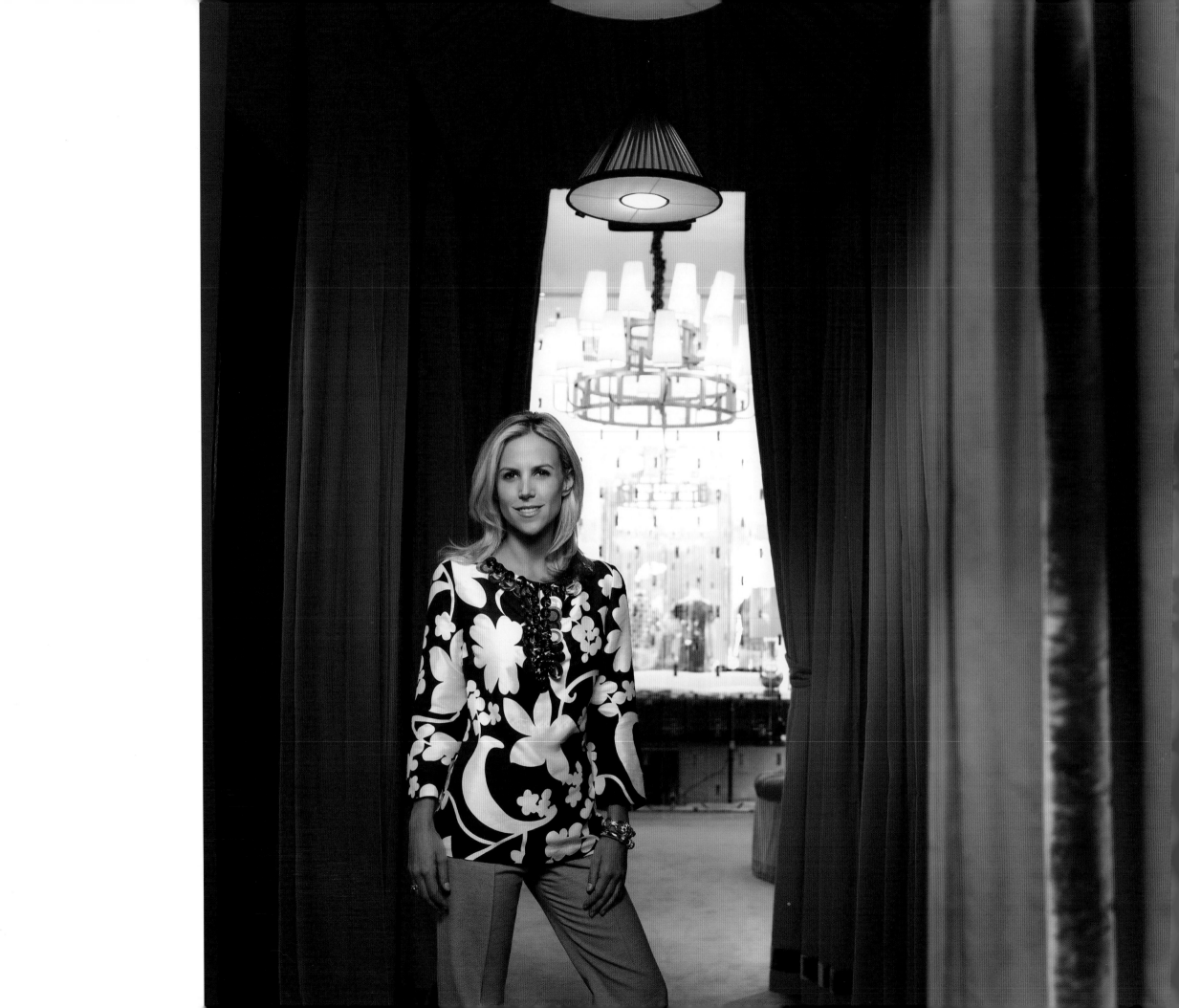

tory burch

Born in Valley Forge, Tory attended the Agnes Irwin School and then majored in art history at the University of
Pennsylvania. She came to New York to work for Zoran, and after stints at *Harpers Bazaar*, Ralph Lauren, and Vera
Wang, she started a sportswear and accessories label with now former husband and venture capitalist Chris Burch in
2004. The company skyrocketed to success, and the Tory Burch label is available in 10 stand-alone boutiques and 250
luxury department and specialty stores in the U.S., Canada and Europe. She has three sons and three stepdaughters.

Photographed in New York

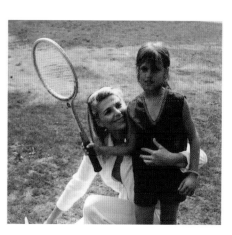

My parents taught me to always approach everything with a positive attitude and to treat everyone with kindness and patience. The whole process of designing a collection from the first inspiration to the final product is an incredibly creative process. I grew up on a farm. I had a fantastic childhood that my brother has described as Tom Sawyer meets Andy Warhol.

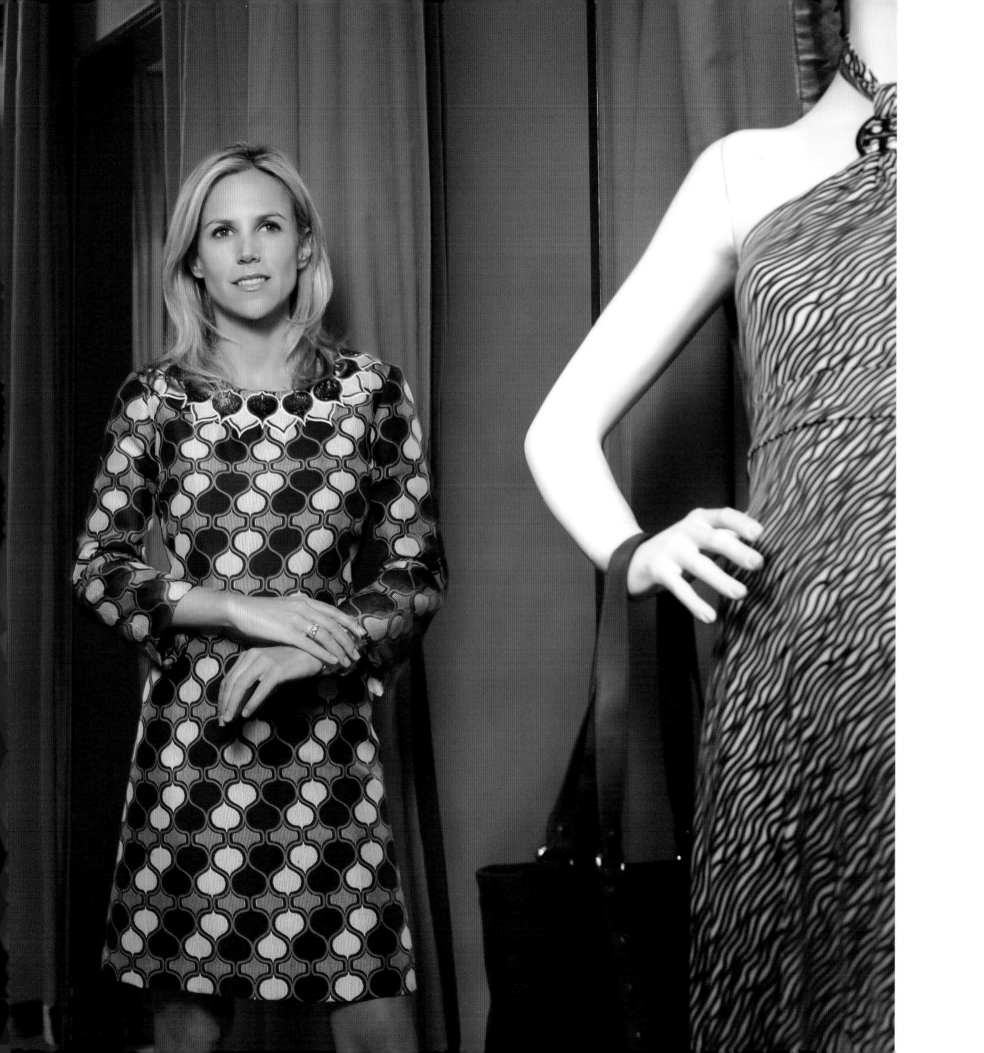

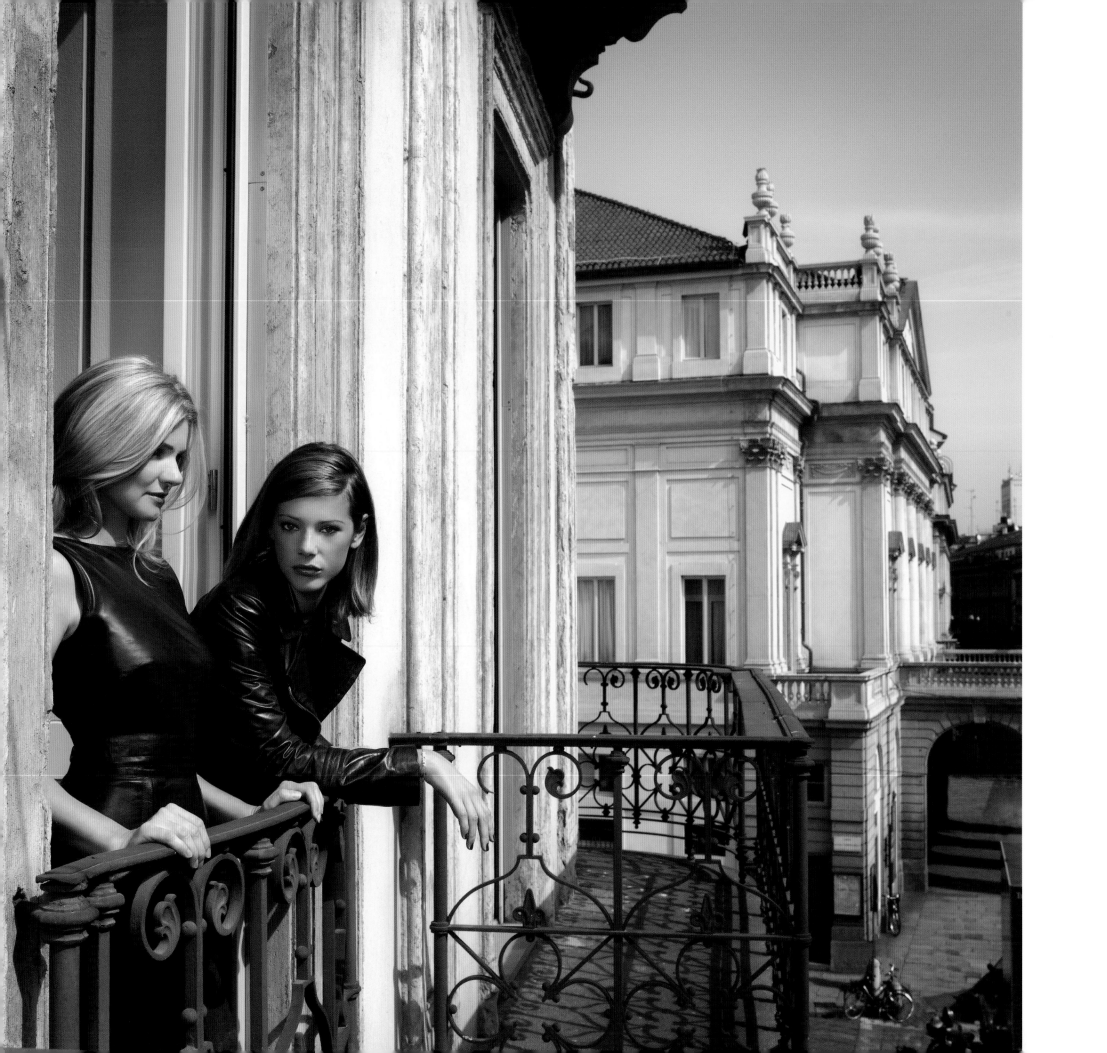

gaia trussardi

Gaia Trussardi studied anthropology and sociology at Richmond, the American International University in London. Her interests in the varying cultural traditions and customs of a broad spectrum of communities have led her to study their influence on fashion, technology and politics. She eventually went to work in the family business founded by her grandfather in 1911, and currently serves as the creative director of the Trussardi brand, having presented her first collection for the company in the autumn of 2006. She is married to Ricardo Rosen.

My parents taught me to be humble and to work hard in order to obtain things.

beatrice trussardi

Beatrice Trussardi studied the history of contemporary art and holds a master's degree in art business and administration from New York University. She has collaborated on exhibitions with some of the major museums in New York City. Since 2002, she has been chairman and CEO of the Trussardi Group. In addition to her management of the family's business, she chairs the Nicola Trussardi Foundation, named for her father. Since 2005, she has served as part of the young global leaders taskforce for the World Economic Forum.

Photographed in Milan

From my parents I learned that responsibility means satisfaction and only both of them lead to successful results. By giving me a very precise vision of the world they (wisely) taught me how to live my life with modesty.

valesca guerrand-hermes

Valesca was born into a Dutch family that moved between Canada, Europe, and the United States. As a mother of two and an active philanthropist, she is passionate about children and knows the value of making a difference. Her involvement with charities supporting youth exemplifies her love and desire to help children everywhere. In 2007, she was awarded the Mother Hale Award for Caring by the Hale House. She is the founder of Babies Come First, a safe haven for abandoned babies that works to provide support for mothers expecting unwanted children.

Photographed in New York

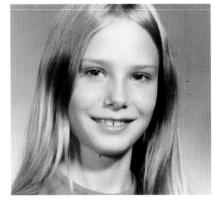

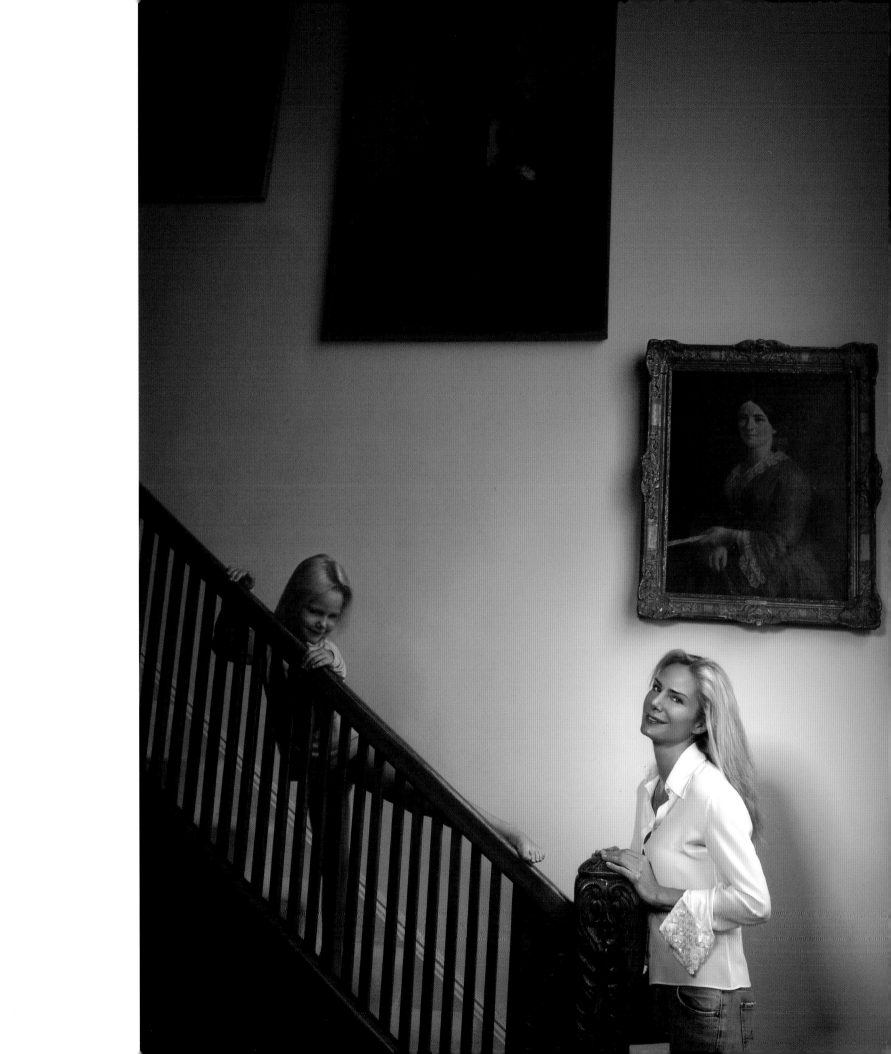

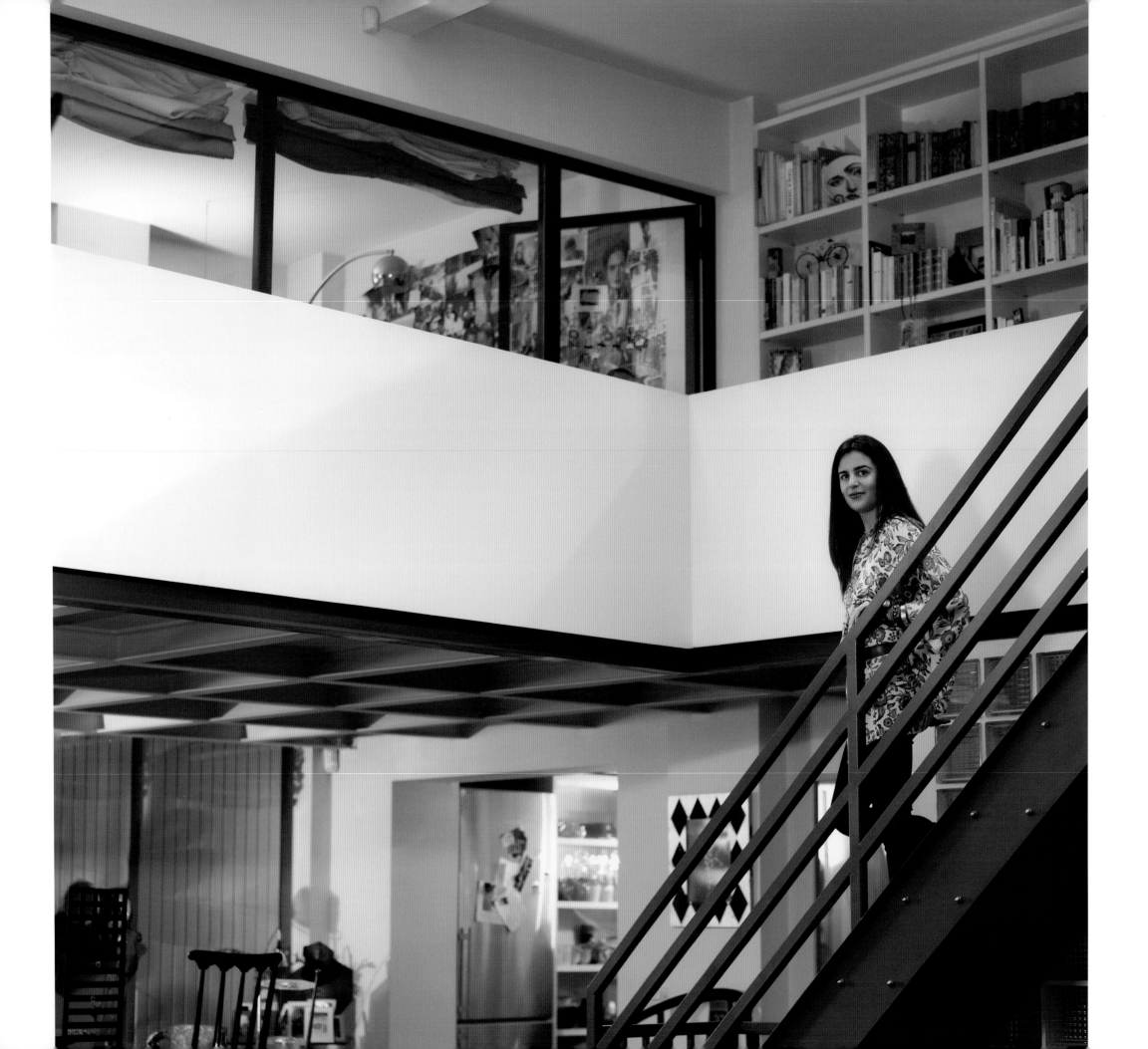

veronica etro

Veronica Etro was born in Milan and studied at the Deutsche Schule Mailand before attending Central
St. Martins College of Art and Design in London in 1993. Having decided to pursue fashion design as a
career, she returned to Milan to assist her brother Kean with the women's wear design at the family
company, Etro, which had been founded in 1968 by their father Gimmo. In 2000, she assumed
responsibility for the women's division and showed her first full women's collection. She is married to
Alessandro Frigerio and they have a son, Fillippo.

Photographed in Milan

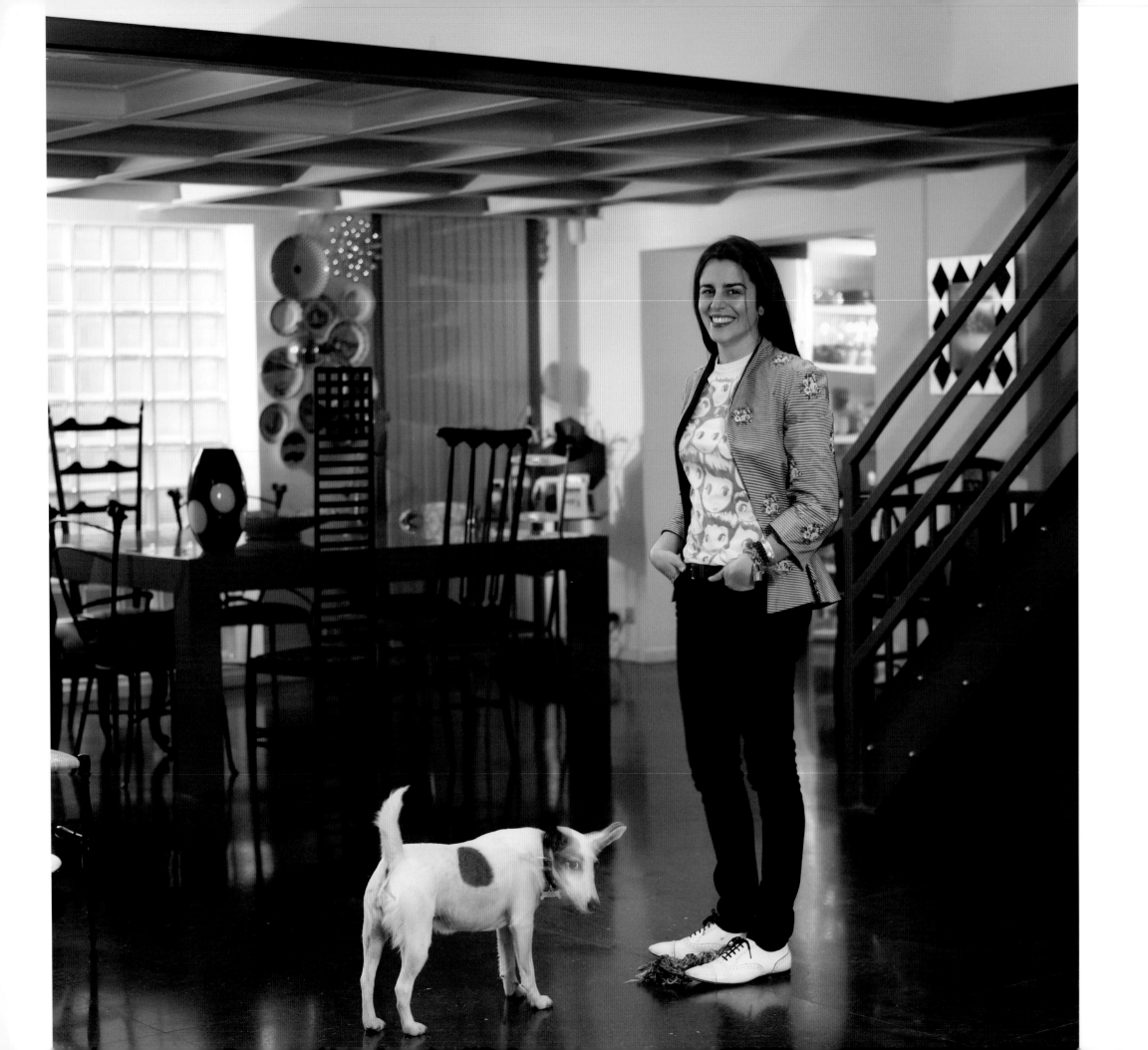

I learned to work hard. My father Gimmo set up the company in 1968, and even though he is the president he still comes to work every day. I also learned to be surrounded by beautiful things. Both of my parents are keen art collectors, and I learned a good deal about art from going to fairs and exhibitions with them. I was always surrounded by textiles, and I learned to work with my hands and be creative. I learned to always keep my eyes open towards new things. To be always positive, curious, to be full of ideas and to break the rules.

"Sometimes I wonder if women really suit each they should live next visit now and then."

Katharine Hepburn

men and
other. Perhaps
door and just

violante avogadro di vigliano de ribains

The Avogadro family line from Vercelli, Piemonte, in Italy, dates from 1039 and includes the chemist Amedeo Avogadro, who in 1811 founded a fundamental constant of chemistry. Violante was born in Milan and raised in Switzerland, then moved to Paris to earn an MBA. She has worked for Donna Karan, Gucci, Ralph Lauren, and Montblanc, overseeing communications in France. She enjoys traveling the world and is an amateur photographer. She married Geoffroy de Ribains in 2006.

Photographed in Paris

My parents taught me happiness, respect for people, a friendly attitude, how to feel comfortable everywhere, and loyalty.

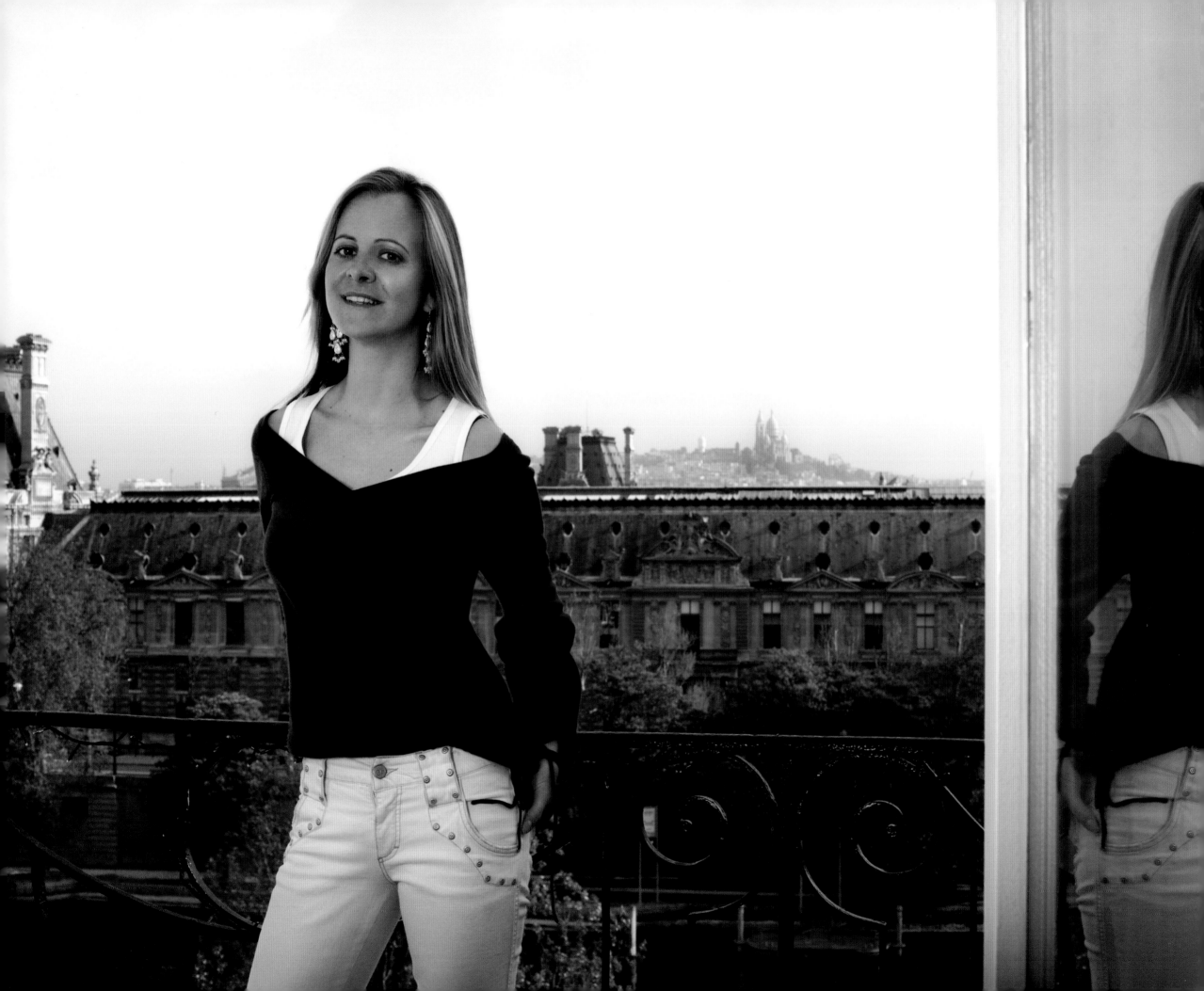

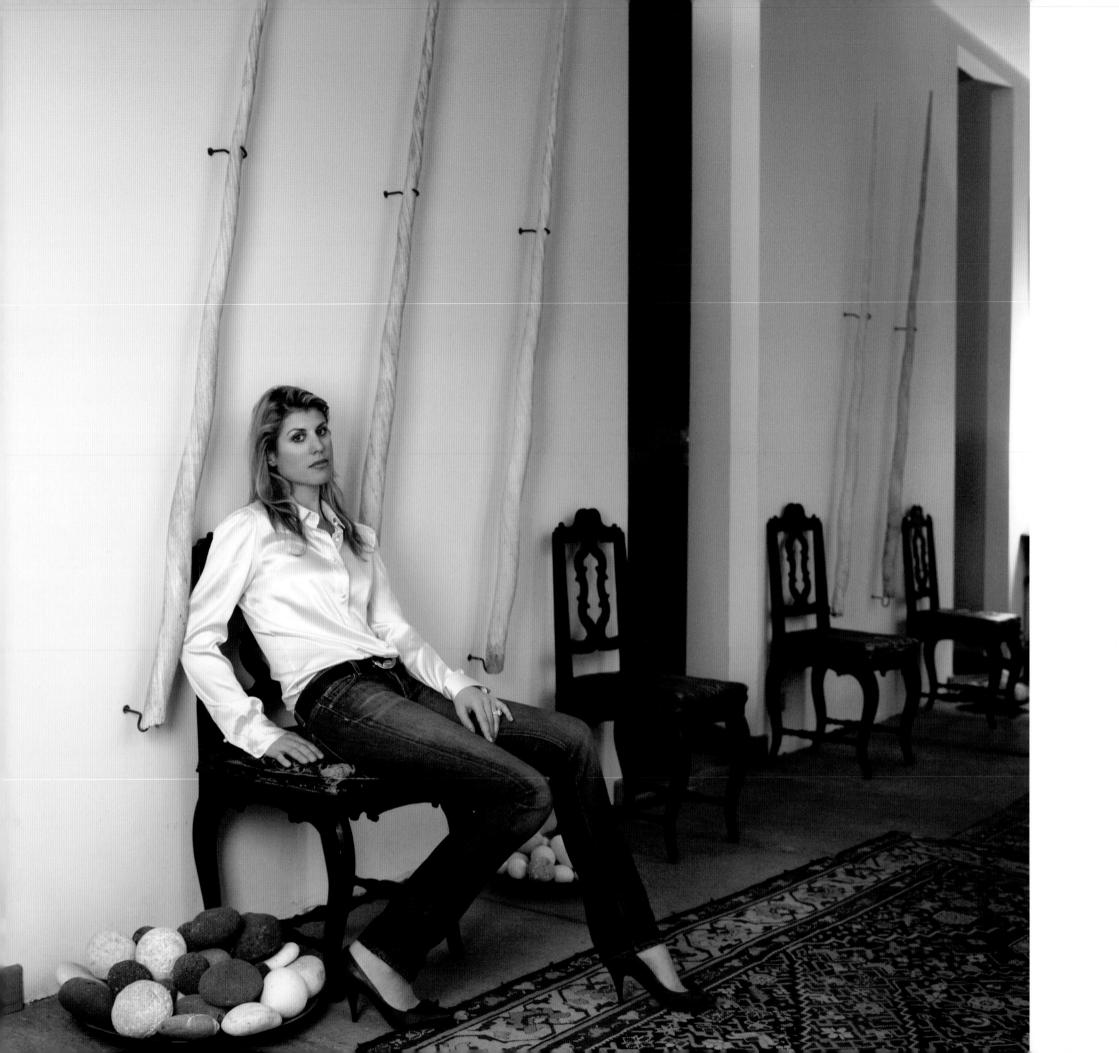

vivia ferragamo

As the granddaughter of the legendary Salvatore Ferragamo, Vivia was destined to become a designer. She studied at the Fashion Institute of Technology in New York after finishing studies in Oxford. She then spent three years working under Emmanuel Ungaro in Paris and launched her own fashion line VIVIA in 2002. Her designs for footwear and apparel are sold in fashion boutiques worldwide. She is married to Alessandro Attolico di Adelfia and lives in London.

Photographed in Milan

The things I remember most: the smell of fresh leather and the special animals that surrounded me, my home and the unity of my family.

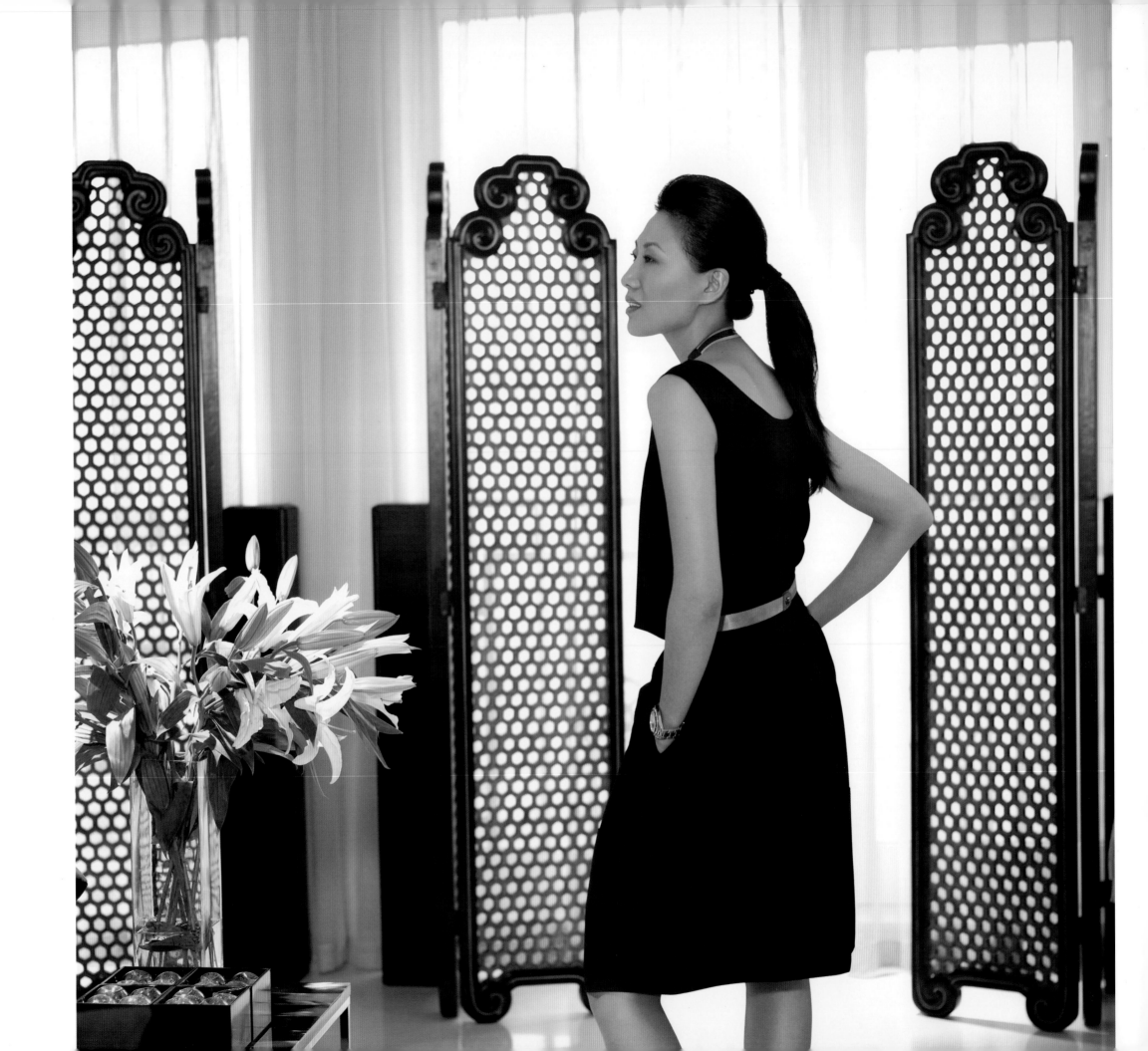

xuejing (yuki) tan

Rising from a family in China's Jiangsu province, Yuki Tan has become one of the most influential style icons and businesswomen in the developing economic superpower. She combines busy international and domestic schedules and is often seen in the Chinese press and on television talk shows. In her role as president of Chinese operations for Folli Follie, a trendy jewelry, watches, and accessories brand that operates in 20 countries, she has been a pioneer in opening the door to affordable fashion for Chinese women. She lives in Beijing with her shipping executive husband Alexander Rocos and their daughter Amelia.

Photographed in Beijing

I learned an international view from my parents. This was quite a gift at a time when my home country was very closed.

yue-sai kan

Yue-Sai Kan was born in Guilin, China where her father was a widely respected painter in the traditional Ling Nan Style. He moved the family to Hong Kong, where she studied ballet and later earned a music degree from Brigham Young University in Hawaii. Not content with pursuing music as a career, Yue-Sai moved to New York City in 1972 with her sister Vickie and started an import/export business. She also hosted a local television show, beginning a career as a TV personality known for bridging the gap between the East and the West. In 1986, her television series *One World* aired on China's national TV network CCTV, giving millions of Chinese the first glimpse of the outside world, and made her a household name in China. In 1992, she successfully transformed herself from a TV personality to an entrepreneur by creating the Yue-Sai cosmetics brand, which is recognized by over 90 percent of the Chinese population today. The company was acquired by the cosmetics giant L'Oreal in 2004, and she stayed on as honorary vice-chairman of L'Oréal China. Yue-Sai has also written five best-selling books — the most recent, *The Complete Chinese Woman*, further solidifying her role as an arbiter of style and taste in China. Both her media work and her cosmetics enterprise have fundamentally changed the way the Chinese look at the world and their social behavior. *People* magazine once named her the most famous woman in China. Yue-Sai lives in Shanghai, Beijing and New York.

Photographed in New York

My parents taught me everything. The value of hard work, integrity, honesty, generosity and the real meaning of money.

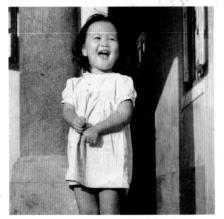

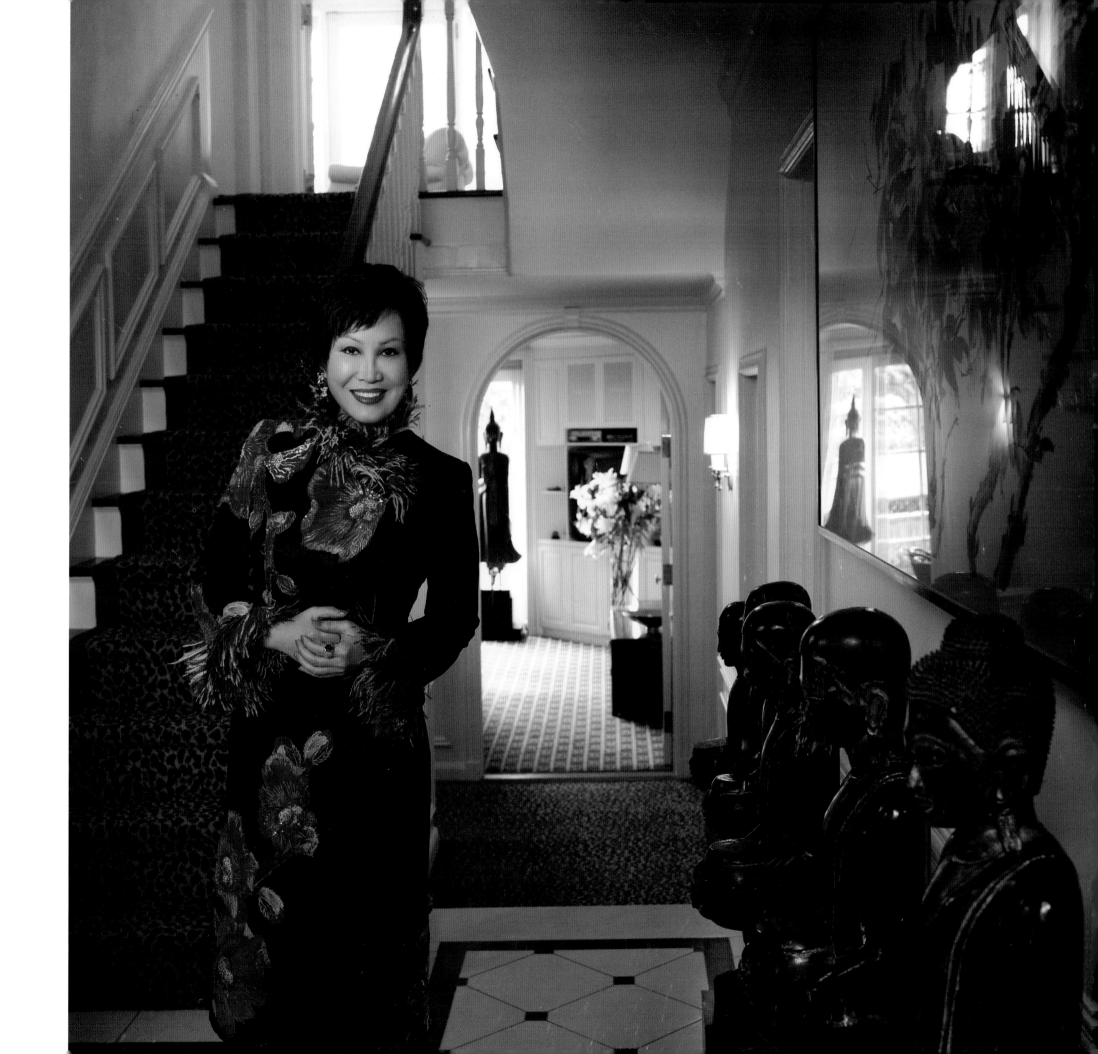

Inheriting Beauty

© 2008 powerHouse Cultural Entertainment, Inc.
Photographs © 2008 Roger Moenks
Foreword © 2008 William Norwich
Text © 2008 Christopher Tkaczyk

Published in the United States by powerHouse Books,
a division of powerHouse Cultural Entertainment, Inc.
37 Main Street, New York, NY 11201-1021
telephone 212 604 9074, fax 212 366 5247
e-mail: inheritingbeauty@powerHouseBooks.com
website: www.powerHouseBooks.com

First edition, 2008

Library of Congress Control Number: 2007941075

Hardcover ISBN 978-1-57687-430-1

Printing and binding by Midas Printing, Inc., China

Text: Christopher Tkaczyk
Foreword: William Norwich
Art Design: Julian Peploe Studio
Post-Production: Catchlight Digital

A complete catalog of powerHouse Books and Limited Editions is available upon request; please call, write, or visit our website.

10 9 8 7 6 5 4 3 2 1

Printed and bound in China

ROGER MOENKS was born in Europe to a French mother and German father, whose career required the family to move around the world, from Lima to São Paolo, Athens, Hong Kong, Paris, Cologne, Dubai, Harare and Nairobi. As a teen, Roger played competitive tennis in semipro tournaments. He moved to New York at age 18 and earned a dual psychology degree and MBA from St. John's University before turning his eye toward photography. His first book, entitled *Class of Click* (Stemmle, 1999), was a portfolio of models from the Click agency in the guise of a high school yearbook. He has shot advertising campaigns for Ritz-Carlton, 2(x)ist, Joss Stone, JetBlue, Showtime, Target and Isaac Mizrahi, and his editorial work has appeared in *L'Officiel*, *Harper's Bazaar*, German *GQ*, *Interview*, *Visionaire* and *Flaunt* magazines.

WILLIAM NORWICH is a contributing editor for *Vogue*. He has been a columnist for the New York *Daily News*, the *New York Post*, and *The New York Observer*, and was the style and entertainment editor of *The New York Times Magazine* until 2004. He has also written for *Vanity Fair* and *Tatler*, and is the author of the children's book *Molly and the Magic Dress* (Doubleday, 2002) and the novel *Learning to Drive* (Atlantic Monthly Press, 1996). He lives in New York.

CHRISTOPHER TKACZYK is a reporter for *Fortune* and has researched companies, interviewed CEOs and investigated corporate wrongdoing. He also has written for *People*, *The Advocate* and *The Mackinac Island Town Crier*. In addition to his work as a journalist, he is also a playwright and actor and appears regularly on the stage of The Metropolitan Opera. He holds a degree in dramatic literature from the University of Michigan and lives in New York.

JULIAN PEPLOE is a freelance art director in New York City. Formerly the VP of Design for Epic Records, Peploe formed his own design studio in 2001, branching out into publishing, corporate identity and fragrance advertising. He continues to art direct music packaging, working with artists such as Timbaland, Jennifer Lopez, Sheryl Crow, Fergie, Faith Hill, Maxwell, Michael Bublé and Rufus Wainwright, among others. He has been nominated for a Grammy for his work and has won awards and recognition from the American Institute of Graphic Arts, the New York Art Directors Club, *How* Magazine, *Print* Magazine and *Creativity* Magazine.